MANAWA

NIGEL READING & GARY WYATT

INTRODUCTION BY DARCY NICHOLAS

PHOTOGRAPHS BY KENJI NAGAI

MANAWA
PACIFIC HEARTBEAT

A CELEBRATION OF CONTEMPORARY MAORI & NORTHWEST COAST ART

Douglas & McIntyre
Vancouver/Toronto

University of Washington Press
Seattle

Reed Books
Auckland

Douglas & McIntyre Ltd.
2323 Quebec Street, Suite 201
Vancouver, British Columbia
Canada V5T 4S7
www.douglas-mcintyre.com

Published in the United States by:
University of Washington Press
PO Box 50096
Seattle, WA 98145-5096 U.S.A.
www.washington.edu/uwpress

Published in Australia and New Zealand by:
Reed Books, a division of Reed Publishing (NZ) Ltd/
Te Karuhi tā tāpui o Reed
39 Rawene Road
Birkenhead, Auckland, New Zealand
www.reed.co.nz
Associated companies, branches and
representatives throughout the world.

Library and Archives Canada Cataloguing in Publication
Reading, Nigel, 1954–
Manawa : Pacific heartbeat : a celebration of contemporary Maori
and Northwest Coast art / Nigel Reading and Gary Wyatt ;
introduction by Darcy Nicholas ; photographs by Kenji Nagai.
Catalogue of an exhibition held at the Spirit Wrestler Gallery,
Vancouver, B.C., Feb. 11–Mar. 11, 2006.
Includes bibliographical references.

ISBN-13: 978-1-55365-139-0 · ISBN-10: 1-55365-139-1

1. Indian art—Northwest Coast of North America—Exhibitions.
2. Art, Maori—Exhibitions. I. Wyatt, Gary, 1958–
II. Nicholas, Darcy, 1946– III. Nagai, Kenji
IV. Spirit Wrestler Gallery (Vancouver, B.C.) v. Title.
N5030.V3R42 2006 704.03'97 C2005-904503-5

Library of Congress Cataloging-in-Publication Data
Reading, Nigel.
Manawa : pacific heartbeat / Nigel Reading and Gary Wyatt ;
introduction by Darcy Nicholas ; photographs by Kenji Nagai.— 1st ed.
p. cm.
Includes bibliographical references and index.
ISBN 0-295-98570-4 (pbk. : alk. paper)
1. Art—New Zealand—21st century,—Exhibitions.
2. Art, Maori—21st century—Exhibitions. 3. Art, American—Northwest,
Pacific—21st century—Exhibitions. I. Title: A celebration of
contemporary Maori and Northwest Coast art. II. Wyatt, Gary. III. Title.
N7406.7.R43 2006
704.03'99442'007471133—dc22 2005021675

National Library of New Zealand Cataloguing-in-Publication Data
Reading, Nigel.
Manawa: Pacific heartbeat / Nigel Reading and Gary Wyatt ;
introduction by Darcy Nicholas.
Includes bibliographical references.
ISBN 0-7900-1036-4
1. Art, Maori—Exhibitions.
2. Indian art—Northwest, Pacific—Exhibitions.
1. Wyatt, Gary, 1958– II. Title.
704.0399442—dc 22

Editing by Lucy Kenward
Copyediting by Wendy Fitzgibbons
Cover and text design by Jessica Sullivan
Front cover: *Karanga (The Calling)*, Todd Couper; photo by Kenji Nagai
Back cover photos by Kenji Nagai and Russell Johnson
Maps by Stuart Daniel/Starshell Maps
Printed and bound in Canada by Friesens
Printed on acid-free paper

All photographs by Kenji Nagai, except where credited separately
All measurements are in inches in the order of height × width × depth

We gratefully acknowledge the financial support of the Canada
Council for the Arts, the British Columbia Arts Council and the
Government of Canada through the Book Publishing Industry
Development Program (BPIDP) for our publishing activities.

C O N T E N T S

ACKNOWLEDGEMENTS

THE LAST SIX YEARS have been a remarkable journey of discovery for the Spirit Wrestler Gallery in Vancouver, Canada. Representing Maori art has been an awakening, not only to a new and powerful culture from so far away but also to a further understanding of our own Northwest Coast peoples. The meetings and shared experiences have deepened our friendships with remarkable artists on opposite sides of the Pacific Ocean.

We believe the artworks speak for themselves. "Manawa" is an extraordinary collection, and the Spirit Wrestler Gallery would like to congratulate all the great artists who in a relatively short time dedicated themselves to producing works to honour this celebration. Their enthusiasm, integrity and professionalism are inspirational to us. We thank them not only for the brilliance of their art but also for sharing their words and trusting us to document their stories. The insights into their world provide the magic that illuminates the art and honours the memory of their ancestors.

Many people have contributed to this project, but first and foremost we must thank Darcy Nicholas for his wisdom in writing the Maori introduction to this book. Darcy, a master Maori painter, respected curator and writer, has championed the cause of Maori art since 1966 and was pivotal in creating this publication.

Many have contributed pearls of information that have helped our writing. We would like to say a special thank you to Christina Wirihana for her insights on weaving, Derek Lardelli for his counsel on terminology and Joe David for his poem.

We especially thank Derek Norton, our long-time partner, who spent many hours editing our writing and supporting us in this project, and gallery staff Colin Choi, Minta Sherritt and Eric Soltys for their invaluable assistance.

We are honoured again to be working with photographer Kenji Nagai, who somehow always manages to capture the spirit within the art.

Manawa is the culmination of many years' endeavours, and numerous people and organizations have contributed, supported and helped us in our representation of Maori art.

In Aotearoa ("Land of the Long White Cloud," the Maori name for New Zealand), Spirit Wrestler Gallery thanks the following for their support: Creative New Zealand—Arts

Council of New Zealand, Maori Made Toi Iho, Poutama Trust and Tourism NZ. We express our sincere thanks to Toi Maori Aotearoa, an organization that has listened, encouraged and supported our endeavours: to Garry Nicholas for his leadership, John Dow for his marketing skills and to the staff, especially Bert Waru and Naomi Singer, for their assistance.

In Vancouver, we thank Larry Grant from the Musqueam Nation for his support to us in welcoming the Maori on Coast Salish land, the Fairmont Waterfront Hotel staff for their professionalism in hosting many of our cultural events, and Jill Baird, Karen Duffek, Carol Mayer, Bill McLennan and the staff at the Museum of Anthropology, University of British Columbia, for their assistance and enthusiasm in supporting our cross-cultural exhibitions.

We offer our warm thanks to the staff at New Zealand Consulate/Trade and Enterprise—Stephen Bryant, Anne Chappaz, Andrew French, Lynne Korcheski, Tony O'Brien, Colleen Wilkinson—and New Zealand high commissioner Graham Kelly, who have all in their own way over the years contributed to building the Pacific connection.

This book would not have been produced if it were not for Scott McIntyre at Douglas & McIntyre listening to our endless proposals on its importance. Without the support of Douglas & McIntyre in Canada, University of Washington Press in the United States and Reed Publishing in New Zealand, we would never have had the opportunity to document this cross-cultural connection. Douglas & McIntyre has shared our vision for years and we thank them, especially Lucy Kenward for her editing and Jessica Sullivan for her design of this book.

Manawa coincides with the tenth anniversary of the Spirit Wrestler Gallery. It has been a great ten years of new directions, innovations and exploring the possibilities together, and this book is an appropriate salute to the future and our belief in Maori art. All of us at the gallery—Nigel Reading, Derek Norton, Gary Wyatt and Colin Choi—thank all our friends, clients and artists, who have joined us on this journey. We could not have achieved this success without the ongoing support of our families, especially our long-time partners, Judy Nakashima, Donna Alstad, Marianne Otterstrom and Christine Huang.

This journey towards *Manawa* began with our introduction to the Maori through the visit of June Northcroft Grant and Roi Toia to the gallery. We would like to acknowledge them both, as we consider them not only great artists but also even greater friends.

We dedicate this book to June Northcroft Grant in recognition of her vision, her encouragement and her support in Aotearoa in enabling this dream to become a reality.

NIGEL READING and GARY WYATT
Spirit Wrestler Gallery
Vancouver, British Columbia

PREFACE

IT'S ALL ABOUT THE CHILDREN

Look to the East for chiefly traits
That family and people may thrive,
Look to the South for warmth
That the hearts of all survive,
Look to the West, dark and silent
Where the ancients reside,
Look to the North, active and strong
Coming our children, a cold wind ride.

In our blood
Our ancients work and play,
In our blood
They sing and dance,
In our blood
They love and wage war,
In our blood
They are,
And in our blood
They shall become our children.

JOE DAVID, NUU-CHAH-NULTH (CLAYOQUOT)

I T I S 1 9 9 5, and Joe David, brimming with excitement, has just returned from a journey. He has a glint in his eye, a knowing smile, as he slowly unwraps his latest creation for our consideration. Joe has been bringing work to us at the Spirit Wrestler Gallery for many years, and we have come to expect the unexpected from the first piece he produces after one of his travels around the world. He has carefully planned visits to elders, teachers, medicine people and artists from many cultures to enrich his vast knowledge of art, but more specifically to discover what is inside the art—the spirit, the skill and the history of the people. The mask he reveals is distinctly Maori, decorated with *moko* (tattoos) and representative of a culture that has continued to haunt and inspire his own work.

Four years later, the Maori, represented by June Northcroft Grant and Roi Toia, attended the AFN-NEXUS '99 Business Conference and its accompanying trade show in Vancouver. While visiting Native art galleries during their stay, they stopped in at the Spirit Wrestler Gallery. This was our fortuitous introduction to Maori art, and it resulted in the Maori being included in our groundbreaking exhibition "Fusion: Tradition & Discovery," which introduced the art of Colleen Waata Urlich, Alex Nathan, Manos Nathan and Roi Toia beside the works of artists from the Northwest Coast, Plains and Inuit cultures. The gallery recognized that cross-cultural contact had been reshaping aboriginal art for a long time, and over the next few years we continued to expand our Maori representation, adding works from Sandy Adsett, Darcy Nicholas, Kerry Thompson and Todd Couper.

I travelled to New Zealand, and my visits were an education in Maori culture as well as an opportunity to experience the warm hospitality, guidance and knowledge of so many artists. I have been privy to many special moments with the Maori: paddling their *waka* (canoes), witnessing their ceremonies and staying on their *marae* (traditional gathering places). Across the North Island of New Zealand, I have met great artists and organizations responsible for promoting Maori art, seen the wonders of the country and the formidable presence of Maori art in museums and cultural centres and as public art throughout the nation. I have become aware of how privileged the gallery is to be working with such a large number of master artists who are deeply committed to their culture and ready to expose Maori art to the world.

In 2001, during a drive between the New Zealand cities of Rotorua and Gisborne, June Northcroft Grant and I hatched the idea to curate a benchmark exhibition in Vancouver to promote Maori art in North America. "Kiwa—Pacific Connections" was born. The initial idea was to have Joe David, as the Northwest Coast representative with the longest affiliation to the Maori, introduce the Maori exhibition. However, this changed after Dempsey Bob visited New Zealand and returned excited from his experience and offering

his support to our exhibition. The idea expanded to become a "welcoming" exhibition showcasing a cross-section of Northwest Coast pieces beside the Maori works of art. Among the Northwest Coast contributors were Norman Tait, Joe David, Dempsey Bob, Tim Paul, Susan Point, Norman Jackson, Christian White and Stan Bevan, who expressed their willingness to support and honour the Maori as a result of either a recent visit to New Zealand or of participation in cultural events with Maori here in North America.

Two years later, in September 2003, "Kiwa—Pacific Connections" opened at the Spirit Wrestler Gallery. Here, people could finally see some of the very best examples of Maori art. The exhibition was a huge success and a revelation to those who witnessed the inter-cultural celebrations surrounding the event. It was a little bit of history in the making.

"Manawa—Pacific Heartbeat" was conceived after viewing "Toi Maori (Te Aho Mutunga Kore): The Eternal Thread—The Changing Art of Maori Weaving" with Darcy Nicholas at the Pataka Museum of Arts and Culture in Porirua City, New Zealand. We developed the idea of "Manawa" with its own identity and theme to complement the "Eternal Thread" exhibition opening at the same time at the Burke Museum in Seattle, Washington.

In "Manawa" we wanted to showcase Maori art through an even stronger team of art-ists. The logical direction was to augment the collection with more three-dimensional work, especially in wood, a medium shared by Northwest Coast and Maori artists and therefore a natural transition for collectors new to Maori art. The final selection of thirty-one Maori and fifteen Northwest Coast exhibiting artists includes those who have developed relation-ships or forged friendships over many years with the gallery, as well as those who, since "Kiwa," have experienced the Pacific connection. All of these artists are people we admire for the quality and originality of their work and respect for their greater vision in support-ing cultural issues and native concerns beyond the arts worldwide.

The purpose of this book is to reach a larger international audience.

It is essential that the history of this cross-cultural Pacific contact be recorded: just as *Manawa* will further reveal Maori art to a North American audience, it will introduce Northwest Coast art to a southern audience in New Zealand. More than that, we feel it is equally important that the Northwest Coast artists who have exhibited their art alongside the Maori be recognized for their contribution towards its success in North America.

Throughout the time I have spent preparing "Manawa" I have remembered these words spoken to me in Maori by my dear friend June Northcroft Grant, to whom I owe so much . . . *He toi whakairo, he mana tangata*. Where there is artistic excellence, there is human dignity.

NIGEL READING
May 2006

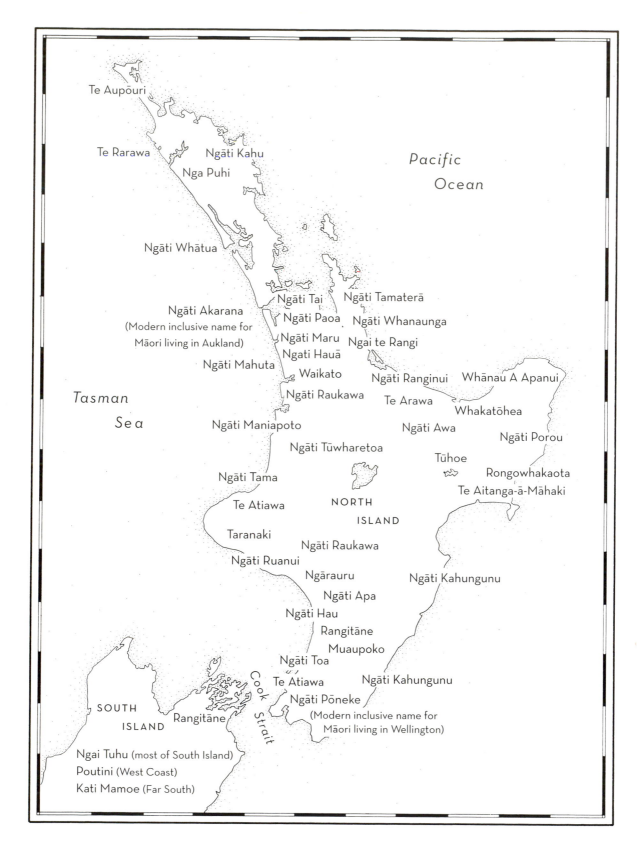

Te Aupōuri

Te Rarawa Ngāti Kahu

Nga Puhi

Ngāti Whātua

Pacific
Ocean

Tasman

Sea

Ngāti Tai Ngāti Tamaterā

Ngāti Akarana Ngāti Paoa
(Modern inclusive name for Ngāti Whanaunga
Māori living in Aukland) Ngāti Maru Ngai te Rangi

Ngati Hauā

Ngāti Mahuta Waikato Ngāti Ranginui Whānau A Apanui

Ngāti Raukawa Te Arawa Whakatōhea

Ngāti Maniapoto Ngāti Awa Ngāti Porou

Ngāti Tūwharetoa

Tūhoe Rongowhakaota

Ngāti Tama Te Aitanga-ā-Māhaki

NORTH
ISLAND

Te Atiawa

Taranaki
 Ngāti Raukawa

Ngāti Ruanui
 Ngārauru Ngāti Kahungunu

Ngāti Apa

Ngāti Hau

Rangitāne

Muaupoko

Ngāti Toa

Te Atiawa Ngāti Kahungunu

Ngāti Pōneke
(Modern inclusive name for
Māori living in Wellington)

Cook
Strait

SOUTH
ISLAND Rangitāne

Ngai Tuhu (most of South Island)
Poutini (West Coast)
Kati Mamoe (Far South)

Maori Tribal Areas of New Zealand

INTRODUCTION

BREATH OF THE LAND

Darcy Nicholas

TAUPARAPARA

*takua e, te tapuwa o te atata hapara
hei kukume mai i nga kawekawe o uru, o ngangana.
ko nga karere whakaari tera i a tamanui-te-ra
i tona whare muramura, i a rori-wha-te-ao.
na tane i kimi, nana i rapu, nana i rangahau
te maramatanga i rukuhia ai i te kore,
i te po-te-kitea. ka wehe i reira a ranginui-e-tu nei,
a papa-tua-nuku e takoto nei hei matutua ia a raua kotahi.
ka tupu ko te kahui atua, ko te kahui tangata, ki te whaiao
ki te ao marama. kokiri! taia te mahi a tangata
kia rere whakawaho ki te ateatanga! hui e! taiki e!*

TRANSLATION

*Recite the rituals of the early morning
to usher forth uru, and ngangana.
The rays that herald the coming of Tamanui the sun
from his blazing house, rori wha-te-ao.
It was Tane who sought to seek and search
the light of day, even into the realm of the unknown
and the darkest of the night. So was separated
Ranginui the infinite space and Papa-tua-nuku the earth,
the original parents of all being.
From there emerged the spiritual forces, and the people,
into the world of being, the world of light.
Launch forth! Dedicate this work of the people
to take flight upon the wings of time! So be it!*

RUKA BROUGHTON, NGA RAURU

THIS STORY IS a combination of oral history told to me by elders as well as nearly forty years of knowledge I've learned while actively helping to drive the development of the contemporary Maori art movement. Today we are still a vibrant and living culture, and it is important that we seek to reach our potential rather than relive our pain. We tell our stories through our art because that is our freedom.

The contemporary Maori arts scene is dynamic and diverse. New technology, and more opportunities to work and exhibit internationally, mean that the wide range of art forms practised by Maori artists is truly global in its influence and scope, though our best art will always reflect our uniqueness as a people at the same time that it seeks to be universal.

Vancouver, with the guidance and support of the Spirit Wrestler Gallery, has become a major landing point for the contemporary Maori art movement. This book, *Manawa*, and the exhibition it accompanies feature some of the artists who have left their mark on the evolution of Maori art as well as the rising new stars. For us, art is of the people and from the people. It changes and evolves as the people change and evolve, until finally it becomes part of the daily fabric of our lives.

We are physically connected to our Canadian and American First Nations people by the sea and more recently by modern technology. Spiritually, we share the vision of our ancestors, and we still hear their voices over the earth and sky, right across the valleys and down to the sea. We are learning more about each other through our growing relationship. The power of art and the creative spirit helps us to transcend time and cultures and accept each other as part of an extended family. Now that we know about each other, we can never feel alone: our First Nations relatives are always welcome on our land. It is the future we share together that is exciting.

MAORI ORIGINS

Maori are the native people of New Zealand. Our land is dramatic and diverse, with beautiful mountains, large forests and wide rivers that meander through fertile country to the sea. Our stories tell of the creation of this land, from the lava flow emerging out of the ocean to the birth of the mountains, rivers, trees and creatures. Our name for New Zealand is Aotearoa.

Maori oral history says we have been on the land from the beginning of time, but colonial history says we immigrated between 500 and 1,000 years ago. Although there have been several waves of migration to our shores, colonial history often ignores the oral history that predates canoe migrations or describes our original ancestors as a different people.

Some of the first known peoples of Aotearoa were Kahui Maunga, Kahui Ao, Kahui Rere, Kahui Tu, Taitawaro, Ruatamore, Pananehu, Moriori, Waitaha, Kati Mamoe and Maru Iwi, tribes whose genealogies were linked to the mountains, rivers and land formations. They married into successive migrations of Pacific people who arrived in canoes over a period of several hundred years. The first people of Aotearoa were known by the original names that described their uniquely different histories, but today their descendants are collectively known as "Maori."

Our ancestors were sea voyagers who travelled across the oceans in double-hulled canoes. They navigated by the stars, the flight of migrating birds, seasonal winds, ocean currents and the flowing patterns of waves. They developed a deep knowledge of the sea that enabled them to travel safely from island to island and across vast stretches of water. Our history and our culture evolved from the experiences of their journey through life. The Maori were fierce fighting warriors, and intertribal wars, which were often prompted by revenge for some misdeed, were vicious. The defeated enemy was often subjected to slavery and acts of cannibalism.

EUROPEAN SETTLEMENT AND THE NEW ZEALAND LAND WARS

Both the Dutch and the Spanish visited our country before the British. It was not until the 1800s that the first British colonists arrived in large numbers. The early settlers were interested only in exploiting the rich land and sea resources, which included gold, timber, large stretches of land suitable for farming and abundant stocks that fed the whaling and sealing industries.

First they belittled our language, then retold our history. The Europeans superimposed their own names on our sacred sites, sent in waves of missionaries to teach new religions, undermined our social structures, introduced diseases and new, more powerful weapons. In time our oral history was ignored, and generations of Maori were subjected to the written colonial history that is taught as part of our education system. Many Maori are now convinced they are foreigners in their own ancestral lands, and they preach these revised migration theories to our people.

In 1840, Maori and the British signed the Treaty of Waitangi, giving British subjects the right to form a government on the understanding that Maori retained their chiefly status over their own lands. At that stage our fierce fighting ancestors outnumbered the British immigrants. In 1843 the daughter of a well-known paramount chief was killed during a conflict between British and Maori forces. That incident escalated into the New Zealand Land Wars that lasted until 1872, although some argue that they continued until the famous battle at Parihaka pa, in Taranaki province, in 1881.

At Parihaka pa (*pa* means "fortified village"), Maori tribes used passive resistance for the first time to fight the onslaught of armed colonial troops. In this battle, many Maori were imprisoned solely because they were unwilling to allow their ancestral lands to be purchased or confiscated. As they resisted, their farming stock was ruined, their women taken and their houses destroyed.

Despite the many conflicts between Maori and the British, there was a mutual expectation and understanding that one day we would have to learn to live together. Following the land wars, peace was restored. Although there was considerable intermarriage—today most Maori carry the ancestral blood of the English, Irish, Scottish, Welsh and French settlers—most of the land that legally belonged to Maori was either confiscated as the colonial government grew in power or sold off illegally by unscrupulous Maori and settlers. The loss of ancestral land has had a devastating effect, because land is the foundation of Maori identity.

THE CHANGING FACE OF MAORI LIFE

During the 1950s, Maori families were often large and lived in relatively loose-knit sub-tribes. In my family there were twelve children, and my mother and elder sisters and brothers "looked after" several others. My father's father married twice and had twenty-five children with his two wives.

Tribal gatherings were often held to discuss major issues or matters of concern brought up by elders or other influential members of the tribe. My generation was raised in an environment in which many of our elders spoke only the Maori language, and the stories they told us were part of the oral histories their elders had told them. The young ensured the elders were cared for, and in turn were given stories that could be carried forward to the following generations.

Living in rural areas meant my generation formed a close relationship with the natural world. We fished and gathered our food from the rivers, the sea and the land. Our traditional food supplies were abundant and the environment was unpolluted. The Maori system of passing knowledge from one generation to another by oral language, and teaching by demonstration and personal coaching, had sustained the survival of our people for centuries. It meant everyone had an important role in the tribe, and people were respected and listened to because of their particular area of expertise.

Major changes occurred shortly after the Second World War. Many more Britons emigrated to New Zealand, strengthening the influence of British and world cultures on the New Zealand public and, subsequently, on the Maori people and their artists. Already the emerging giant of American culture had been experienced during the Second World War,

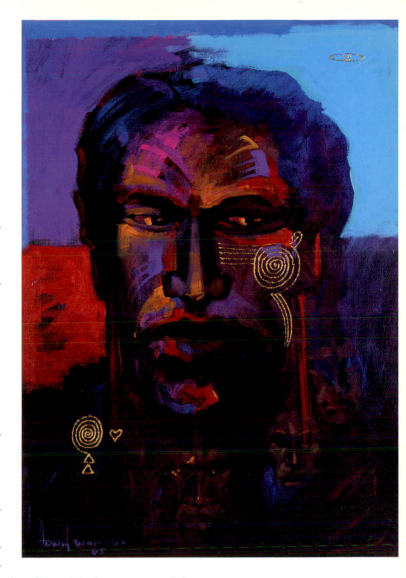

when the United States responded to British prime minister Winston Churchill's strong request to protect New Zealand from Japanese invasion. Tens of thousands of American soldiers were based in New Zealand during that time, and they left behind a culture of American music, dance and fast food.

When the New Zealand troops returned home after the Second World War, they brought with them stories of different cultures, great works of art and another way of looking at the world. However, they also carried the burden and sadness of leaving behind large numbers of comrades who had died on the battlefields and been buried in foreign countries. These were powerful emotional times when society was changing, and these influences were felt strongly in New Zealand. Maori, like the rest of the world, moved into a massive phase of cultural evolution that lasted from 1945 into the 1950s and beyond.

In 1952, Elizabeth was crowned Queen of England and won the hearts of older and newer generations of New Zealanders. Britain was affectionately referred to as "the home country." At the same time, the memories of the thousands of American soldiers made their mark, and when rock 'n' roll stormed through the United States it simultaneously swept New Zealand. When Bill Haley, Elvis Presley and later the Beatles became international stars, they also became stars in New Zealand.

In New Zealand, the latter part of the 1950s brought major migrations of young Maori men and women into the cities. Although that generation retained its tribal links, the children of these Maori, born into urbanization, had fewer ties to their tribal ancestors. Television, movies, radio, records and picture magazines bombarded our country with new and exciting images, and both urban and rural Maori were drawn away from tribal life. By the late 1960s, the Maori exodus to the cities had reached huge proportions and changes to the environment made traditional practices of gathering food from nature difficult. There had been a great increase in the number of factories, and chemical pollutants had been released into the sea. Dragnet fishing, in which trawlers tow huge nets that scoop up everything in their path, had destroyed large parts of the ocean floor and made it into a desert. In

addition, commercial fishing had stripped coastal waters of the seafood previously available to families to sustain their day-to-day lives. These days, Maori have to purchase most of their seafood from supermarkets and other commercial outlets.

CONTEMPORARY MAORI ART

The very early Maori artists laid the foundation from which Maori art evolved and Maori culture is reflected. They were known mainly by their tribal affiliation rather than as individuals, and the tribal styles of carving and weaving they created have been handed down to succeeding generations. Ritual and cultural practices were preserved through rigid disciplines that forbade any variation or deviation, meaning that the "craft" and the "ritual" of Maori culture were part of a carefully planned system of passing skills and knowledge to specifically talented individuals only. This custom guaranteed that tribal practices and stories and the unique development of tribal differences in the art forms were retained. We record our history and culture through carving, weaving, facial and body tattooing, traditional ritual, song and dance, the movements and the words repeated over and over again as rhythmic incantations until they form part of our soul. In this way, each hill, mountain and river and every other single feature of the land has its own story and is included in the oral history of our people.

As the environment, the tools and the needs of the people changed, variations on an old style began to evolve. The first major shifts had come with the introduction of metal chisels, as early as the late 1700s and possibly earlier. With these tools, artists were able to carve sharper and deeper lines, and they began to depict colonial images. Although there were several shifts in Maori art during the 1800s, the largest changes occurred after the Second World War. The influence of other cultures presented Maori with a new way of seeing the world. The use of new tools, materials and techniques and concepts meant that endless possibilities of artistic expression were emerging. The young Maori artists in the 1950s were sculptors, painters, printmakers and mixed-media artists.

Among those who played a major part in the formation of the contemporary arts movement were Sandy Adsett, Clive Arlidge, John Bevan Ford, Fred Graham, Ralph Hotere, Para Matchitt, Muru Walters, Cliff Whiting, Arnold Wilson and Selwyn Wilson. Some of the women were Cath Brown, Freda Kawharu, Katerina Mataira and writer and designer Amy Brown. They broke down the walls of tradition, questioned their elders and debated world art issues and techniques. At the same time, they were part of a dynamic drive by the visionary art educator Gordon Tovey, who set out to discover or invent the elusive "New Zealand art." Together with non-Maori artists, they were liberating our country from the

conservative "British Academy" style of art they had inherited with colonization. They developed the new art forms upon which generations of New Zealand and Maori artists would build.

By the 1960s, contemporary Maori artists had formed small individual groups exhibiting in joint shows around the country. One of the emerging young giants in the 1960s was Selwyn Murupaenga (known as Selwyn Muru), a painter, sculptor, poet, broadcaster and playwright. Muru is an expert in Maori language, ritual, oratory and history. He created a completely individual approach that showed the land as a living ancestor. In the minds of many Maori he gave the land song, history and ancestral voice, and his Maori view of the land gave non-Maori artists insight into another spirituality. The land he painted was "Maori land." Muru's *Parihaka* series was arguably the most important group of paintings completed by a New Zealand artist. The Parihaka "incident" as painted by Muru shows both the fight for, and the birth of, a nation. Muru also wrote plays and poetry and directed several important documentaries and stories for television.

Working in television and film at the same time as Muru were rising stars Barry Barclay, Merita Mita and Lee Tamahori, who played a major role in the developing Maori film industry and went on to become filmmakers in the international arena. Tamahori directed the Maori film *Once Were Warriors* and since then several Hollywood movies, including the James Bond adventure *Die Another Day*.

Muru's close friend Buck Nin also emerged as an important Maori sculptor and painter. Nin completed his doctorate in the United States and was renowned for his entrepreneurial skills. A larger-than-life intellectual artist, Nin, like Muru, was a visionary. For many years he had dreamed of a Maori art school and university, and with his close and equally visionary friend Dr. Rongo Wetere created Te Wananga o Aotearoa, the University of New Zealand, a Maori university that now caters to more than 50,000 students. Today the *wananga* (place of learning) is an important contributor to the ongoing development of Maori art, and it also offers courses to the wider community of new immigrants, New Zealanders and overseas students.

Nin completed several large-scale paintings, which expressed the history and importance of land as an integral part of Maori identity. He was an immaculate draftsman, but in later life suffered ill health and often planned and created his work with the assistance of apprentices working under his guidance. Sadly, he passed away in 1996 at the young age of fifty-four years. Maoridom lost one of its great artists.

In the latter part of the 1950s and into the 1960s, Sandy Adsett, John Hovell, Para Matchitt, Cliff Whiting and Arnold Wilson were some of the first contemporary artists to

introduce new styles in the art of the ancestral houses. This group created an "assemblage" style that incorporated carving, weaving and a wide range of media from bone to steel and glass. Matchitt, Whiting and Wilson, in particular, completed important murals and works of art throughout the country. Although these three also initiated major developments to the *kowhaiwhai* (rafter patterns) on ancestral houses, it was Sandy Adsett and John Hovell who painted them onto pieces of board and canvas for display as paintings in public galleries. Generations of artists followed them. Adsett's designs were also transformed into high-fashion garments initiated by Whetu Tirikatene, who later became influential in the formation of the Maori and South Pacific Arts Council (MASPAC) when she was a cabinet member in New Zealand's Parliament.

In the 1960s, urban Maori gangs such as Black Power, the Mongrel Mob and the Nomads copied the American gang movements, particularly with regard to skin self-embellishment. Although many of the gangs treated the prison gang tattoo as a serious art form, it was several years before *ta moko*, the traditional form of Maori body art, was revived. Some of its early exponents included Te Aturangi Clamp, Rangi Kipa, Mark Kopua, Derek Lardelli, Riki Manuel and Laurie Nicholas.

By the mid-1960s, educators like Frank Davis were writing the history of contemporary Maori art as part of the school curriculum. Davis, a New Zealand artist, a speaker of the Maori language and husband of Waana Davis, the current chairperson of the Maori arts organization Toi Maori Aotearoa, wrote the stories of young unknown artists like myself, Ross Hemera, Robert Jahnke, Albert McCarthy and John Walsh into the annals of Maori and New Zealand art. At a time when the Maori art movement was ignored by the art gallery establishment, Davis was our champion. He was a *pakeha* (white person), but he respected Maori. He told of visiting a school and asking in the Maori language who spoke Maori. Not one student answered. He was very concerned that he had embarrassed the Maori students and vowed never to use the Maori language again. I was with Frank when he suddenly fell ill. Weeks later, Davis, one of New Zealand's great people and a dear friend, passed away.

As a result of Davis's efforts, we became the next generation of contemporary Maori artists. Robert Jahnke introduced a new sophistication to the contemporary Maori art scene with skills in animation, design and the use of new technology. Both he and Ross Hemera played an important part as teachers and educators in fostering and developing the next generation of contemporary Maori artists. Contemporary sculptor Matt Pine, who returned to New Zealand from Britain around this time, introduced a more conceptual and minimalist approach to Maori sculpture. He continues today with his uniquely individual style, which is slowly gaining momentum among emerging younger Maori artists.

THE BIRTH OF CONTEMPORARY ART ORGANIZATIONS

A collective called the New Zealand Maori Artists and Writers Society was formed in the 1960s to consolidate the talent, networks and knowledge that were loosely held by Maori artists around the country. Georgina Kirby, who would later become Dame Georgina for her services to Maori, and the educator, writer, artist and broadcaster Haare Williams were two prominent driving forces behind this movement. Although the group was officially incorporated as a society, it became a collective because many of the artists did not pay their annual fees. From time to time they pledged membership, but they also wished to remain autonomous; that is, many of them did not want to belong to an organized group, but at the same time they cherished being able to brainstorm ideas and techniques with equally dynamic artists.

These were happy and exciting times during which we were surrounded by strong personalities and creative minds. The broadcaster and Ngati Porou scholar Wiremu Parker, Maori Queen Te Atairangikaahu and the renowned weaver Dame Rangimarie Hetet provided strong support for Maori artists and writers with their presence. Several other tribal elders backed the society and attended annual conferences to join the discussions and debates that were a hallmark of the gatherings. The artists assembled each year on different tribal lands, where they held art workshops and exchanged stories and ideas.

The Maori Artists and Writers Society later became known as Nga Puna Waihanga. It included painters, sculptors, weavers, poets, writers, actors, singers, dancers, filmmakers and experts in language, ritual and tradition. The intention was to create a forum for artists of Maori heritage to meet annually, learn tribal history and new techniques, and plan other major events that would profile Maori art to our people. These meetings became the catalyst for major exhibitions of contemporary Maori art to be shown in New Zealand galleries.

Some of the great Maori writers to emerge from the association were Patricia Grace, whose books are published in several countries; Keri Hulme, who won the Booker Prize with her novel *The Bone People;* Witi Ihimaera, who wrote several novels, including *Whale Rider;* celebrated poet Hone Tuwhare and writers Arapera Blank, Rowley Habib, Keri Kaa, Katerina Mataira, Dun Mihaka, Meremere Penfold, Bruce Stewart, Apirana Taylor and several others.

Within the association there were often arguments, factions and disagreements, some of which lasted for years. Some of the artists were very knowledgeable in Maori tradition and culture whereas others were still searching for their Maori identity. Tribal, gender, individual and age differences also caused conflict. It was a dynamic art scene that made us grow stronger. Unfortunately, this movement lost its impetus as it was taken over by Maori artists who were schoolteachers and academics and the annual artist meetings

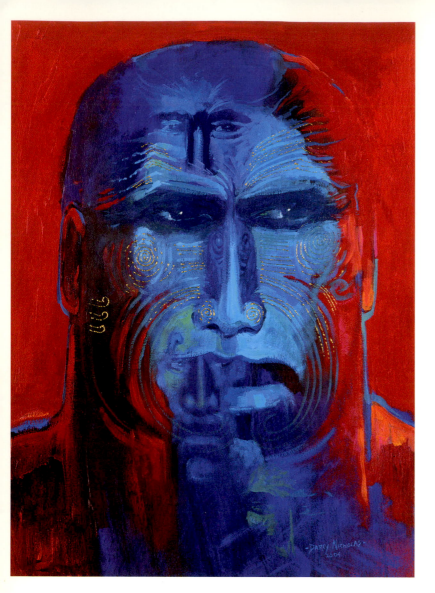

became unofficial holiday camps for Maori and non-Maori university and polytechnic students.

I recall walking into a classroom around that time to give an art lesson to a group of young Maori artists. Finding no brown person in the room, I quietly walked out again, without giving the lesson. At that time in our lives we were so focussed on developing the Maori art movement that we began to resent the number of non-Maori who were attending the annual conference. The senior artists who gave the association its history and knowledge eventually stopped attending, and the Maori Artists and Writers Society ceased to exist.

For the Maori artists, the line between music, dance, poetry, painting, sculpture, traditional incantations and all the other forms of expression was indefinable. Many of the artists specialized in all these fields, so it was no accident that the success of Maori actors, filmmakers and musicians inspired poets, painters and sculptors. In music, significant Maori show bands had developed, and they excelled in the New Zealand, Australian, Asian and American music scenes. Some of the great individual stars who emerged from the music scene of the 1960s were Sir Howard Morrison and the celebrated international opera stars Dame Kiri Te Kanawa and Inia Te Wiata. They were followed later by popular singers like Rhonda Bryers, John Rowles and Frankie Stevens. As these individual entertainers expanded the boundaries of achievement, new artists were coming onto the scene. Many commentators at the time described this period as the Maori Renaissance, a time when we extended ourselves beyond our traditions and moulded them with the cultures of the world.

In 1963, the New Zealand government established the Queen Elizabeth II Arts Council, a funding agency designed to support the cultural sector. Two Maori Members of Parliament, Whetu Tirikatene-Sullivan and Koro Wetere, and the Maori Artists and Writers Society played a significant part in creating the Maori and South Pacific Arts Council in 1978, a sub-agency specifically dedicated to bolstering Maori art by funding programs for Maori artists

and providing policy advice to government. Among the key artist representatives on the council were Witi Ihimaera, Dame Georgina Kirby and Haare Williams.

The late Sir Kingi Ihaka, himself an expert in Maori life, language and culture, chaired the first MASPAC board of governors. Although artists initially saw him as being very conservative, he became more outgoing, sharp humoured and creatively challenging during his tenure and close interaction with the contemporary artists. His first executive officer was Rangi Nicholson, who was succeeded by Piri Sciascia. In a gesture of biculturalism, this position was later upgraded to assistant director of the Queen Elizabeth II Arts Council.

MASPAC went through a number of changes. First it became the Maori Arts Council under the leadership of Kuru Waaka when it separated from the South Pacific Arts component. Under this structure it had both a policy and operational role, with a number of its own committees specializing in both traditional and contemporary Maori art forms. When the government decided to strengthen the policy roles of the Queen Elizabeth II Arts Council in 1994, it was renamed the Arts Council of New Zealand (also known as Creative New Zealand). The new Maori part, Te Waka Toi, replaced the Maori Arts Council at the same time and its operations department was separated from the Arts Council. Known as Toi Maori Aotearoa, this organization maintains and governs a wide range of Maori art disciplines involving traditional and contemporary artists.

The first head of Toi Maori was Eric Tamepo, who was succeeded by Garry Nicholas, the current chief executive. Once a small office providing services to various committees of arts disciplines, Toi Maori has flourished to become an organized body that reaches out tribally, nationally and internationally to develop and promote the wide range of Maori creative and traditional arts.

THE SECOND GENERATION OF URBAN MAORI AND ART

By the 1970s, the young adults who had drifted to the cities in the 1950s had given birth to a new generation of Maori born and raised in the city and therefore separated from their tribal roots. Unemployment in New Zealand had greatly escalated by this time, and the government implemented a range of employment programs, based on similar ones offered in the pre-war United States.

Despite the economic pressures, new Maori arts groups formed as part of the government employment programs at the Wellington Arts Centre. (The centre was the first of the art employment programs established by the government in 1980.) Contemporary theatre companies such as Te Ohu Whakaari and a Pacific Island group, Taotahi, were established under the artistic direction of Colin McColl; Maori actor Rangimoana Taylor later became

Facing page:
Hidden Warriors
Darcy Nicholas
acrylic on paper
29 × 22 inches

artistic director of Te Ohu Whakaari. The new works these groups presented were more about contemporary living than direct expressions of Maori or Pacific Island art or culture.

An African-Maori dance company called Merupa Maori was founded under the musical and dance direction of Kincho Katshablala, a former cast member of the famous South African musical *Ipi Tombi*, and Rangitihi Tahuparae, an expert on Maori language, ritual, history and weaponry. Tahuparae had also helped form Te Ohu Whakaari, which successfully staged its first play, *The Gospel According to Tane*, written by Selwyn Murupaenga, and initiated, among many other things, the Whanaki *rangataua* (emerging warriors) group. This powerful body of highly skilled Maori warriors used traditional and contemporary weaponry and methods of fighting. He also trained very select groups of young people in Maori ritual, language and traditional dance.

The Maori language and other educational and developmental programs progressed under the visionary leadership of Ihakara Puketapu, the secretary of the government's Department of Maori Affairs. He had previously worked in New Mexico, and from the 1960s onward he instituted several cultural and business exchanges with the Navajo and Hopi Nations of the American Southwest as part of a focus on small industries involving crafts.

Puketapu also set up Te Kohanga Reo Maori, immersion language programs for preschoolers. Hundreds of small tribal and urban language "nests" throughout the country have increased the number of native speakers. However, as the Maori language is adjusted to fit into "English-language format," its poetic nature is changed—a shift that may be unavoidable as we become part of the competitive global economy and the language loses its day-to-day use.

Maori language flourished on the radio under Huirangi Waikerepuru and Professor Whatarangi Winiata, who in 1982 helped form the first Maori radio station, Te Upoko o te Ika (Head of the Fish). Today there are more than twenty-five Maori radio stations around the country as well as a Maori television station, which celebrated its first anniversary in April 2004. Puketapu was also responsible for *kokiri* centres, training facilities that promote language and culture, such as art and weaving, as well as life skills under the Maori Access employment programs.

INTERNATIONAL EXHIBITIONS

In 1984, a major exhibition of traditional Maori carving opened at the Metropolitan Museum of Art in New York City, later travelling to Chicago and San Francisco. The exhibition, "Te Maori," received rave reviews in the United States and acted as a catalyst for

New Zealand to review its attitude towards Maori art and culture. Until "Te Maori," New Zealand art galleries had labelled Maori art as "*marae* decoration." *Marae* are traditional Maori gathering places.

That year I won a Fulbright Award and travelled throughout the United States meeting Native American and African-American artists. Katherine Rust of New Mexico introduced me to a network of Native American artists, including Harry Fonseca, Allan Houser, Dan Namingha, Lillian Pitt, Juane Quick-to-See Smith and several others, many of whom later travelled to New Zealand to meet and work with Maori artists. We immediately felt a bond with Native Americans.

The reaction to "Te Maori" gave Maori artists a new confidence at the same time that it transformed the attitude of the museums and art galleries in New Zealand. Maori artifacts were now displayed as works of art rather than as building decorations. Bicultural programs were developed, and major museums took greater pride in their collections of Maori art.

The main organizers behind "Te Maori" were Ihakara Puketapu, Professor Hirini Moko Mead and Piri Sciascia, the administrative executive who oversaw the project. Professor Mead was not always popular with contemporary Maori artists. Intellectually sharp and highly knowledgeable in Maori history and culture, he kept the senior artists on their toes and was often misunderstood. He was seen by some of the more senior contemporary artists as a formidable foe rather than an educator and ally and, like Sir Kingi Ihaka, was considered to be highly conservative. However, from my observations both Sir Kingi and Professor Mead helped give substance to the contemporary art movement by continually questioning it.

One of the key issues facing Maori then and still today, as we change and become global, is what "Maoriness" we hold on to and take into the future. Each step we take in a different direction is another step away from who our parents and ancestors were. That step into the future will eventually define the next generation of Maori.

The Contemporary Maori Arts Trust had formed in 1980. Comprised of men who had emerged as artists in the 1950s and 1960s, the trust was designed to act as a catalyst to allow elite groups of artists to discuss oral history and knowledge, debate important concepts of traditional and contemporary Maori art, and support important art exhibitions. This was a time of considerable upheaval for Maori, when there was high unemployment. Maori had experienced more than twenty-five years of urban drift, and a generation of Maori elders was passing on.

When a respected master carver challenged the Arts Trust for being arrogant, he pointed to me because I was the youngest of the group at the time. Arnold Wilson, the elder

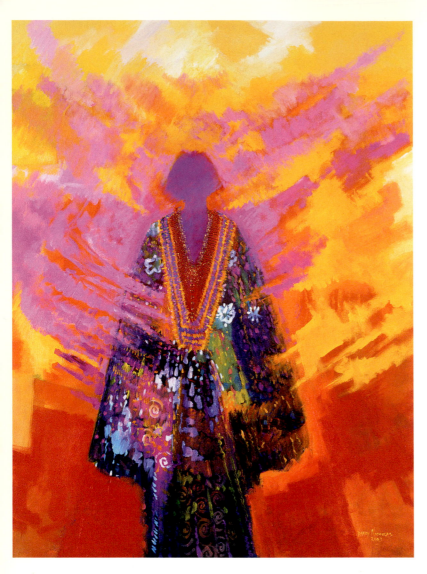

of our group, kept calling out to me to "get him." The master carver wasn't sure whether it was to be a physical or verbal rebuttal. (In retrospect, I realize that criticizing the youngest was a probe to test the strength of the group: getting me to answer was a deliberate show of strength.) When the master carver finished his rebuke, he sat down and looked sternly at me.

I looked at the beautiful carvings in the house and they gave me my answer; it was as if they wanted to play the game as well. I replied reluctantly to the master carver, "If you call us arrogant then we must be, because you are the expert in arrogance. What is more arrogant than the master carver who walks into the forest of Tane, cuts down his eldest child and carves it in his own image?" This reference to Tane Mahuta, God of the Forests, was followed by laughter throughout the group and big smiles from the master carver. Then one of the senior artists commented: "If we don't provide the pathway for our future artists too, then the bloody academics will do it for us." In many cases, unfortunately, this is what has happened.

A major exhibition of Maori art entitled "Maori Art of the 1980s" was launched at Pipitea Marae in Wellington in 1980, and with it a festival that showcased the work of contemporary Maori artists on a grand scale for the first time ever in New Zealand's capital city. Sponsored by the Department of Maori Affairs, these events featured sculptors, painters, weavers, poets, writers, dancers and artists working in a range of media. The major forces behind this project were Colin Knox and writer Bruce Stewart; my job was to put the exhibition together. The only way to obtain the pieces was to hire a big truck, go to the artists' studios and just take the work from them. Several pieces were arriving at the last minute, and we still had to build an entire gallery out of timber and cardboard. Myself, Buck Nin, our Greek designer Tolas Papalazou and some helpers worked all day and all night. We installed the final piece just as the doors opened and Maori Queen Te Atairangikaahu walked in at dawn to inaugurate the exhibition. The artworks looked magnificent and, during the week we were open, drew 2,000 people a day into the makeshift gallery.

In the wake of "Te Maori" there were a number of exhibitions of contemporary Maori art. Once "Te Maori" returned to New Zealand, it toured throughout the country and was accompanied by "Maori Art Today," curated by the Wellington Arts Centre Trust in partnership with the Maori and South Pacific Arts Council. Both organizations also combined to curate "Seven Maori Artists," which toured Australia in 1985, and "Maori Artists in Africa," which toured in 1987. The Maori Arts Council curated and toured the exhibition "Te Waka Toi: Contemporary Maori Art" in the United States from 1992 to 1994.

Thanks to these exhibitions, by the late 1980s Sandy Adsett, Fred Graham, Ralph Hotere, Paratene Matchitt, Selwyn Muru, Buck Nin and Cliff Whiting had all emerged as important New Zealand artists.

THE EVOLUTION OF MAORI WOMEN'S ART

Male artists dominated the contemporary Maori art movement despite the fact that the international women's liberation movement was well established. Until the 1980s the visual art of Maori women was dominated by traditional weaving. Weavers such as Dame Rangimarie Hetet, her daughter Diggeress Te Kanawa, Te Aue Davis, Erenora Puketapu Hetet, Puti Rare, Emily Schuster and many others were creating new contemporary pieces by drawing on traditional knowledge. In 1983, the Aotearoa Moananui a Kiwa weavers was formed, a combination of Maori and Pacific Island weavers who met each year. Changes in the arts structures in New Zealand saw them re-establish themselves in 1994 as Te Roopu Rarangawhetu o Aotearoa. Today, many of them are part of the "Toi Maori: The Eternal Thread" exhibition touring the United States in 2005 and 2006. This is the first major exhibition of Maori weaving to tour internationally, and it was curated by the Pataka Museum of Arts and Culture in Porirua City in New Zealand, in partnership with Toi Maori Aotearoa.

During the late 1970s and early 1980s, government-sponsored employment programs had sprung up. The Wellington Women's Gallery developed and grew in profile and membership to the extent that its impact was felt throughout the country. At the same time, small groups of contemporary female Maori artists were emerging. Many of the important members of this movement had anglicized names; it was a time when urban Maori were rediscovering their identities, and many Maori born outside the culture were discovering or adopting Maori names. A lot of these women's work was based on searching for identity, lost land, myths and legends, reconciling male and female issues, and grappling with some academic ideas on being Maori.

The Maori women's art movement was mainly Wellington inspired. It adopted the name "Haeata" and was a strong and focussed group under the driving force of educator and

expert in Maori culture Keri Kaa. The women challenged a wide range of Maori issues and wrote their own female "herstory" instead of accepting male-biased "history." At times they were perceived as anti-male and anti-colonial as some of the individuals struggled with their own identities in the early stages of the group's development. Most of the leading male artists preferred to keep away from the women's group and in many cases were guilty of male chauvinism that is not unusual among Maori men. Eventually the contemporary Maori male and female artists formed a peaceful space between them and worked alongside each other to create a series of major touring exhibitions throughout the country.

Prominent among the emerging female Maori visual artists were Shona Davies, a dynamic and creative painter and sculptor (later known as Shona Rapira Davies), and the passionate expressionist and colour painter Emily Pace, who has now adopted her family name and is known as Emily Karaka. Also part of this movement were the minimalist abstract painter Susie Roiri and the poet and creative installation artist Janet Garfield, who later adopted her family name, Roma Potiki. Emerging around the same time were the painter Kura Thorsen (now known as Kura Te Waru Rewiri) and the creatively intelligent painter and installation artist Diane Prince. Australian-born Robyn Porter (now known as Robyn Kahukiwa) embraced her newly found Maori culture by illustrating books and myths and legends under the guidance and encouragement of the Maori women's movement. These artists held several exhibitions of women's art, promoted female writers, organized artists' workshops and encouraged younger artists. It was not easy for them. Along with the female writers, poets, filmmakers and actors, they became an important part of the development of the contemporary Maori art movement.

Individual artists such as June Northcroft Grant, Hariata Ropata Tongahoe and later Gabrielle Belz appeared from outside the group, but each created powerful paintings and prints that were distinct in style and remain so today. Rising young painters like Star Gossage, Huhana Smith, Saffronn Te Ratana and many others are following them.

THE RISE OF MAORI CLAY ARTISTS

In the 1980s, a number of Maori artists began working in clay and expanding the scope of their art. Although some artists who were teachers in the New Zealand Department of Education in the 1960s had explored clay art, the movement began to develop its greatest momentum under Manos Nathan, Hiraina Poulson, Paparangi Reid, Baye Riddell, Wi Taepa and Colleen Waata Urlich.

Nathan, Poulson and Reid introduced their clay art to the New Zealand Crafts Council at a meeting in the mid-1980s. Present were the director and the crafts advisory officer

for the Arts Council and myself as director of the Central Regional Arts Council. The pieces were raw and exciting, but they did not conform to the highly developed British- and Japanese-influenced pottery style that had evolved in New Zealand. The work failed to excite the crafts adviser—but I knew when I saw the pieces that this was a significant development in the history of Maori art.

Nathan, Riddell, Taepa and Urlich, as exponents and teachers, were the major influences on this powerful new form of Maori art. Nathan and Riddell were recipients of a Fulbright Award that allowed them to spend several months working with clay artists in New Mexico. Nathan, Riddell, Taepa and Urlich continue to develop their careers on the international art scene with exhibitions in Australia, the United States, Canada, Britain, Asia and Greece. Their work is featured in several publications on Maori and New Zealand art.

Equally important was the clay art of Shona Rapira Davies, now established as a leading New Zealand and Maori artist. She created large-scale public clay installations and sculptures that endure today as major works of New Zealand art.

Paerau Corneal was the next significant artist to join the main group. Young artists now emerging include Davina Duke, Carla Ruka and Cameron Webster, who have a sensitivity of touch that is of their own generation. Other clay artists are coming from the Toihoukura Maori art school based in Gisborne.

NEW DIRECTIONS IN MAORI ART

The first of the government-sponsored traditional Maori art schools was the New Zealand Maori Arts and Crafts Institute based in the city of Rotorua. In 1967, the first intake of students to the institute's carving school, Te Wananga Whakairo, began the task of learning and retrieving the disciplines of ancestral carvers. The great Ngati Porou (*ngati* means "people of") master carvers Pine and Hone Taiapa were the first tutors, and they were followed by a long line of master carvers skilled in traditional knowledge and experienced in carving ancestral houses. One of the first students under Hone Taiapa in 1967 was Clive Fugill, who is the current master carver at the institute. Today there are twelve full-time students, each of whom commits to study for three years. A number of the graduates and carvers associated with the institute now operate other small private schools around the country. Some of the major contemporary artists who have emerged from the New Zealand Maori Arts and Crafts Institute are Lyonel Grant, Gordon Toi Hatfield, Riki Manuel, Fayne Robinson and Roi Toia.

The year 1990 marked the 150th year since the signing of the Treaty of Waitangi. To commemorate this anniversary, a series of major festivals was held around New Zealand.

African master sculptors Bernard Matemera, Nicholas Mukomberanwa, Bernard Takawira (all three of whom, sadly, have now passed away) and Lorcadia Ndandarika travelled to New Zealand to work with leading Maori artists. I had previously visited Zimbabwe with other Maori artists as one of the judges of the Zimbabwe Heritage Art Competition, a yearly contest that highlights great achievements in Zimbabwean stone sculpture. Artists Helen Kedgley, Arnold Wilson and I selected the pieces of Zimbabwean sculpture that toured New Zealand in a major exhibition between 1990 and 1992. Kedgley and her husband, New Zealand high commissioner Christopher Laidlaw, have played a significant part in building the Maori-African connection from its beginnings in 1987 and onward.

In 1990, Sir Peter Elworthy, a prominent New Zealander and farmer and his wife, Lady Fiona of Timaru, worked with John Tahuparae and me to put together a sculpture symposium on their farm estate, Craigmore, in south Canterbury province. This conference included several Maori and African sculptors and a Japanese sculptor, and we learned much from each other's distinct approaches to sculpting stone. There was also much joviality, deep discussion and understanding of each other's cultures. The African artists—Matamera, Mukomberanwa, Ndandarika and Takawira—imaged the unknown spirit within the rock and drew it out instinctively, chip by chip. Where they caressed the stone, the Maori artists attacked it with gusto and power tools, roughly establishing the form, then sculpting the detail.

Atsuo Okamoto, the Japanese sculptor, sat on the hill overlooking the sculptors for three days, sketching and making mathematical calculations. By then the Africans were confused by him and the Maori bemused. Word was that Okamoto was lazy. On day 4, he strode down from the hill with his plan. Much to the horror of the other sculptors, he mathematically smashed his stone, carved the pieces, then over the next week proceeded to glue them all together again. The result was an Okamoto masterpiece. He had hollowed the rock, placed river stones in the middle of it, glued it together and then carved the outer layers. Okamoto was sponsored by the Japanese government, and he later took Brett Graham to Japan as his assistant. Graham has since become one of New Zealand's foremost sculptors.

In 1982, the first of the contemporary Maori art schools, Tairawhiti Polytechnic, opened in Gisborne under the leadership of Sandy Adsett, Steve Gibbs and Derek Lardelli. These three became the driving force responsible for helping young Maori learn their traditional language, dance and music, as well as for developing the modern skills of painting, sculpture and weaving. Earlier, Ross Hemera and Robert Jahnke had taught a Maori art program at Waiariki Polytechnic in Rotorua. Later, Adsett left the team at Tairawhiti

Polytechnic to found Toimairangi School of Maori Visual Culture in Hastings, one of the many new Maori arts schools forming under Te Wananga o Aotearoa.

Other Maori art schools now include Wananga o Raukawa, whose main tutors are Kohai Grace and Diane Prince; the Wananga o Awanui a Rangi, with tutors Julie Kipa, Rangi Kipa, Wi Taepa, Christina Wirihana and Kura Te Waru Rewiri; Massey University under Professor Robert Jahnke, Shane Cotton and Rachel Rakena, and many private schools whose teachers are leading Maori weavers, such as master weaver Erenora Puketapu Hetet and her husband, master carver Rangi Hetet.

Shane Cotton, Brett Graham, Michael Parekowhai, Lisa Reihana and Peter Robinson have been leading the third generation of important artists in the contemporary Maori art movement. Strongly intellectual and creative in their approach, they reflect the state of their generation of Maori. A "tidal wave" of young Maori artists is rapidly following in their tracks. They are the graphic designers, filmmakers, new technology artists, fashion designers, contemporary weavers, jewellers, performance artists, poets, writers, animators and business entrepreneurs.

MAORI CULTURE since colonization in the 1800s has become more a "way of life" than a bloodline. There are now an estimated 500,000 people of Maori ancestry, and to find a person who is not of mixed blood would be very rare. The continuing ownership and building of tribal houses and the ongoing practices and teaching of Maori ritual, art, language and history maintain the strength of being Maori. What we look like, how we sound and what we think or define ourselves to be is something for future generations to decide.

"We look into the eyes of our ancestors and then we turn away."

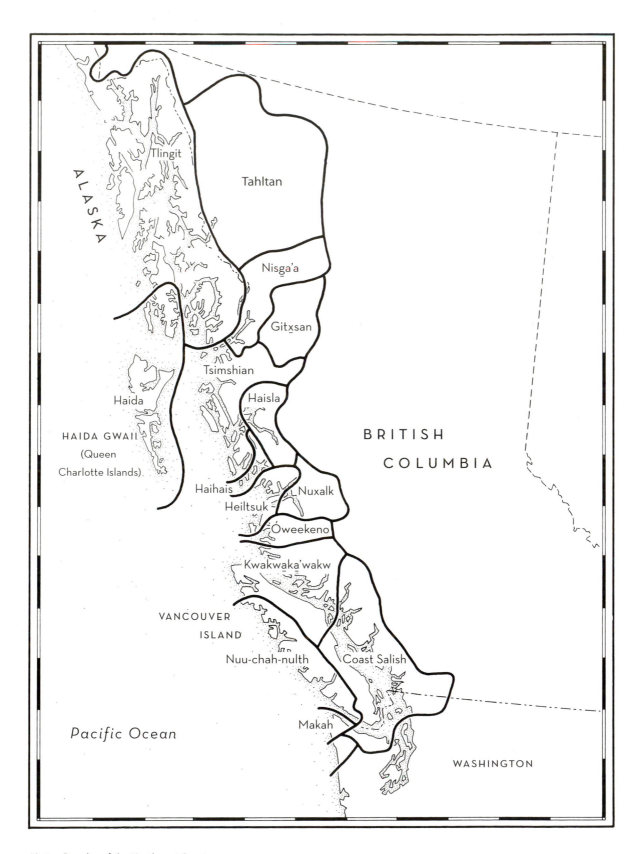

Native Peoples of the Northwest Coast

MANAWA

PACIFIC CONNECTIONS

Nigel Reading and Gary Wyatt

We are linked to our ancestors by blood and by spirit, by living histories and by ancient art forms. It is these elements that ensure that I hold the mantle of whakairo *(the ancient art of woodcarving) in both hands with the respect and care that it commands. This way, I might hold onto the past knowledge and wisdom in one hand and I might explore new horizons with the other.*

ROI TOIA, MAORI ARTIST

"MANAWA—PACIFIC HEARTBEAT" is a celebration of two extraordinary art-making cultures reaching out across the Pacific Ocean to exhibit together today. The similarities between the two groups, the Maori from New Zealand and the First Nations artists of the Pacific Northwest coast, are many and often quite astonishing. Along with stories of historical interaction, the parallel histories of these powerful societies have, in the present day, made this artistic collaboration a natural fit.

New Zealand, named Aotearoa ("Land of the Long White Cloud") by the Maori, is located 12,000 kilometres (7,500 miles) southwest of Vancouver, British Columbia, Canada, a city that is a southern landmark of the Northwest Coast nations whose territory extends northward into Alaska. Geographically these two cultures are near polar extremes on the globe.

New Zealand comprises three islands. The smallest one, Stewart Island, is the most southern point. The South Island mirrors British Columbia with a spine of snow-capped mountains, deep fjords and panoramic vistas. The North Island is punctuated with active volcanoes, thermal hot springs and the last giant trees. Aotearoa is the land of the *tangata whenua*, people of the land.

In the 1960s, the Maori and the Northwest Coast peoples were among the many aboriginal cultures around the world who began to see the vital importance of better understanding their history and documenting their own traditional culture. Spurred on by the interest and energy of the younger generation, the elders offered stories that shared the wisdom

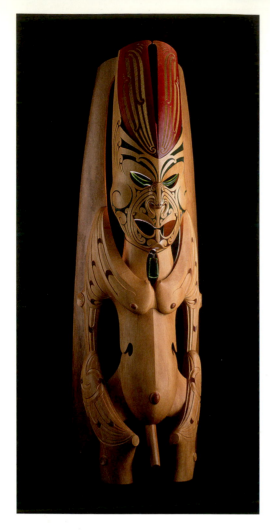

**Ruatepupuke—
Originator of Carving**

("Kiwa—Pacific Connections"
exhibition, 2003)
Roi Toia
kauri with jade inlay
73 × 23 × 14 inches
Private collection

of the past and tied the present to that time. Building the foundations for the future often meant filling voids left by the devastating effects of foreign disease that had diminished the original populations and dealing with the aftermath of earlier government policies that forced assimilation and denied the established indigenous social structure. The rebuilding began by investigating history and restoring ceremonies, which returned a sense of pride and identity to the people of these first nations.

A natural extension of this rebuilding process was to visit other aboriginal nations to study their efforts in preserving language and culture and to learn from their overall successes. The Maori and the Pacific Northwest coast peoples found a natural affinity and allegiance with each other and immediately began to forge long-term bonds, which now include close friendships, travel to participate in ceremonies and shared exhibitions of their art.

"Manawa" represents only one small segment of the many interactions between aboriginal groups today that further cultural causes and possibilities for the future. The relationship between the Maori and the Northwest Coast has been active for more than twenty-five years and will likely continue for many generations.

ORIGINS

The Maori and the Northwest Coast peoples have many similarities: they were both geographically isolated, which allowed them to develop as relatively intact societies over time. Both were food-rich compared with many other hunter-gatherer cultures, with a close and abundant food supply from both the land and the sea, which allowed for the development of permanent settlements with a defined social structure.

Universally, richer cultures have always produced finer objects, and this was certainly as true for the Maori as it was for the peoples of the Northwest Coast, both having highly developed ceremonies using complex carved and decorated regalia. Villages took pride in having a number of highly skilled resident artists who created objects for ceremony, elaborately carved architecture and objects for daily use, and the artisans were respected and had status. In both regions, villages came to be defined by the uniqueness of their artistic style, which evolved over time. Both cultures had a history of warfare that was sophisticated in method and strategy. In a similar fashion, both cultures had also perfected the building of

large ocean-going canoes (in Maori, *waka*) that were used for fishing, for trade and commerce and to visit other villages for ceremonies or warfare.

New Zealand Maori origins have been traced as an island-hopping migration that began in Asia, travelled through Southeast Asia and into Polynesia and finally settled on Aotearoa around AD 800. Mythology purports that the supernatural hero Maui landed on the northern tip of the South Island, fashioned a hook from bone and caught and raised the North Island—the traditional homeland of the Maori—from the depths of the Pacific Ocean.

On visiting the home of Derek Lardelli: "I saw a very beautiful and powerful lithograph print by him of Maui's hook. The jawbone with moko *etched into it was so elegant and powerful in its directness and simplicity that it has kept me overwhelmed and inspired to this day." —Joe David, Nuu-chah-nulth artist* (fig. 1)

The Northwest Coast nations may also have migrated from Asia using a northern route, coming across the Bering Sea by canoe, or possibly much earlier by land when a land bridge formed in successive ice ages and connected the fifty kilometres (thirty miles) between what are now Siberia and Alaska. Some of these people stayed along the northern shores; others moved inland to pursue larger game such as caribou and muskox. Still others ventured southward into warmer climates and were able to establish permanent villages because of the great abundance of fish and game, with the annual return of the salmon assuring a principal food source. The densely forested coast provided huge stands of cedar, which were used to make everything from tools and canoes to clothing and large family homes. For this hunting and gathering culture, the environment enriched the way the people lived.

Protected by the coastal mountains and the Pacific Ocean—and the virtually impenetrable rain forest—a culture developed that flourished in its isolation from much of North America. Trade routes were nurtured and pushed largely north and south using ocean waterways. This allowed chiefs of wealth and status to decorate their family masks, headdresses and other possessions with shells and exotic material acquired from places as far away as California and the Arctic, symbols of their powerful and extensive trade network.

Maui's Hook

("Kiwa—Pacific Connections" exhibition, 2003)
Joe David
alder, red cedar rope
10 × 11 × 10 inches
Private collection

Fig. 1

Raven's Knowledge

("Kiwa—Pacific Connections"
exhibition, 2003)
Stan Bevan
alder
22½ × 12 × 6 inches
Private collection

The people of the Northwest Coast describe their origins as a series of transformations—different animals transforming into other animals and finally becoming humans. Certain creatures, particularly Raven, were present from the very beginning, surviving the Great Flood and carrying the knowledge of the incremental changes that slowly evolved the world to its present state. The ancestral connection to the natural and supernatural worlds was recognized with the adoption of personal family crests and larger clan moieties that controlled hereditary positions and marriage. Families venerated their ancestors, describing lineage and history through the elaborate acting out of stories, using masks and objects in ceremonial performances before the village and invited guests from other villages. The obligations and prestige of these events were such that people travelled great distances to attend these "potlatches," which could range in length from a few days to several months.

"It was very much like visiting my own people. I feel a connection to the Maori that begins with the rich culture and history; our histories are both carved in wood in many of the same ways."

Fig.2

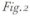

—Stan Bevan, Tahltan-Tlingit artist (fig. 2)

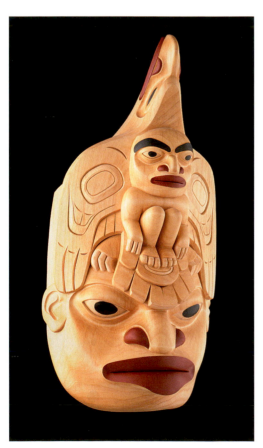

Public ceremony, speeches and performance served as documents of history, and the witnesses to these events were paid with elaborate gifts such as carved boxes, spoons and woven blankets. (In turn they accepted the responsibility to recall and validate the information brought forward at that potlatch at future gatherings.) Oral history was carried forward this way from one generation to the next, and stories from ancient history remained vital and relevant to the understanding of each family, village and nation.

One such story, preserved in the oral history of the Hesquiat people from the northwestern shore of Vancouver Island, tells of contact made in ancient times between the Maori and the Northwest Coast. The Nuu-chah-nulth/Hesquiat artist Tim Paul relates this story as told to him by his grandfather, who was from the village where this event occurred:

Three Maori in a large ocean *waka* followed the powerful trade winds that flow at different times northward and southward connecting New Zealand and North America and landed at this northern village. Here they remained for three years waiting for the winds to reverse. In preparing for the return journey, they joined local carvers in building two Nuu-chah-nulth–style canoes. At

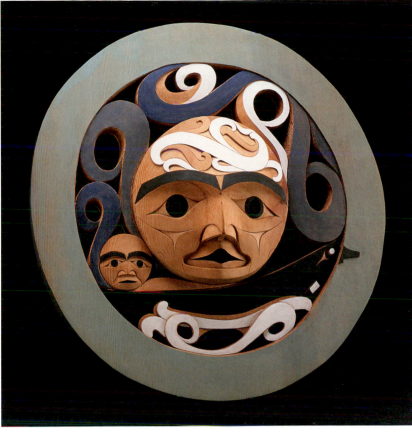

the time of departure, they were presented with three wives—and assuming that they arrived home safely, it is likely that family ties exist between the two nations. (Tim Paul, quoted in exhibition catalogue *Kiwa—Pacific Connections*, 2003)

Hundreds of years after this event, Tim Paul, as First Carver for the Royal British Columbia Museum, was asked to carve a totem pole as a gift from Canada to New Zealand in honour of the 1990 Commonwealth Games. Following the Games, the pole was moved and permanently installed at Awataha Marae

Saa-Yaa-Cit-Tu The Ocean Way Off Shore with the Tradewinds Blowing the Maori Canoe Towards Home
("Kiwa–Pacific Connections" exhibition, 2003)
Tim Paul
red cedar
26 × 25 × 5 inches
Private collection

in Auckland. Tim Paul was invited to oversee the totem pole raising and was welcomed by more than 2,000 Maori dancers, with great honour and respect bestowed upon him by his hosts. In 2003, he accepted an invitation to be part of the cross-cultural exhibition "Kiwa—Pacific Connections" at the Spirit Wrestler Gallery in Vancouver, and he took this opportunity to respond publicly to the earlier events in New Zealand by presenting two masks to the Maori, with instructions to take them home, write songs, create dances and make them real.

"The circle is now complete—we as a family are one. The totem pole that was brought to Awataha was from a great family and Hesquiat history. Two important figures on the totem pole, the Wolf (the first-born son) and the Killerwhale on the Hupa kwa num (Chief's treasure box), have the same spirit. They are one. We brought our crown, our great headdresses and the sea serpent that is our identity. From Tachu, the house of Tilh-wis, three Maori men came with the warm trade winds to my grandfather's home from my mother's side and stayed with my family for three years until the trade winds came back. My family gave them two canoes and each of the three Maori men went home with a wife from our family and homeland. The white designs are our roots—Maori and Tilh-wis." —Tim Paul, *Nuu-chah-nulth artist* (fig. 3)

Among the most interesting cultural similarities was the historic development of intricately woven cloaks and robes, the Maori traditionally using flax (*harakeke*) interwoven with bird feathers and the Northwest Coast tribes weaving a blend of mountain-goat wool and cedar bark. For both, weaving and creation were serious and labour-intensive endeavours requiring skills that were passed on from generation to generation. Even the harvesting of material to be used was similarly connected to issues of survival, celebration

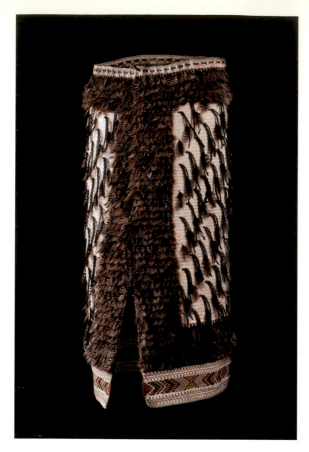

Kakahu Korowai, 1985
("Toi Maori: The
Eternal Thread"
exhibition, 2004–06)
Dame Rangimarie Hetet
flax fibres, feathers, loosely
woven cords and dye
38 × 45¼ × 2 inches
Courtesy of
Waikato Museum
Photo by Norman Heke

Fig. 4

and prestige. The robes were the ultimate gift to only the highest-ranking chiefs and elders. Planning for the ceremony at which a robe was to be presented was begun years in advance, with responsibility delegated to a worthy weaver who then began the journey of designing and weaving the robe over the next year or more.

The production of Northwest Coast robes has evolved through several distinct styles. The oldest known weaving style is Ravenstail, followed by the more intricate Chilkat or Naxiin style and finally by a more easily produced vestment known as the button robe, which is not woven but uses appliqué techniques. After contact with the Europeans, who settled on the Northwest Coast, artists created button robes using the Hudson's Bay Company trade blanket; they cut an appliqué design of a family crest and attached it to the blanket with many shell buttons outlining the design, a concept inspired by the European sailors, who wore coats covered in buttons. These robes were more easily produced and allowed virtually everyone at a ceremony to have a robe representing their family, although high aesthetic standards still distinguished the better designers and sewers.

Among the Coast Salish peoples in the southern part of British Columbia, there was also a weaving tradition in wool that was used to produce elaborately woven mats and wall panels on a large scale; later, the Salish created sweaters that became world renowned.

"Initially Maori cloaks were worn as basic clothing but evolved in design and complexity for certain uses ranging from war to ceremony. There are essentially four variations of the Maori cloak: kaitaka, *an unadorned surface with decorative panels known as* taaniko; pukupuku *and* kahu kuri, *war cloaks without ornamentation that are said to have given physical power during hand-to-hand fighting (both designs are made the same way, but the* kahu kuri *is overlaid with narrow, vertical strips of rawhide dog skin with the hair attached);* korowai, *an elaborately decorated garment with side panels of hanging cords, and finally the* kahu huruhuru, *a woven and densely decorated cloak with feathers. In today's society, the cloaks are largely worn by elders, high-ranking officials and dignitaries at family-hosted ceremonies and play a major ceremonial role at times of death within Maori families. Mana (prestige) is attached to the cloaks and is carried through the generations by each wearer, giving strength and esteem. Cloaks were inherited and passed on within families or were given as high-ranking gifts. Cloaks were also exchanged between families to create intertribal harmony. It is known that cloaks were given as gifts (koha) rather than traded between tribes, and it is also known that cloaks were traded with Europeans.*

There were specific robes that were worn by men and women." —*Christina Wirihana, Maori artist (from experience, from the teachings of her mother, Metekino Lawless, and from the book* Te Aho Tapu: The Sacred Thread, *by Mick Pendergrast, 1987) (figs. 4, 5)*

Two prominent Maori weavers, Emily Schuster and Christina Wirihana, visited Europe and while there began to research Maori weavings in museum collections. They came across a contemporary Ravenstail robe woven by Cheryl Samuel (who had visited the great museums of Europe to research Northwest Coast robes), which led to Cheryl Samuel being invited to visit New Zealand and be part of the Arts Festival at the 1990 Commonwealth Games. By accepting this invitation, Samuel, like many artists before her, explored a cross-cultural experience by finding the similarities in techniques within her specialized field; she was handed from weaver to weaver on her journey of several weeks through New Zealand.

The celebration of the art of weaving is the constant thread that runs through the work of all the artists included in this collection. By its nature, weaving is the most solitary of endeavours, which is possibly why the artists seek time together—to experience and share the communality of weaving. Virtually all of the fabric artists included here have connected through working on collaborative pieces, sharing techniques and materials and inspiring each other. Cheryl Samuel, Haida artist Evelyn Vanderhoop and Tsimshian weaver William White have all spent time working with Maori weavers.

Also noteworthy are the similarities in the designs of the large permanent structures built by both cultures. The Northwest Coast peoples believe their longhouses hold the spirit of the people—the room holds a living, breathing entity, the smoke hole represents the breath escaping, the carvings represent ancestors who are still present in the room. The Maori believe that the *whare tupuna* (ancestral meeting house) takes on the form of the body of an ancestor. Roi Toia uses the ceremonial meeting house Ihenga to explain:

Standing in the body of the house (*poho*), the front slanting façade boards become the outstretched arms (*maihi*) with the fingers (*raparapa*) and the pinnacle mask of the ancestor's face (*koruru/wheku*) at the apex. The central ridge of the roof represents the backbone or spine (*pou tahuhu*), with the rafters becoming the ribs (*heke*). Each rafter is supported by a carved ancestral wall support (*poupou*) and represents a noted ancestor of the tribe. The centre ancestor-

Kohikohinga Rau Manu
Me Nga Taniko: Taniko
Korowai, 2002
("Toi Maori: The
Eternal Thread"
exhibition, 2004-06)
Diggeress Te Kanawa
flax fibres, feathers and dye
46 × 46 × 1 inches
Courtesy of the artist
Photo by Norman Heke

Fig. 5

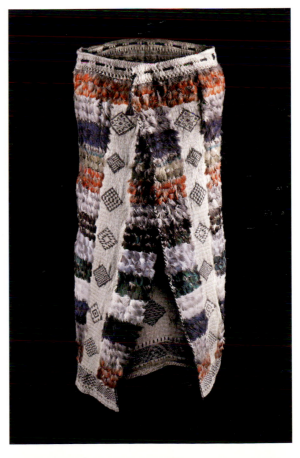

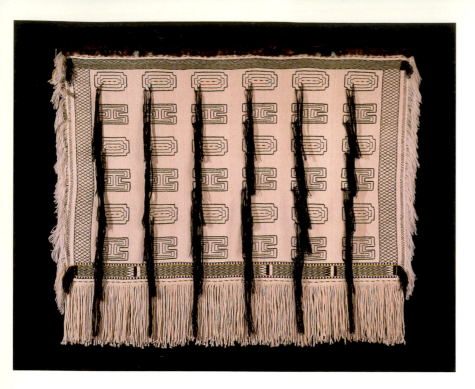

Ravenstail Robe

(*Mythic Beings*, 1999)

Delores Churchill and

Evelyn Vanderhoop

merino wool, fur,

abalone shell

51 × 62 inches

Private collection

supporting pole is called the heart pole (*poutokomanawa*). Often Maori people will *hongi* (press-nose greeting/the exchanging of life essence) to this pole, as it represents the heart of the house and is a sign of respect to the ancestors who have departed to the spirit world. This is but one component that symbolizes the importance of the physical and spiritual connection of the living to their ancestors by unbroken lines of descent. The *marae atea* (gathering place fronting the meeting house), *whare tupuna* (principal ancestor's house), *whenua* (tribal lands) and *turangawaewae* (spiritual home/rightful place to stand) are all intricate parts to the "life-giving force" and "heartbeat" of the Maori. (Roi Toia, speaking to Nigel Reading at Ihenga at Waiariki Institute of Technology in Rotorua; Ihenga was designed and carved by master carver/*tohunga whakairo* Lyonel Grant)

Public interest in Northwest Coast art began with the realization that a powerful culture already existed in the West at a time when new cities were being established along the east coast of North America. The nations of the Northwest Coast were among the last of the world's indigenous peoples to be affected by colonization. A number of major museums (largely in the eastern United States) had started to acquire artifacts from indigenous nations in the hope of forming collections that could rival those in the great museums of Europe. The sheer range and diversity of what was then available from the Pacific coast greatly interested collectors and museums, and numerous expeditions went to the Northwest Coast in pursuit. Today, few museums in the world with an anthropological mandate do not include at least some historic Northwest Coast objects, and in many cases these collections are extensive.

The cultural reawakening that began in the early 1960s quickly gathered momentum, and artists felt challenged to create works that would equal historic masterworks for both a growing market and use within the culture itself. There were many pockets of strong cultural activity throughout the Northwest Coast; such prominent artists as Willie Seaweed, Mungo Martin, Henry Hunt and Doug Cranmer were among the many artists born in traditional villages and schooled in their culture.

Prominent also was Haida artist Bill Reid, an accomplished artisan and eloquent speaker whose first job after leaving school was in radio broadcasting. When he discovered

and developed his artistry he captured the imagination with his words and set the highest standard for quality and detail in his work, first with his mastery of jewellery design and later with monumental commissions in a variety of media. Fellow Haida Robert Davidson had a natural gift for design, which began with printmaking and progressed into wood and precious metals. Davidson's long career has included a personal commitment to support and strengthen his culture by creating a platform for contemporary ceremonies and cultural issues, as well as making artwork of the highest calibre.

They were not alone during this formative time; there emerged from each of the major Northwest Coast nations a number of young but very dedicated artists who would earn recognition as masters by forging a contemporary direction within an established historic style. In this collection, Norman Tait, Joe David, Dempsey Bob and Tim Paul are contemporary artists who were a vital part of the resurgence of the art and culture of their respective nations. These dedicated artists have contributed greatly to the strong cultural milieu that now exists, and they have become teachers and ambassadors in addition to their profession.

Two early landmark exhibitions of Pacific Northwest coast art were "Arts of the Raven" at the Vancouver Art Gallery in 1967 and "Legacy—Tradition and Innovation in Northwest Coast Art," which opened at the Royal British Columbia Museum in Victoria in 1971. "Legacy" travelled extensively until 1981, eventually blending historical artifacts with contemporary works, and gave curatorial acknowledgement both locally and globally to the growing number of dedicated contemporary artists. Since that time many exhibitions have established the contemporary art of the Northwest Coast as a vibrant, powerful entity, and many of these shows have toured internationally to a receptive and growing audience.

At about the same time in New Zealand a similar movement had started among Maori. Individually, many artists had achieved worldwide recognition. Collectively, the art began to be shown internationally (and particularly within North America) only in the 1980s. Maori realized that real understanding of their culture necessitated that both artists and elders be present and participate to offer context and relevance. Exhibitions designed with this

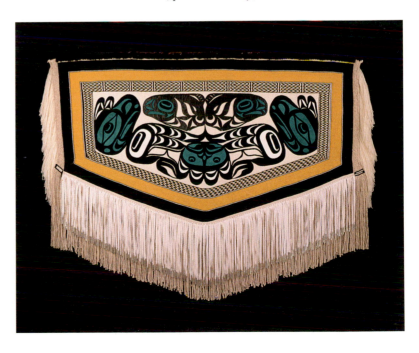

Klukwan Yadi (Child of the Village That Was Always There)
("Premonitions: Artists Exploring the Possibilities" exhibition, 1998)
Cheryl Samuel and Tsa-Qwa-Supp (Art Thompson)
merino wool, cedar bark, leather appliqué and fringes, beaver fur, tin cones
34 × 62 inches
Private collection

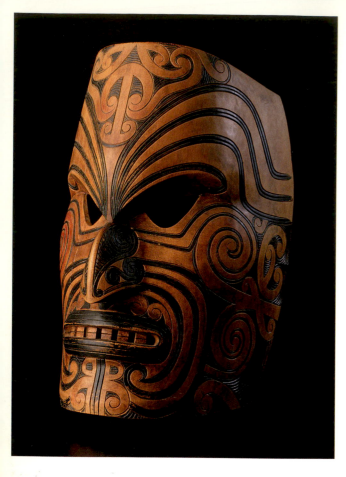

Maori Warrior

(Te Atinga Wananga
Symposium, 1995)

Joe David

totara

13 × 10 × 11 inches

Private collection

foundation have been significant because the presence of the cultural delegation has validated the power and diversity of the work to a relatively new audience and reaffirmed that the culture that produced the work is extant today.

Originally we didn't think of sending so many people over to the exhibition—we were still thinking of workshops—but our experience from an earlier visit in San Diego showed us that this really wasn't the way to do it. To allow this exhibition to travel, it had to have a cultural dimension for it to carry out the kinds of protocols we felt were important in presenting ourselves on an international platform. We needed people to fulfill these roles. For instance, we had to have *tohunga* (experts) to do *karakia* (sacred incantation) and all the initiations and dedications. We had to have people to *whaikorero* (make a speech) and someone to *karanga* (call out in welcome). We needed that balance within the party of the people.

To me, the interesting thing was that immediately after our people entered the area that held the exhibition, it became their *marae* (traditional Maori gathering place). They felt secure—you could see it—and as they looked at all the works, whether they were modern or traditional, they looked at them as *taonga tuku iho*, as works that had been handed down from the ancestors. It was this experience that really confirmed for them, and for us who observed it, that, yes, there was a real place in the international scene for the Maori people to participate. (Cliff Whiting, Maori artist, in *Taiarotia— Contemporary Maori Art to the United States of America*)

In September 1984, the "Te Maori" exhibition opened at the prestigious Metropolitan Museum of Art in New York City. This unveiling of a monumental collection of Maori treasures to a North American audience was a historic moment. The collection was the first to leave its homeland with the approval of the Maori people, and the exhibition opened with the rituals and chants handed down from their ancestors. The opening became a turning point for Maori as their culture was launched to the world, and their art became internationally known as an indigenous art. "Te Maori" was an enormous success and it continued to tour throughout the United States.

Several months before this important exhibition opened in Chicago, Nisga'a master artist Norman Tait was finishing a monumental totem pole commissioned by that city's

Salish Loom
("Kiwa—Pacific Connections"
exhibition, 2003)
Susan Point, RCA
yellow and red cedar, glass
80 × 32 × 18 inches
Collection: Smithsonian
National Museum of the
American Indian

Field Museum of Natural History. This pole soon led to another major connection between Maori and the Northwest Coast people:

> In 1982, I completed a commission for a fifty-five-foot totem pole, "Big Beaver," for the entrance to the Field Museum in Chicago. I travelled with a Nisga'a delegation to Chicago to ceremonially raise the pole. In my address to the large crowd gathered for the event, I stated that a pole would only be erected on land that you owned—and thanked the city of Chicago for the gift of such a beautiful city! The mayor, Jane Margaret Byrne, who spoke next, then publicly presented me with the city! The Field Museum was in the midst of finalizing the protocols for the opening of a Maori exhibition and was asked to include a local welcoming, including a warrior contingent, to ensure that the intent of the Maori was a peaceful celebration on foreign soil in response to an invitation. Given my new ownership of the city, I was asked to make a return visit to Chicago with Nisga'a ceremonial warriors to welcome the Maori to Chicago. In return they presented me with a ceremonial chief's adze, and I wear this whenever I welcome the Maori in my homeland. (Norman Tait, Nisga'a artist)

The next major exposure in North America was the 1992–94 exhibition "Te Waka Toi: Contemporary Maori Art." The premise for this show came from the prominent Maori artists Sandy Adsett and Cliff Whiting, after they attended Maori art workshops held in the mountains outside San Diego in 1986 and 1988. They envisioned an exhibition that would show Maori as a living culture to the rest of the world. Opened at the San Diego Museum of Man in 1993 to coincide with the New Zealand America's Cup yachting challenge hosted by that city, "Te Waka Toi" toured throughout the United States. With a subtext of cultural exchange, the exhibition quickly became a search to find other artists and aboriginal groups who were surviving and dealing with cultural issues in modern North America.

Joe David had made his first visit to New Zealand in 1983–84, taking his wife, Paula Swan, to introduce their newborn child, Marika, to her grandparents:

> My first and most precious moments with the Maori were visiting in Auckland at the home of Amelia and Eruera Sterling. Amelia Sterling had looked after Paula when she was a child, and she and Eruera were

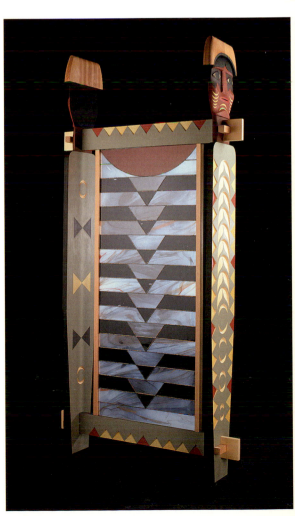

Facing page:

**Ulths-Ma-Koake
(Wildman)**

("Fusion: Tradition &
Discovery" exhibition, 1999)

Roi Toia

California redwood

18 × 18 × 14 inches

Private collection

delighted to see her and meet the new family. The feel of their home and their voices and movements were so loving and real that I knew, beyond any doubt, that like my child, I was home. These elders loved and respected us on the basic facts that we were life and we were theirs.

To this day, the memory of seeing them sitting side by side on their porch smiling and waving to us as we left fills my heart to bursting and will forever tie my soul to their people. I have been reborn a number of times in a number of ways by a number of different people—and through our daughter, Marika, I was born to the Sterlings and the Maori of the East Cape—and no matter how many more places I go and other people I become, I will in my heart and soul also remain Maori. (Joe David, Nuu-chah-nulth artist)

During this visit David toured the National Museum of New Zealand in Wellington. Under the dim light, he saw the historic masterpieces of Maori culture and drew numerous comparisons to the art of his own people. As he entered a particular exhibition hall he saw, across the room from him, what is considered to be one of the great national treasures of New Zealand: a powerful carved mask of the Te Arawa people, decorated with *moko* (tattoo) designs. From a distance, he saw only the spiritual essence and the outline of the shape, which to Joe David was definitive Nuu-chah-nulth, his own tribal style from the western shore of Vancouver Island. Thinking that he might wish to investigate this in his own work, he photographed the mask for future reference.

In 1995, Joe David made his second visit to New Zealand, to attend Te Atinga Wananga Symposium and its "Te Atinga 1995" exhibition at Apumoana Marae in Rotorua.

Living in a world that smothers itself in concrete and noise, it is all too often impossible to sense the gifts and movements of spirit. But perhaps, for me, "Te Atinga 1995" at the Apumoana Marae in Rotorua was a sacred gift resulting from my initial journey.

Luck and coincidence are meaningless in the houses of the ancients. The fact is that this gathering of indigenous nations at Apumoana Marae brought with them a momentum of power and purpose that moved through ten glorious days and nights . . . and has continued to rumble through the communities and studios of the arts like a cultural thunderstorm, awakening and nourishing a dream of the ancients for the future.

And I believe it could be too soon to realize the fullness of the dream. Like an ant in the colony of time, it is all I can do to be committed and content with my gift, however great or small. It is a wonder and mystery of power how the heart can trust and inspire

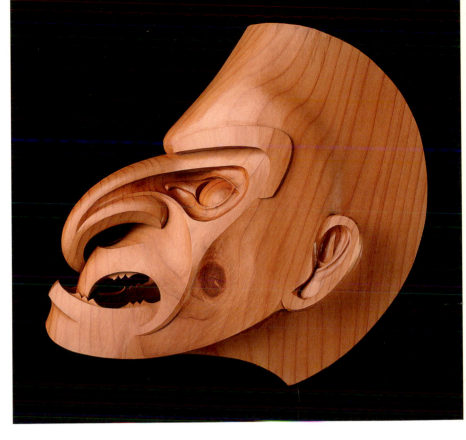

Fig. 6

the mind to greatness, but I believe that power placed my heart, mind and soul into the fold and play of the Maori at Apumoana, like the calling of a faraway child to a big Mother Earth, the feeding and teachings of the ancients. (Joe David, Nuu-chah-nulth artist)

Joe David roughed out a Nuu-chah-nulth mask while at the Wananga festival that year and then returned to Wellington to revisit the mask that had made such an impression on him years before. Realizing that the historic Maori mask still held power and fascination for him, he completed the mask he had started at the Wananga festival with an incised *moko* design in honour of this experience and he resolved to explore his interest and cultural connection to Maori.

The next year he again travelled to New Zealand, where he met and befriended wood-carver Roi Toia, and they were inspired to investigate their many cultural similarities. Toia wished to reciprocate the honour of the cross-cultural mask already completed by Joe David by carving a portrait mask representing Joe David in Maori form. Carved in North American redwood, it is titled *Ulths-Ma-Koake (Wildman)*. Both works show the respect the artists have for each other, and their continued friendship has influenced their art.

I asked if I could return the compliment that he had awarded my culture by his skilled inter-pretation of Maori imagery translated through the eyes of a First Nations artist. Could I interpret a First Nations mask through the eyes of a Maori artist? To this he confidently agreed with vigour. And so, it was sanctioned.

There are three contributing entities represented in this carving. Firstly, the "Eagle" that acts as a guardian and protector over Joe. Secondly, the Ulths-Ma-Koake that had visually impressed me so much and, lastly, a portrait of a master carver and friend, Joe David himself. The final result was the representation of spiritual destiny and the celebration of friendship and respect . . . to me, one of the fundamental components that underpin whakairo (ancient art of carving) and the essence of indigenous parallels. —Roi Toia, Maori artist (fig. 6)

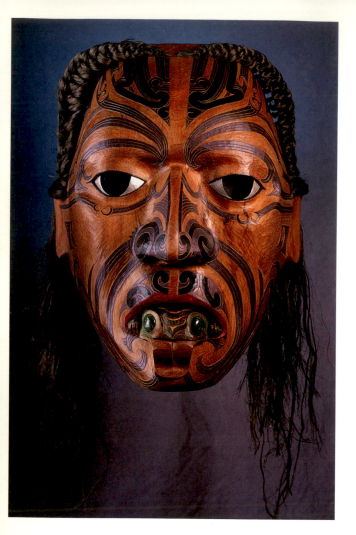

Fig. 7

As much as Maori artists today are looking to the future for inspiration, there are also those who look to the past. Although the people of the Northwest Coast once practised tattooing, it is the resurgence of *ta moko* (traditional tattooing) among Maori that is being acknowledged and accepted both within the culture and around the world. The tattoo as a personal art form is gaining recognition worldwide, and Maori tribal *moko* designs have become among the most instantly recognizable.

Riki Manuel, Derek Lardelli, Gordon Toi Hatfield and Rangi Kipa are all recognized exponents of the arts, but they are now also dedicated leaders in the art of *ta moko*. Much of their commitment and time is devoted to teaching and reintroducing this body art by building an understanding of the ancient practice. For "Manawa," all four artists have contributed sculptural works that reflect their personal style and inform their unique *moko* designs.

Ed Archie NoiseCat accompanied Joe David to the Wananga festival in 1995. While he was there he carved a Coast Salish mask in collaboration with Maori artist Derek Lardelli:

The moko *design on the face was rendered by Derek Lardelli, who is one of the most prominent traditional body and facial artists in Aotearoa today. The mask was carved as a portrait of Mr. Lardelli at the 1995 Wananga [of] Indigenous Arts gathering in Rotorua. The frog emerging from the mouth not only mimics the protruding tongue of a warrior while immersed in the* haka, *but also indicates Mr. Lardelli's connection to the supernatural world. I carved the mask at the gathering and finished the detailing at home in my studio in the USA. Before I left New Zealand, I asked Christina Wirihana to help me with the hair on the piece. She harvested the flax, dyeing it in the traditional way in a specific type of black mud. She also plaited the hair to keep it away from the moko.*—Ed Archie NoiseCat, Coast Salish artist (fig. 7)

To a large degree, the freedom that contemporary Maori art now enjoys came from the early acknowledgement that graphic arts are intrinsic to art and are as valid as woodcarving or other traditional disciplines. Maori painting has blossomed in many different directions—as one can see readily in comparing the styles of Sandy Adsett, Darcy Nicholas, June Northcroft Grant and Steve Gibbs. Gabrielle Belz, the renowned printmaker, is also an accomplished painter. These individuals have risen in stature as artists and as educators who teach their students to understand their culture and artistic traditions but also to find

their own voices: the students are encouraged to become Maori artists but to consider the entire world as a possible influence. Many of the artists in this collection have travelled extensively to study and experience the art and artists of other countries.

In 1984, Darcy Nicholas became the first Maori artist to be awarded a Fulbright scholarship, which he used to travel to the United States to research contemporary aboriginal and African art, thus gaining a broad perspective on the American aboriginal art movement. He landed in San Francisco and continued through New Mexico, before travelling to Washington, D.C., and New York City, where he met artists and visited museums.

> "We walk parallel lines with our ancestors. Their knowledge and wisdom guides me in an ever-changing world, yet at the same time the richness of native cultures around the world lets me know that we were never alone. As creative artists, those ancestors give us a third and fourth eye that open up limitless possibilities of creativity." (Darcy Nicholas, Maori artist)

Darcy Nicholas as general manager of cultural services for Porirua City is also director of the Pataka Museum and art gallery there; June Northcroft Grant now runs her own business in Rotorua, and Sandy Adsett has dedicated his life to teaching and academic development in Aotearoa. He has been responsible for the opening of two Maori institutes of learning on the east coast of New Zealand's North Island: Tairawhiti Polytechnic in Gisborne and Toimairangi School of Maori Visual Culture in Hastings. Bob Jahnke is a professor at Massey University in Palmerston North, New Zealand, and is regarded as one of Maoridom's leading academics. He has introduced a Maori visual arts program that includes Te Reo Maori (Maori language) and Tikanga Maori (Maori protocol) and leads to a bachelor's degree. All four artists, in addition, dedicate much of their time to sitting on numerous committees to advance and support Maori arts, and they frequently travel abroad to promote Maori interests.

In 1989, Manos Nathan and Baye Riddell were also awarded Fulbright scholarships and visited the American Southwest to study pottery traditions. At the time, Nathan was a respected woodcarver and Riddell was one of the few Maori ceramic artists. They worked in the Southwest with Hopi artist Al Qoyawayma and Pueblo artist Jody Folwell, before securing funding through Fulbright for the two Americans to visit New Zealand and further their awareness of ceramics there.

The power of this cultural exchange with the Pueblo and Hopi peoples of the American Southwest is very evident today, thriving in the clay medium for Maori. Colleen Waata

Facing page:
Rua Nuku
(Te Atinga Wananga
Symposium, 1995)
Ed Archie NoiseCat
totara, flax and jade inlays
18½ × 14¾ × 11½ inches
Private collection

Urlich, Wi Taepa, Manos Nathan, Baye Riddell and Paerau Corneal are now referred to as *nga toko rima* ("the five fingers of fire on the hand," from a Maori story about how the supernatural hero Maui obtained fire for humans) that have guided and nurtured the development of ceramics among their people. All five are founding members of Nga Kaihanga Uku (the national Maori clayworkers' organization).

After visiting the Southwest and meeting and interacting with Hopi silversmith Mike Kabotie, Nathan and Riddell invited him to New Zealand to host a metal workshop that was attended by a number of Maori artists, including Alex Nathan. The Maori have no tradition of working in metal—all their tools, utensils and weapons are made from bone, hardwoods and jade. It was only through these workshops and contact with Kabotie that Alex Nathan saw the possibilities and turned his expertise in wood and stone carving to silver. He was the first Maori artist to do so.

Maori pendants, known as *nga taonga* (treasures), are rendered in bone, shell and jade and often carry names and stories pertinent to the family and history of the wearer. Prominent designs incorporate references to the *koru* (fern frond), a symbol of growth and rebirth; *matau* (fish hook), a representation of prosperity; tools such as the *toki* (adze blades), a symbol of the artist; various weapons, and supernatural creatures and guardians steeped in history and mystery, such as the *manaia* (birdlike guardian figures), *taniwha* (water spirits) and Hei Tiki (the first man in the Maori world, who descended from the stars). Traditionally given as symbols of respect and esteem, today the pendants are instantly recognizable ambassadors for the Maori.

Pounamu—greenstone, or New Zealand jade—is revered and highly valued by the Maori; it is used for *nga taonga*, weaponry, tools and implements. Hepi Maxwell, a renowned jade artist, has been working with the stone for many years and his delicate, stylized pieces decorate the homes and grace the bodies of many famous people. Lewis Gardiner reveals a different vision in jade, preferring to work in monumental forms and more traditional themes. Kerry Thompson also works in jade but has established himself as the leading bone artist. Rangi Kipa is noted for delicately incising ivory but also, more recently, for introducing hand-carved Corian® (a synthetic material) into his work, giving traditional forms a very contemporary feel in a variety of bright colours.

Woodcarving is the obvious connection between the Maori and the Northwest Coast peoples, as both have a long and refined tradition in this medium. Both historically carved ornate totem poles (in Maori, *pou*), longhouses (*whare tupuna*), ornate figures (*tekoteko*) and canoes (*waka*), among many other objects similar in each culture.

Due to clear-cutting, which has decimated old-growth stands of native totara and kauri trees across much of New Zealand, wood for carving monumental buildings, sculptures

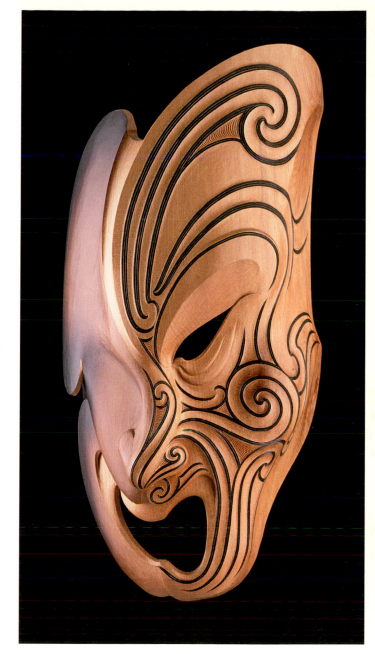

Fig. 8

and large ocean-going canoes is now a limited resource, respectfully taken and only under strict guidelines. Much of the wood available today to artists is recovered from swamps, old buildings, trees felled by storms, and through reclamation of trees harvested in the 1880s but unaccessible till recent years. Alex Nathan oversees much of the protection of the last enclaves of giant kauri trees in the Waipoua forests north of Auckland, including the methods of road construction through this environmentally sensitive area. Nevertheless, great effort is made to continue the traditions of carving in indigenous wood.

"Over the years, Maori have overcome many obstacles that lie in their path and their tenacious nature has helped them survive and succeed in the modern and changing world." —Todd Couper, Maori artist (fig. 8)

The scope of Maori art today encompasses many viewpoints, both traditional and contemporary, and this is as true for the artists working in wood as it is for those producing in other media. Prominent among the wood artists is the celebrated master Lyonel Grant, who has been the driving force in the construction of many significant meeting houses in New Zealand. Ross Hemera is another noted carver whose work as a constructivist artist embraces a full cross-section of perspectives from cultural to societal issues. Ian-Wayne Grant, Fayne Robinson, Roi Toia, Simon Lardelli and Todd Couper have all been influenced traditionally but have developed their own distinctive personal styles and represent a new era of Maori woodcarving.

Maori custom has a deep-seated belief in the obligation to impart knowledge, to nurture and embrace the young. Today, artists are expected to consider higher education to master technical skills, including the study of Maori art and culture, and they are further encouraged to teach and pass on their knowledge to the next generation. Senior master artists Fred Graham, Sandy Adsett and Darcy Nicholas, all of whom were part of the nucleus of young Maori artists who strived to re-establish the arts in the 1960s, continue to take the lead in their commitment to exhibit, teach and support the promotion of Maori culture in New Zealand and worldwide. Many of the artists whose works are part of "Manawa" are so dedicated to their cultural obligations that they can rarely produce work for the growing

Fig. 9

Pacific Crossover

(The Return to
the Swing, 2001)
Sandy Adsett
acrylic on canvas
40 × 30 inches

market. Renowned sculptors Fred Graham and Lyonel Grant are so continuously involved in major commissions and public installations that they prefer to occasionally release special works for specific events that will represent Maoridom on a broader scale.

To further their education and broaden the knowledge of Maori, artists have been given support to attend workshops overseas, and at home they have hosted several conferences and invited international aboriginal artists to participate. This philosophy has allowed Maori art to evolve through the ready acceptance of new ideas, materials and techniques that comes with exposure to a wide range of artists from around the globe.

"The theme reflects the spirit of the gathering and the interaction of native Pacific Rim artists linked with the Puget Salish legend of 'The Return to the Swing' (The Creation of Humankind). In 2001, artists from many countries met at Evergreen State College in Olympia, Washington, and the longhouse became a forum to exchange ideas and celebrate shared and cross-cultural experiences." —*Sandy Adsett, Maori artist* (fig. 9)

In 2001, North America hosted The Return to the Swing: Gathering of Indigenous Visual Artists, held at Evergreen State College in Olympia, Washington. This first Pacific Rim gathering in North America included the exhibition "The Return to the Swing," and its workshops produced an exceptional body of work that was documented in the publication/exhibition "Hitéemlkiliiksix (Within the Circle of the Rim): Nations Gathering on Common Ground," which toured internationally until 2005.

"This painting relates specifically to the interaction of Maori with the various tribal nations from the North American continent. The similarity of customs and cultures led to the painting at Evergreen State College in Olympia, Washington, which features a woman, who could be from either culture. We both wear feathers in our hair. We both have kakahu *(cloaks) that have been woven with specific tribal patterns. Maori women wear* moko kauwae, *facial tattoos to denote status and identity. First Nations and Native Americans also paint particular tribal marks on their faces. We have* kaitiaki, *or guardians, who remain protectors of family and tribes, similar to the clan totems of the indigenous tribes of the Americas. Hospitality is the basis of Polynesian culture, the meeting and greeting and welcoming of visitors; this, too, is evident in the relationships we have with our native brothers and sisters. This painting is a celebration of that relationship."* —*June Northcroft Grant, Maori artist* (fig. 10)

The Return to the Swing brought Maori artists to North America, where they were exposed to the numerous cultural groups of the Pacific coast and the American Southwest. Each meeting brought new possibilities and friendships, and these have set the stage for the next international forum. The structure and purpose of the gatherings has presented an entirely new way of looking at aboriginal art, both past and present:

> Traditional knowledge was made tangible through telling stories, exchanging artistic techniques, sharing songs and performing dances. Because the participants were all native artists, their interactions began beyond the simplistic discussions that often take place at other venues. Discussions such as the use of traditional versus non-traditional materials, the spiritual and personal significance of images, and the appropriateness of certain protocols did not begin from scratch. It was obvious from all participants that the tradition is always contemporary, that spirituality and personal development are important to all native imagery and that exchanges are guided by rules established within the various communities. The participants were able to engage in more sophisticated discussions about the nature of native art because they all had a native perspective. (Professor Mario A. Caro, Evergreen State College)

In 2005, more than forty visiting artists from Canada, the United States, Australia and the South Pacific attended Te Mata: Gathering of Contemporary Indigenous Visual Artists, held at the Toimairangi School of Maori Visual Culture in Hastings. This was the third gathering to be held in New Zealand and it followed previous events sponsored by Toi Maori Aotearoa's Te Atinga (Committee of Contemporary Maori Visual Arts). The gatherings promoted living cultures, reinforced the Pacific Rim network and enabled younger Maori visual artists to share the energy and become part of the network.

In the past twenty years, many Maori have landed on North American shores for various events. Sculptor Tupare Te Whata accompanied Fred Graham as part

Ruahine—Woman of Two Peoples

("The Return to the Swing" exhibition, 2001)
June Northcroft Grant
acrylic on canvas
40 × 30 inches

Fig. 10

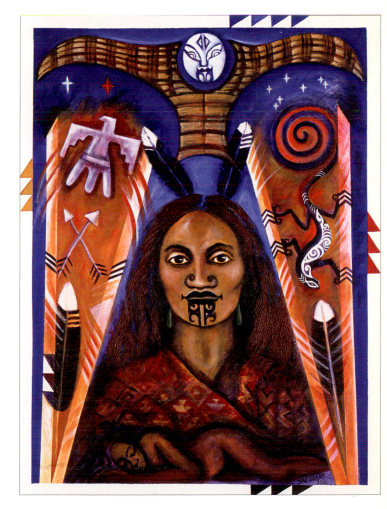

of the Island '86 Art Program on Vancouver Island. Tupare carved a *pou* (totem pole) in Duncan (self-styled "the City of Totems") and Fred Graham carved *Eagle with Salmon*, a sculpture for the community of Port Alberni. John Bevan Ford, Sandy Adsett, Riki Manuel, Roi Toia and other Maori also have, over the years, attended events in Canada, and many more have visited the United States. In 1996, Fred Graham returned to North America to complete a commission for the Burke Museum at the University of Washington in Seattle.

KIWA—PACIFIC CONNECTIONS

"Kiwa—Pacific Connections" was held in Vancouver at the Spirit Wrestler Gallery in 2003 and was the largest exhibition of contemporary Maori art shown outside New Zealand. It was also the first step in exhibiting the art of the Northwest Coast and the Maori side by side. The artists liked the premise that the Pacific Ocean was the connecting force that led to so many cultural parallels, and they also embraced the idea of making work that fused the two cultures. The art was brilliant and innovative, and its success elicited a commitment to continue building this relationship into the future.

Fig. 11

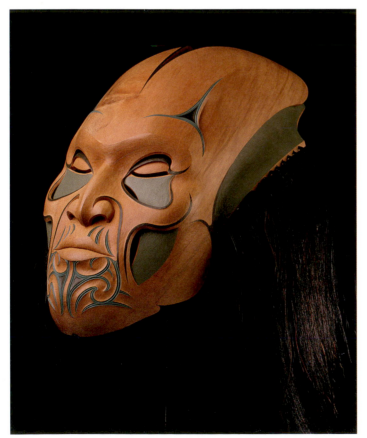

"*I carved this mask as a tribute to the First Nations people. It represents the strong bond that we have not only as similar cultures but also as great friends, and the strengthening of those connections throughout the 'Kiwa' exhibition. I learned many things about the culture and also saw with my own eyes the strong connection their people have with the land and their surroundings. I got to know the First Nations peoples and to witness some of the customs, and the more I experienced, the more similarities I saw. This was my first trip to Canada, and the many beautiful artworks by the Canadian artists inspired me to do a carving that is my interpretation of two distinctive styles as one, symbolizing the melding of the two art forms and the unification of two peoples described in one word as 'strong.' I chose a woman's face, as it is the woman who brings life into the world, which is crucial to the survival of our cultures.*" —*Todd Couper, Maori artist* (fig. 11)

A large Maori group attended "Kiwa"; their respected elder Te Hau Tutua led seventeen artists, eight performers and a number of supporting Maori. The eight participating Northwest Coast artists greeted them, the welcome led by their respected elder Larry Grant, of the host Salish nation. Parallel to the exhibition, a number of the Maori artists offered lectures, workshops and performances at other venues and institutions in Vancouver, which culminated in a culture-sharing event at the Museum of Anthropology at the University of British Columbia. The historic totem poles bore witness to Maori performing the spectacular *haka*—a fierce, ritualized challenge involving dance and chant—in the museum's great hall, silhouetted by sunlight filtering through towering glass windows that opened onto a panoramic backdrop of mountains. Dance groups and elders from the Coast Salish, Haida, Kwak-w<u>a</u>ka'wakw, Nuu-chah-nulth, Nuxalk and Tlingit nations united on the stage and invited the Maori to join them to celebrate this gathering of two great nations from either side of the Pacific.

"The paddle designs incorporate motifs of both the Salish and Maori, connecting and hopefully mirroring the commonalities of our cultures. Our mutual respect for our ancestral heritage, our Mother Earth, and all life that is a constant part of us, is a link that we share and pass to the next generation." — *Susan Point, Coast Salish artist* (fig. 12)

TOI MAORI: THE ETERNAL THREAD

The Eternal Thread is more than weaving, it is about whakapapa *(genealogy), ancestors and patterns in life.* —Darcy Nicholas, Maori artist

"TOI MAORI (Te Aho Mutunga Kore): The Eternal Thread—The Changing Art of Maori Weaving" opened at the Pataka Museum and art gallery in Porirua City in New Zealand in January 2004. The exhibition is massive in scope and represents some of the greatest examples of Maori weaving, with family-owned flax and feather robes being assembled for a tour on both sides of the Pacific. The exhibition opening was complemented by a small Northwest Coast weaving collection from the Tlingit and Tsimshian nations, featuring works in Ravenstail, Chilkat and button-blanket styles by visiting artists Linda and Virginia Bob, Anne Smith and William White. A dance group led by renowned carver Dempsey Bob also included Norman Jackson, and Stan Bevan supported them.

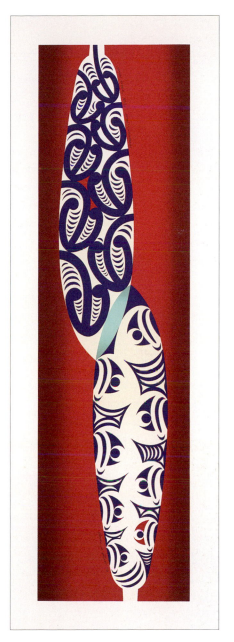

Fig. 12

Fig. 13

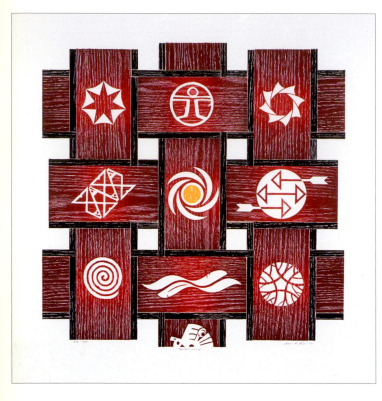

Above:

Sacred Weave

("Kiwa–Pacific Connections" exhibition, 2003)

Susan Point, RCA

woodblock print edition 50

27½ × 27 inches

Facing page:

Eagles

("Kiwa–Pacific Connections" exhibition, 2003)

Dempsey Bob

alder, horsehair

21 × 8 × 9 inches

Private collection

"*The Sacred Weave presented here is an attempt to connect the Salish and the Maori by using a large woven format, representative of basketry, which was a common practice in both cultures. The motifs within the weave relate to the circle of life, on and above Mother Earth, and elements of the continuing cycles of change.*" —Susan Point, *Coast Salish artist* (fig. 13)

During the week of opening celebrations of "The Eternal Thread," Dempsey Bob, assisted by Stan Bevan and Norman Jackson, carved a totem pole as one of eight sculptures commissioned by the Pataka Museum for Te Rauparaha Park in Porirua City to commemorate the *haka* "Kamate Kamate." Over three visits, Dempsey has helped various members of his family to attend artistic events in New Zealand to share the personal journey he has enjoyed with the Maori people.

"*Seeing the Maori culture up close, and being with them, made me see and respect my own culture more. It opened a door for me in my work that cannot be closed again. Our experience together as artists was magical and powerful. Great art comes from good and great people.*" —Dempsey Bob, *Tahltan-Tlingit artist* (fig. 14)

MANAWA—PACIFIC HEARTBEAT

Following the success of the "Kiwa—Pacific Connections" exhibition, there was great interest on the part of all participating artists to build on the energy and make this excitement happen again. The exhilaration surrounding the "Eternal Thread" tour inspired "Manawa—Pacific Heartbeat" and the ongoing recognition of Maori art in North America. "Manawa" is an exhibition of forty-six artists from two cultures, and its opening in Vancouver is timed to support and complement the opening of the "Eternal Thread" exhibition at the Burke Museum in Seattle.

As "The Eternal Thread" showcases the best of Maori weaving, the plan for "Manawa" is to bring together a sister exhibition that is equally impressive but reflects the overall influence weaving design has had on Maori and Northwest Coast art as a whole. The works represent the current directions of art in both cultures, in the full range of media being used today. The real and fundamental message of the "eternal thread" is that it is the connective path of the ancestral bloodline that is the common bond. The challenge to a broader group

of Maori and Northwest artists has been to explore the theme of the weave—the bond that unites them—in their work.

The direct translation of *manawa* is "heart," but depending on the context it can have far deeper meanings. "Manawa" was also the name chosen for this exhibition by Maori to describe the universal bond between all indigenous people—the heartbeat.

Christina Wirihana, an unceasing ambassador for Maori weaving, represents this art form in "Manawa." Her travels and initiatives in the Pacific Northwest have already connected her to Cheryl Samuel, Evelyn Vanderhoop and William White, who have all contributed to the revitalization of weaving on the Pacific Northwest coast. The Alaskan Tlingit weaver Lani Hotch was inspired by her own family's history of basket making to become

Fig. 14

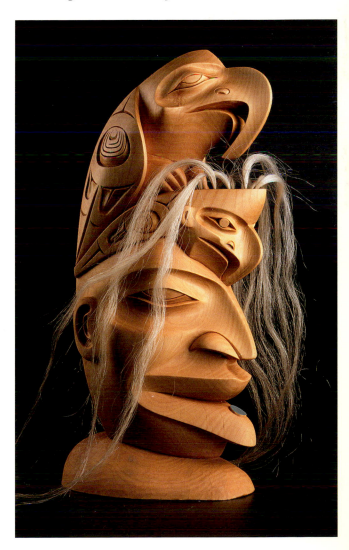

a weaver of traditional robes. Isabel Rorick is the most documented and exhibited of the contemporary Northwest Coast spruce-root weavers, and she has helped define weaving as a fine art. It is a rare opportunity in any contemporary first-nations exhibition to represent textile arts; to have a completed robe and two aprons of this quality from three nations is an honour.

The fifteen Northwest Coast artists represented in "Manawa" all have previous associations with Maori, and the stories of many of their experiences flow through this book. Their participation in the exhibition offers a surprising overview of the Northwest Coast tribal styles and includes master artists of each region. Cross-cultural exhibitions can offer unique challenges, and each artist has responded with enthusiasm, in many cases being deeply honoured to reciprocate previous hospitality and experiences with Maori. Thematically their work speaks of ancient connections, marriages, parallel customs and powerful friendships that can exist between individuals who share a similar passion and responsibility towards maintaining cultural traditions.

Joe David is the anchor of the collection, due both to his long-term association with Maori and his deep personal interest in the spiritual practices of world aboriginal peoples, which has taken him on many quests and journeys during his life. Joe David, Norman Tait, Robert Davidson, Dempsey Bob and Tim Paul have dedicated their lives to creating a vibrant, living

Te Manawa—The Heart

("Kiwa—Pacific Connections"

exhibition, 2003)

Fred Graham

stainless steel on medium-

density fibre board

59 × 23½ × 5 inches

Private collection

art and to teaching and passing on their skills and knowledge to the next generation of artists.

"Manawa" paves the way for future generations to follow. This collection includes a number of the strongest young artists to emerge in recent years. Many have had the privilege of being born into a world where art is once again part of the fabric of life and the decision to become an artist is a natural one, supported by family and community. They have learned traditional skills and techniques, but they are also aware of the greater art world, and it has been equally natural for them to consider new materials that bridge tradition and innovation.

Susan Point is predominant in this group, and she is recognized not only as the foremost female artist of the Northwest Coast but also as the artist who has brought Coast Salish art into the modern art movement. The host city of Vancouver stands on traditional Coast Salish territory, and Susan has graciously acted as the adviser to the large Maori contingent respectfully seeking permission to bring their people, protocols and art to be displayed and exercised on this traditional territory. Haida artist Christian White is the most distinctive argillite carver of his generation. Preston Singletary is a Tlingit artist who attended the prestigious Pilchuck Glass School in Stanwood, Washington, and increasingly contributes his expertise to many first-nations initiatives that involve glass as a medium. Norman Jackson and Stan Bevan are from the new generation of woodcarvers; both trained at the Gitanmaax School of Northwest Coast Indian Art in Hazelton, British Columbia, then committed to further classical training with master artists to ensure they were qualified to represent their culture to the world.

The same is true for the Maori who are building for their future generations. There is a deliberate inclusion in the exhibition of younger artists who are exploring new directions, such as Chris Bryant and Israel Birch in the visual arts; Roi Toia, Simon Lardelli and Todd Couper in woodcarving; Kerry Thompson in bone, and Lewis Gardiner in jade. The true legacy of "Manawa" is passing on knowledge to the next generation. This cannot be better illustrated than in having Brett Graham and his father, master sculptor Fred Graham, exhibiting here side by side. Both share the same passion for producing big sculptures in metal and mixed media and have become renowned for their large public installations throughout New Zealand.

Manawa—Pacific Heartbeat captures the *mauri* (universal essence of life) of this exhibition: Two Peoples, Two Hearts, Beating as One.

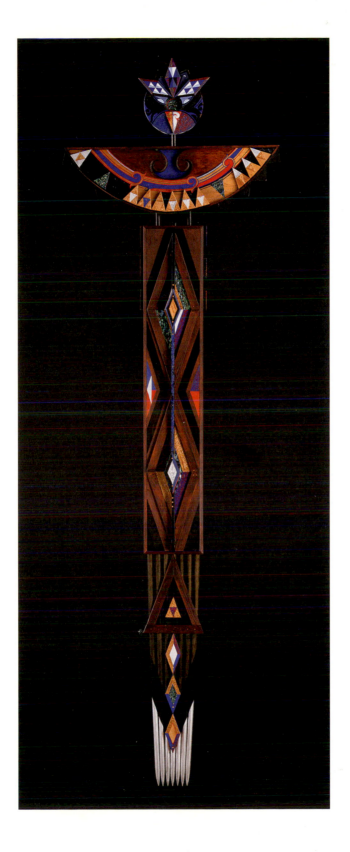

Facing page:

1 **Karanga (The Calling)**
Todd Couper
kauri
22 × 19 × 14 inches

*In the Hokioi I see a parallel with
the great significance Eagle has
throughout First Nations culture,
so for me this sculpture was a way
to acknowledge the First Nations
people and to pay homage to
the land on which we have come
together to celebrate this occasion.*

2 **Uhi Wero, Uhi Taia,
Haumi E, Hui E, Taiki E!**
Derek Lardelli
rimu, acrylic paint, lacquer, metals
and abalone shell inlay
90 × 26½ × 4 inches

*This multimedia piece has
double imagery: the* uhi,
*or needle, and the Hokioi,
or ancient bird figure. The* uhi
*is employed during the practice
of* ta moko *(body art). Here
Hokioi, the giant eagle, once
again takes to the skies.*

3 **Poutama Bracelet**

Alex Nathan

sterling silver

3/4 inches wide × 6 inches long

In ancient lore, the stepped Poutama design symbolized the climb into the heavens made by Tane in his quest to obtain the three baskets of knowledge from Io Matua . . .The steps denote progress and advance, signifying the growth of humans, ever striving for betterment.

Facing page:

4 **Na Tane Te Iringa Necklace**

Alex Nathan

sterling silver and cultured abalone pearls

2 × 1 3/4 inches (pendant),

17 inches (chain)

Traditionally, paua *(New Zealand abalone) shell was used to depict the eyes of the ancestors commemorated in woodcarvings. Here the* paua *pearls are represented as stars, and sometimes the stars are referred to as "little eyes."*

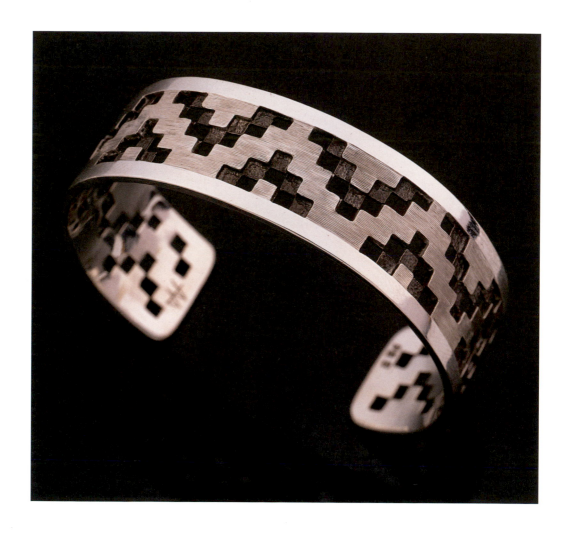

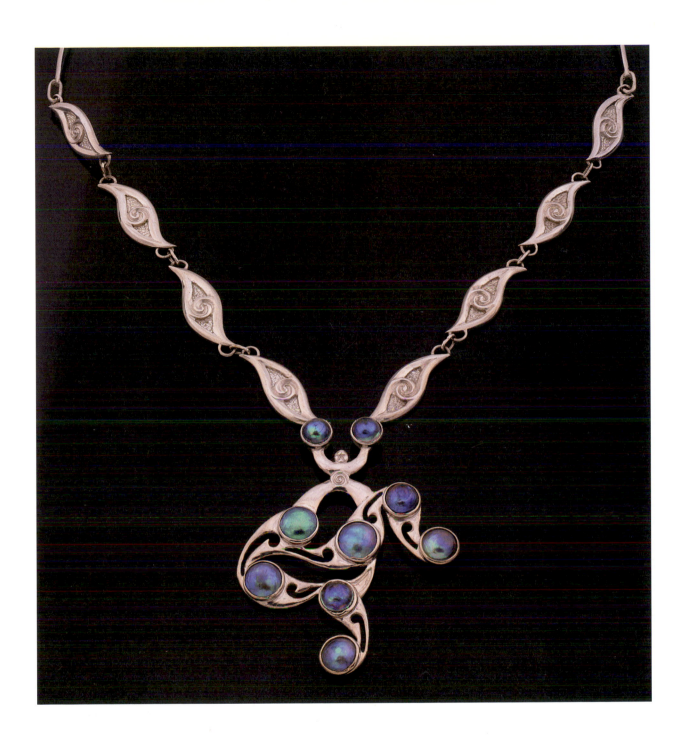

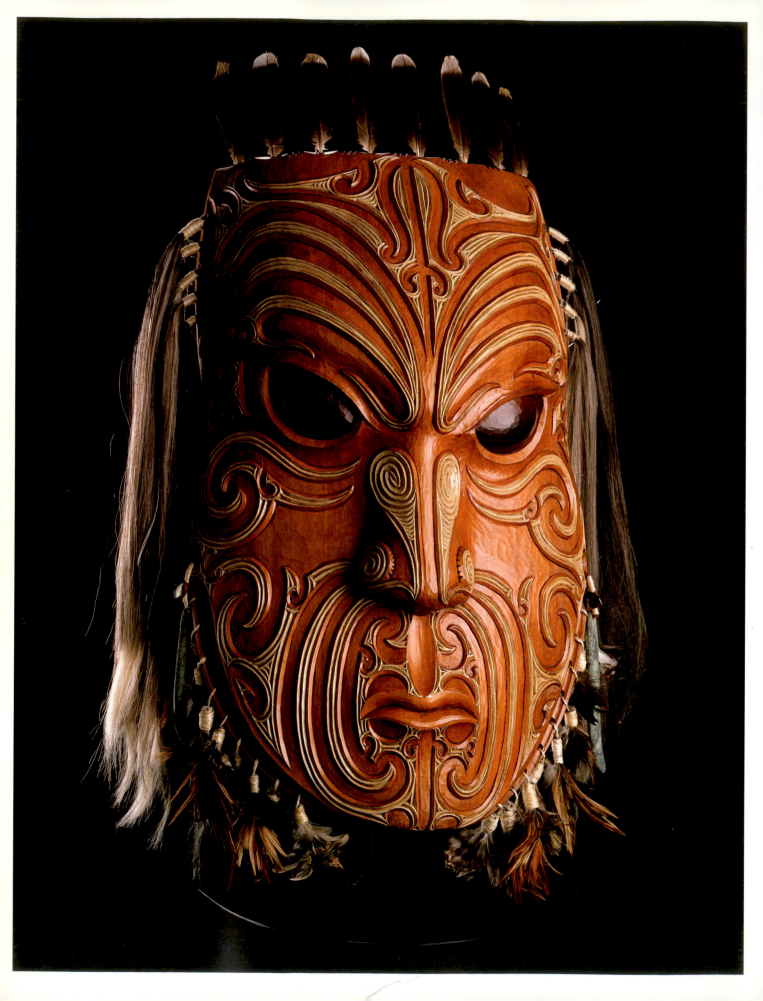

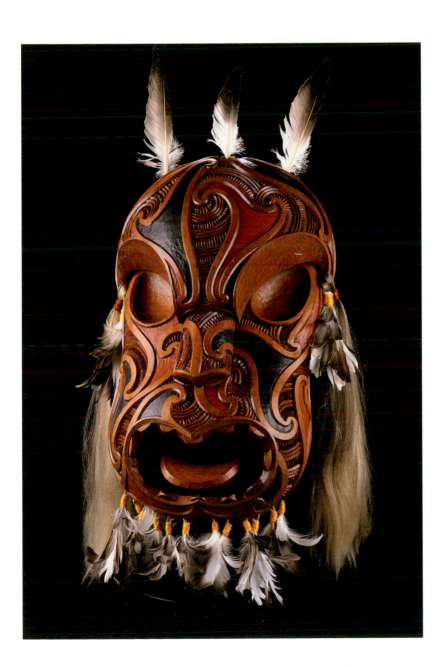

5 **Mataora**
Gordon Toi Hatfield
totara decorated with jade, chicken
feathers and synthetic hair
25 × 15 × 9 inches (excl. feathers)

6 **Uetonga**
Gordon Toi Hatfield
totara, decorated with synthetic
hair and albatross feathers
24 × 14 × 9 inches (excl. feathers)

*Mataora asked Uetonga to paint
designs on his face, and Uetonga
complied, with the condition that
Mataora's* kaitiaki *(guardians)
remain with Uetonga. Mataora
entered the house of Uetonga, but
to the amusement of those within,
Mataora's face designs* (kiri
tuhi) *began to run, causing him
great embarrassment.*

7 **Whakaarotia—To Contemplate,
 Consider, Think About**
 Steve Gibbs
 acrylic and sand on
 medium-density fibre board
 21 × 30½ × 1 inches

 *The image of the shark has
 a double meaning. In one sense
 it refers to one of our* kaitiaki
 *(guardians) that protects
 our fishing grounds and our
 coastal areas. In another sense
 it represents the many recent
 arrivals to these shores who . . .
 generally, through greed and
 thoughtlessness, destroy the
 coastal environment that we
 currently have.*

Facing page:

8 **Tataihono—Ancestral
 Connections**
 Steve Gibbs
 acrylic, gold leaf, sand
 on medium-density fibre board
 25 × 40 × 1 inches

 *The colour of this piece is bone,
 which is linked to the concept
 of* iwi *(a tribe of people connected
 by blood). The central design
 element is the* rauru, *two
 elements locked together. All
 of the imagery is held within the
 wings of a hovering bird.*

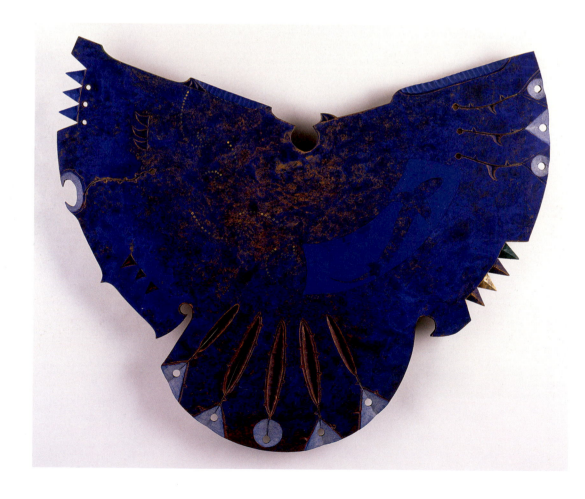

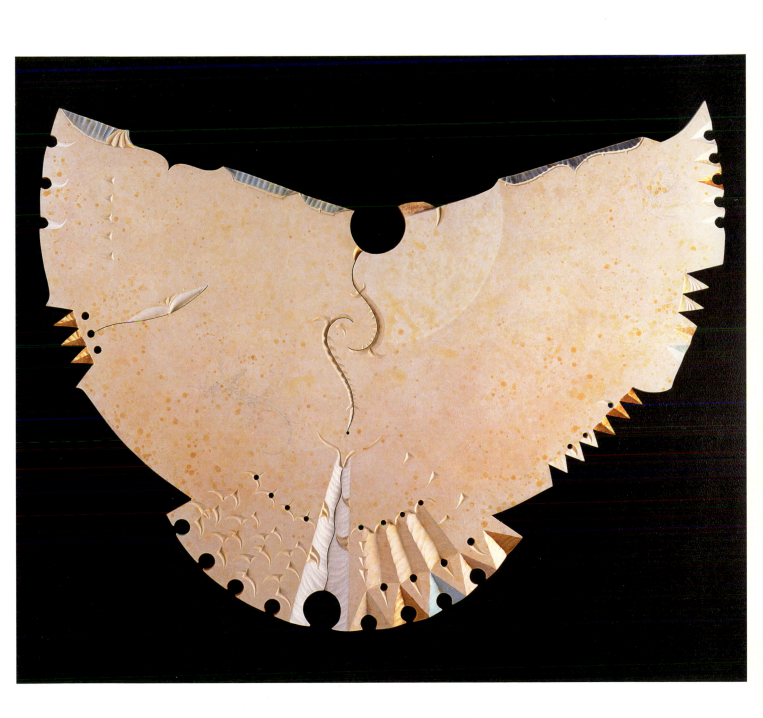

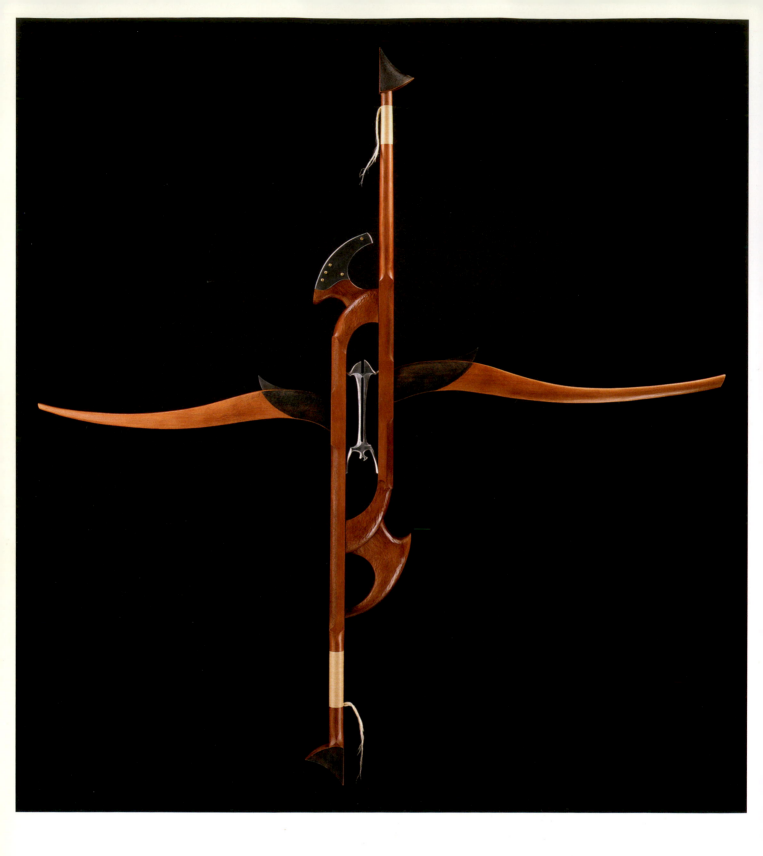

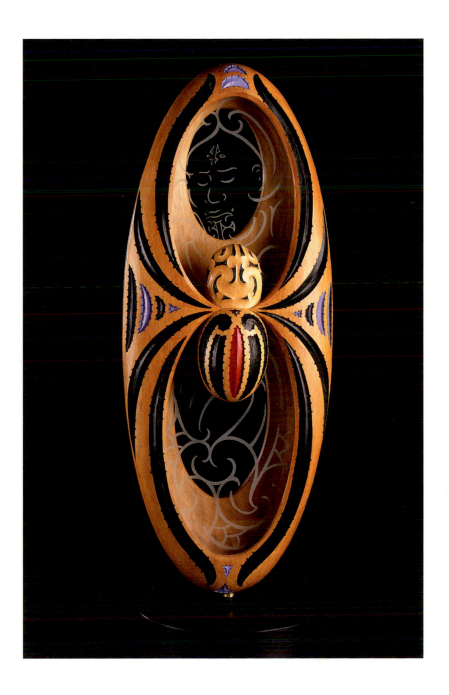

9 **Te Wairua O Hokioi
(The Spirit of the Eagle)**
Ross Hemera
totara, aluminum and flax fibres
85 × 80 × 2½ inches

*This work is inspired by both
the Hokioi myth and the artistic
treatment of its depiction in the
rock drawings. It uses a bird as a
metaphor for the free and creative
spirit of our ancestors. It also
shows a mast as a metaphor for
the courage and skill required by
our ancestors . . .*

10 **Te Ahorangi—
The Heavenly Thread**
Ian-Wayne Grant
kauri and kopara wood,
sandblasted glass with
abalone shell inlay
25½ × 19 × 3 inches (excl. base)

*The creative nature of the spider
and its eye for detail helped
inspire Maori women to be
diligent, patient and dedicated
to the art of* raranga *(weaving),*
taniko *(fine decorative weaving)
and* tukutuku *(latticework).
Te Pungawerewere (The Red-
back Spider) represents the true
nature of weavers and the artistic
manner in which they create their*
whariki *(mats),* kete *(baskets)
and* kakahu *(cloaks).*

11 **Spirit Warrior**

Darcy Nicholas

acrylic on macrocarpa

with opal inlays

23 × 12 × 9½ inches

*This is an image of my
ancestor Tamarau, who has
the power of flight. He returns
in the form of a cloud.*

Facing page:

12 **Caged Culture**

Sandy Adsett

acrylic on canvas

48 × 36 inches

*Pourangahua, a chief from
Aotearoa, sailed back to Hawaiki
to replace the* kumara *(sweet
potato) plants that had perished
during the first long, perilous
voyage of exploration. For the
return trip with the fresh supplies,
the powerful* tohunga *(spiritual
man) Ruakapanga lent the chief
his two giant birds to carry the*
kumara *plants swiftly to these
new lands to the south.*

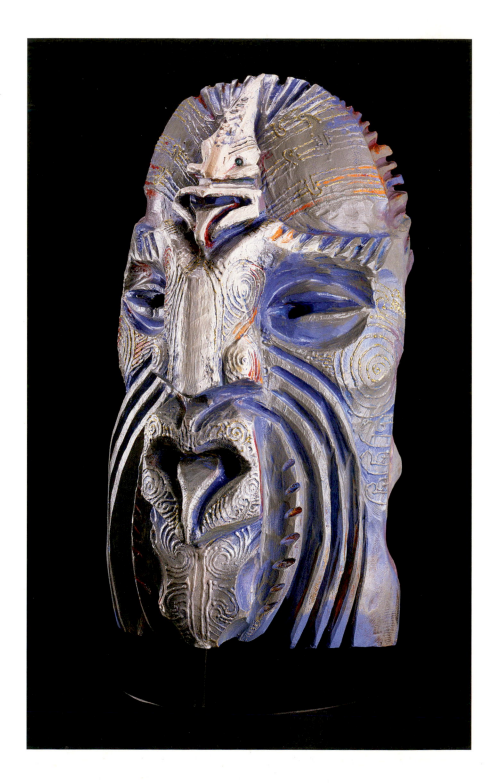

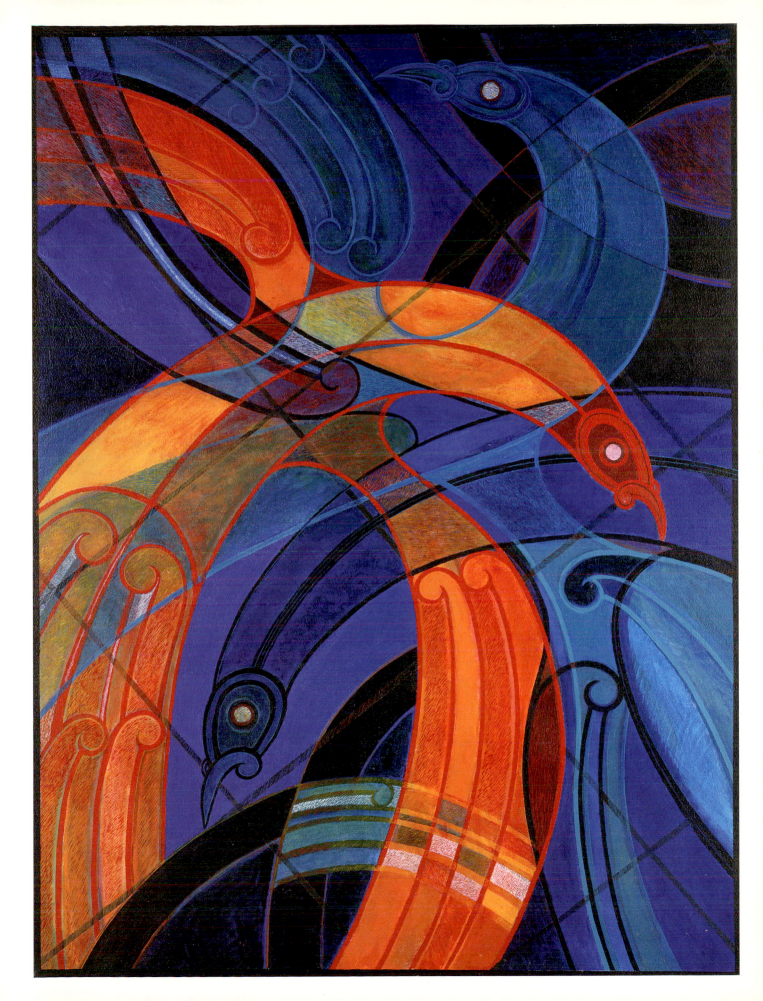

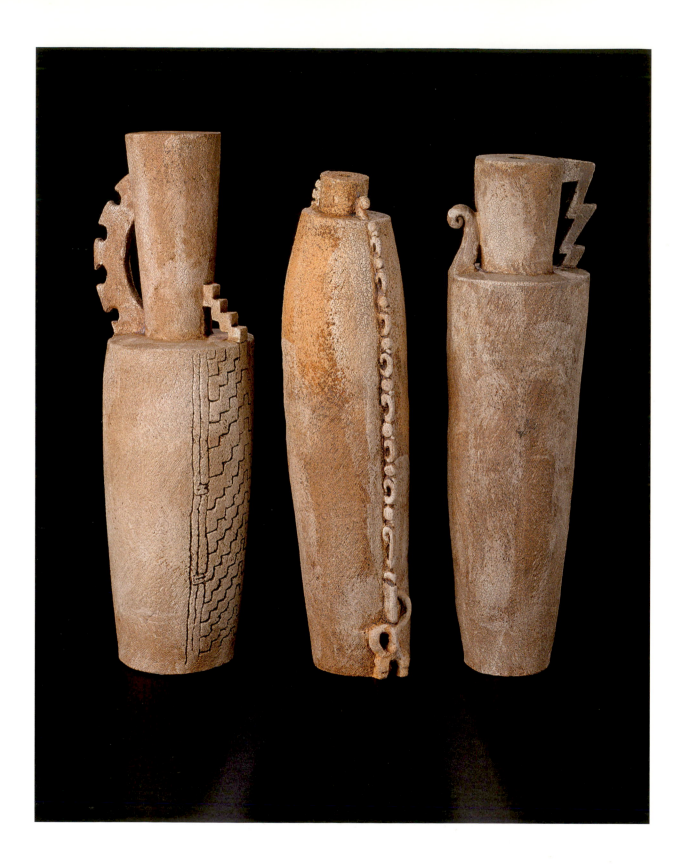

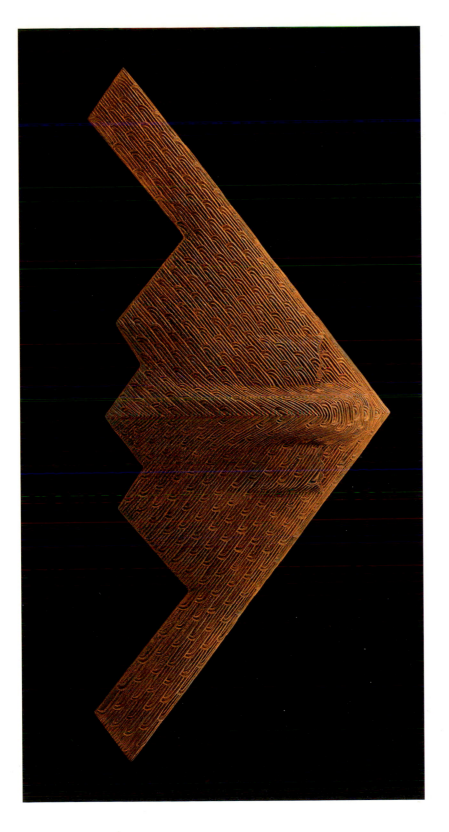

13 **Kia Kotahi Mai Ki Te Ao Nei**
Wi Taepa
raku clay, oxides and white slip
each pillar approximately
19 × 5 × 5 inches

*My works reflect the link
Maori have to the spiritual and
natural world as the provider of
the breath of life. The art forms
are used as an umbilical cord
that is central to my identity
and also provide a link to the
indigenous peoples overseas.*

14 **Foreshore Defender**
Brett Graham
cast iron (edition size 3 with 1 proof)
78 × 34 × 4 inches

Foreshore Defender *is my
gesture, if perhaps a little
pathetic, to protect what is left
of our land. I hereby evoke the
spirit of the Pacific "flying bat,"
or the state-of-the-art "stealth
bomber," to save us, even though
cast in iron and fortified only by
the chisel marks of days of old.*

15 **"Kei a Te Po Te Timatatanga o**
Te Waiatatanga Mai a Te Atua.
Ko Te Ao, Ko Te Ao Marama,
Ko Te Ao Tu Roa"
Israel Tangaroa Birch
lacquer and mixed media
39 × 39 × 1½ inches

A musical instrument called the
pumotomoto *informs this work.*
Pumotomoto *translates as "the*
fontanelle." In old times when
a baby was born, the tohunga
would play over the area of the
child's fontanelle. This was a
transmission of generational
knowledge through the medium
of sound.

Facing page:

16 **Dragonfly Hat**
Isabel Rorick, RCA
spruce root
7 × 14½-inch diameter

I believe that the right to the use
of certain patterns was passed on
through families, and I believe
that I am entitled to weave the
Dragonfly pattern because all the
hats that I have seen in museums
across North America that were
created by my great-grandmother
were woven in variations of this
particular pattern.

Facing page:

17 **Hiilang—Thunderbird—
Supernatural Being**
Robert Davidson, RCA, CC
acrylic on canvas
60½ × 40 inches

*The flap of its wings
booms across the grey sky.*

*The opening and closing
of its eyes—shooting
lightning bolts to the earth.*

*This supernatural being's rare
visits still create awe today,
as they did in ancient times.*

18 **Raven Dancing Across the Sea**
Christian White
argillite, catlinite, abalone
11 × 5 × 4 inches

*Dancing is a big part of my life.
My late father, Chief Edenshaw,
Morris White, started dancing
traditional Haida performances
at about the age of forty. I grew
up watching and listening to the
traditional songs. Many beautiful
appliqué-designed robes decorated
with mother-of-pearl buttons were
being made for dancing.*

19 **Maori Moon**
Norman Jackson
totara with abalone inlay
7 × 6 × 1½ inches (excl. stand)

This moon was inspired by
my visits to New Zealand . . .
The carving honours the power
of the moon that controls the
tides of the great Pacific Ocean,
the tides that link the northern
coastal peoples in North America
to the southern Maori people
of Aotearoa.

Facing page:

20 **Northern Eagles**
Dempsey Bob
alder
10 × 10 × 8 inches

In this piece, a young eagle sits
on top of the mature eagle, and
a human sits on top of them both.
The young eagle sits on top of his
elder, being carried along on his
journey. In a sense, our ancestors
are carrying us all.

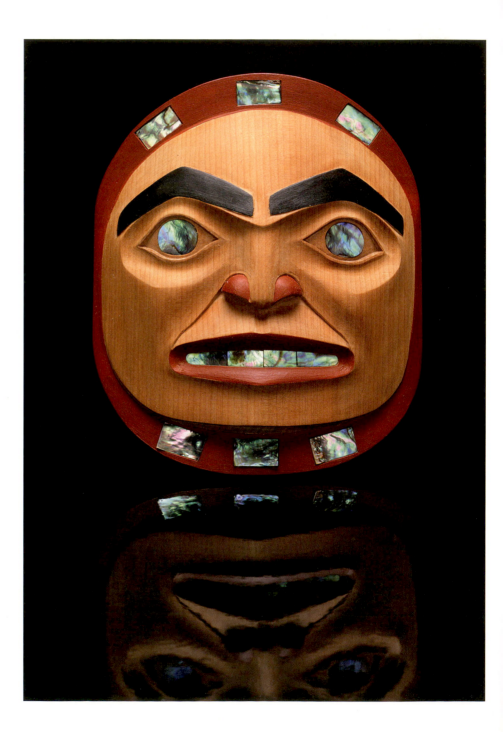

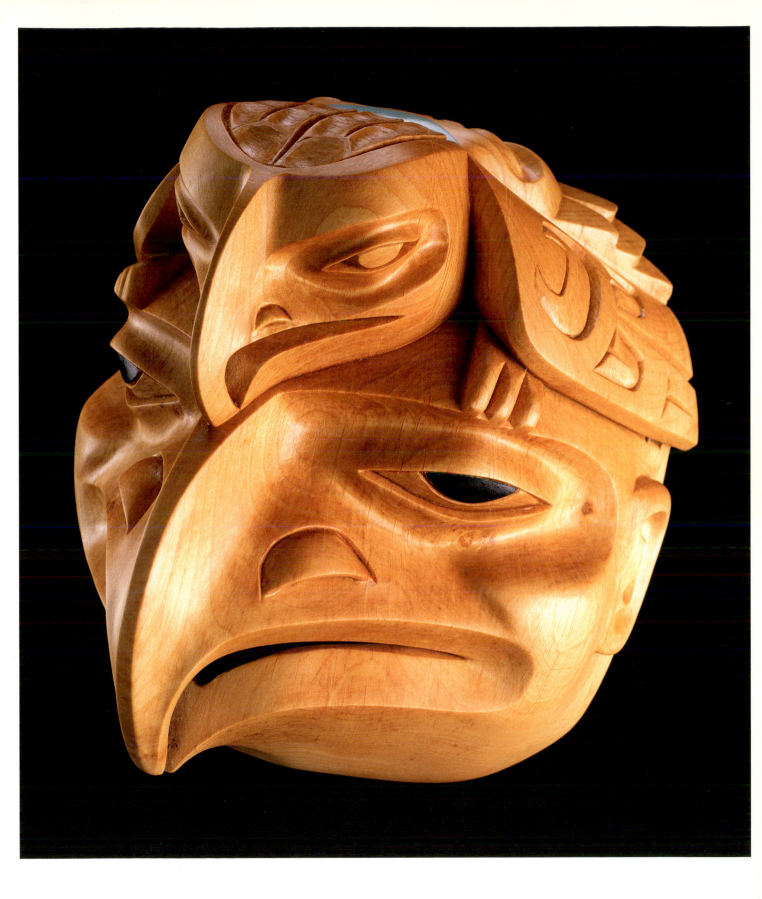

{1} **Karanga (The Calling)** · TODD COUPER

The Hokioi was the largest eagle in the world, a mystical bird that inhabited the North and South Islands of Aotearoa. It preyed on large flightless birds, such as the moa and takahe, but became extinct when this main food source slowly disappeared some 500 years ago. One account said it lived on the mountaintops, was very rarely seen and then only in flight, but occasionally could be heard calling its name: *"Hokioi, Hokioi, hu."* The mystery of this bird can only be interpreted as the allure of a magnificent creature that had power and prestige among the animal kingdom and beyond.

In the Hokioi I see a parallel with the great significance Eagle has throughout First Nations culture, so for me this sculpture was a way to acknowledge the First Nations people and to pay homage to the land on which we have come together to celebrate this occasion. The strong bond we have through our cultures and our enduring friendships is one that I emphasize, and I represent that unity in the form of the eagle head. The inspiration for this piece was the common thread of our strong lineages that go back to the beginning of creation, that being our ancestors who have gone before us.

The title of this piece, *Karanga (The Calling)*, brings attention to *whakapapa* (genealogy) and the importance we place on who we are and more so where we come from. We must pay tribute to our ancestors, for it was the imparting of their knowledge and wisdom over many generations, through oratory and the arts, that has held our cultures strong and continues to survive and prosper. Therefore, wherever we go we can take comfort in knowing that our ancestors are with us and in times of need are always there to call on for strength and support.

{2} **Uhi Wero, Uhi Taia, Haumi E, Hui E, Taiki E!** · DEREK LARDELLI

This multimedia piece has double imagery: the *uhi*, or needle, and the Hokioi, or ancient bird figure. The *uhi* is employed during the practice of *ta moko* (body art). Here Hokioi, the giant eagle, once again takes to the skies.

The chevron mat of chieftainship was spread out for people to lie on while receiving *ta moko*. *Muka* (flax fibre) was used for wiping away blood and therefore continued the genealogical connection between the ancestors Mataora and Niwareka, between *moko* (tattoos) and *muka* (flax fibres). It is an ancestral link that takes us back to the god of earthquakes, Ruaumoko (Water Trembling with Lizards). Ruaumoko was the parent of Manuongaonga (Bird of Pain), who was the parent of Uetonga (Southern Trail), who gave birth to Niwareka (Great Delight), who married Mataora (Living Face).

Here, then, are the art forms of *harakeke* (flax), associated with the sacred weaving house of Niwareka, and *ta moko*, related to the ritual fires of Mataora, which are joined

1 2 3 4

once again by "Te Aho Mutunga Kore: The Eternal Thread." *Uhi wero, uhi taia, haumi e, hui e, taiki e!* The challenge is laid, the challenge is accepted, let us join, let us begin, it is done!

{3} **Poutama Bracelet** · ALEX NATHAN

This bracelet is constructed using overlay techniques with hand-carved patterning on the surface. The design is based on the traditional *tukutuku* (decorative stitched or woven latticework that adorns the interior walls of meeting houses) pattern known as Poutama, meaning "Stairway to Heaven."

In ancient lore, the stepped Poutama design symbolized the climb into the heavens made by Tane in his quest to obtain the three baskets of knowledge from Io Matua (Io the Parent, the Supreme Being of our cosmogony). The steps denote progress and advance, signifying the growth of humans, ever striving for betterment.

{4} **Na Tane Te Iringa Necklace** · ALEX NATHAN

Traditionally, *paua* (New Zealand abalone) shell was used to depict the eyes of the ancestors commemorated in woodcarvings. Here the *paua* pearls are represented as stars, and sometimes the stars are referred to as "little eyes." This constellation of stars referred to as Matariki (Pleiades) appears in the sky around mid-June. The Maori New Year begins with the first new moon after the first pre-dawn appearance of Matariki, as explained in this Maori *whakatauki* (proverb):

> *Ka puta a Matariki; Ka rere a Whanui; ko te tohu o te tau*
> Matariki (Pleiades) reappears; Whanui (Vega) starts its flight;
> these are the signs of the time of the New Year.

Matariki's reappearance is a time to pause and reflect on the year that was and the year to come.

The title of the necklace alludes to the suspending/hanging of the stars by Tane, represented here in the design as the figure atop the Matariki cluster. He is one of the children of Ranginui (Sky Father) and Papatuanuku (Earth Mother), and he separated his parents by forcing his father up into the heavens. In doing so he brought light into the world. Tane was responsible for many feats including fixing the position of the sun and moon and distributing *whanau marama* (children of light/stars). He caused the stars to be arranged on the body of Ranginui to illuminate Heaven and Earth.

The following extract from an invocation tells this story:

5 6 7 8

Tane Matua, Tane nui a Rangi, Tane Whakapiripiri
Nau i wehe nga Matua
Nau ko te Po, Nau ko te Ra
Nau i whakairi te Whanau Marama
Nau ko te Awatea

Tane, the Parent; Tane, the great son of Ranginui; Tane the Conjoiner;
By you were divided the parents
By you is the Night, by you is the Day
By you were suspended the Children of Light
By you is the broad daylight

{5} **Mataora** · GORDON TOI HATFIELD
{6} **Uetonga** · GORDON TOI HATFIELD

The story of Mataora is an interesting look at relationships, reconciliation and commitments. Mataora himself was about to rediscover these concepts in a most permanent way. The story goes that the two lovers Mataora and Niwareka had a disagreement. As a result, Niwareka returned to her people who lived in Rarohenga (Underworld), leaving Mataora to ponder his thoughts.

As time went by, Mataora succumbed to his feelings and decided to seek her out, in doing so hoping to win back her respect. Accompanied by his *kaitiaki* (guardians)— Pekapeka (bat), Kaka (parrot), Ruru (owl) and Kiwi—provided by Tane, Mataora met Uetonga at the entrance of Rarohenga. This man, he would later learn, was the father of Niwareka. Uetonga was painting at the time and listened to Mataora tell the story of how he had come to Rarohenga to look for his wife. Uetonga explained to the young man that no one would recognize him because he had no markings (*moko*) on his body.

Mataora asked Uetonga to paint designs on his face, and Uetonga complied, with the condition that Mataora's *kaitiaki* remain with Uetonga. Mataora entered the house of Uetonga, but to the amusement of those within, Mataora's face designs (*kiri tuhi*) began to run, causing him great embarrassment. He returned in shame to Uetonga and asked him to make permanent the lines that he had painted. Uetonga once again complied and began to carve the designs into Mataora's face.

According to tradition, Uetonga had already positioned the guardian birds in specific sections of the house. Pekapeka was tucked into the *tahuhu* (apex), Kaka rested in the corner of the *matapihi* (window), Ruru was positioned on the *taumata* (place of oratory) and Kiwi perched on the *turangawaewae* (sacred ground).

Looking at the carving of Mataora, we are able to see the abstract form of this representation. The forehead is the origin of contemplation and of knowledge, thoughts and processes represented by Pekapeka; the eye and nose markings are where sight and senses are represented by Kaka; the areas around the mouth and chin demonstrate the spoken word, wisdom and oratory represented by Ruru, and the areas moving from the side of the nose, around the mouth and onto the cheek are the supporting processes and commitments represented by Kiwi. Uetonga's *moko* is an interpretation of how the tattoo might have looked in a more abstract form.

{7} **Whakaarotia—To Contemplate, Consider, Think About** · STEVE GIBBS

This piece refers to the beauty and fragility of our seabed and foreshore (coastal lands), and the considerable debate about rights to *kaimoana* (traditional seafood-gathering traditions), waterfront access and ownership. Until now these have always been taken for granted. The influx of moneyed people from other countries wanting to purchase large tracts of this land has made us realize that our natural coastal areas are vulnerable. Now we realize they're open to being raped and pillaged like many of our other natural resources.

The image of the shark has a double meaning. In one sense it refers to one of our *kaitiaki* (guardians) that protects our fishing grounds and our coastal areas. In another sense it represents the many recent arrivals to these shores who see coastal areas such as ours as ideal land on which to build large holiday homes and plunder fish resources and generally, through greed and thoughtlessness, destroy the coastal environment that we currently have. These fears permeate this piece.

Describing these pieces for "Kaahu," an exhibition at the Maia Gallery in Gisborne, Steve Gibbs noted:

> These works are from a series that engages in a number of cultural concepts with which we are dealing within our present social environment. I use the image of a bird in flight, which references *kaitiakitanga* (guardianship, protection) and cultural *tohu* (signs). I've always dreamed that I could fly... They are about keeping knowledge safe and then sharing it or passing it on to the right people, like our children, when they are ready.

{8} **Tataihono—Ancestral Connections** · STEVE GIBBS

The title refers to the ancestral connections that exist through the interweaving of indigenous cultures. The imagery relates to connections through *whakapapa* (genealogy): connections through blood, connections through thought.

An important connection in this piece is the reference to *tohora*, the whale. As an indigenous people of the South Pacific, we regard *tohora* as ancestors who are regarded as *tipua*, as carriers of sacred knowledge. The colour of this piece is bone, which is linked to the concept of *iwi* (a tribe of people connected by blood). The central design element is the *rauru*, two elements locked together. All of the imagery is held within the wings of a hovering bird.

{9} **Te Wairua O Hokioi (The Spirit of the Eagle)** · ROSS HEMERA

As I gaze intently at graphic images on limestone rock surfaces, I am mindful that these drawings are visual expressions made by my ancestors. They contain the earliest narratives of Ngai Tahu, Ngati Mamoe and the Waitaha people. I am attracted to imagery portraying the human figure, fish, dogs and birds. I scan across highly stylized figures whose animated gestures signal "I am," "I am alive and I relate to all the creatures of this land." Soon my observation is fixed on the figure of a most impressive bird—a large, almost human creature carrying its young on its back. This is Hokioi, the giant eagle. Resting my eyes a moment, my mind is filled with wonder. Hokioi, your back is so strong, your wings so vast; you command the skies over this land, and you carry my imagination away with you. Did you also bear the spirit of my ancestors from and to far distant lands? Did you acquaint the spirit of my forebears with those across the expanse of Te Moananui a Kiwa—the mighty Pacific Ocean? For they, too, immortalize you in their stories and art. And while your shadow fades, I still hear your call from far distant shores—*"hokioi, hokioi."*

Rock drawings in the South Island of New Zealand include a wide range of subject matter. Stylized depictions of natural phenomena, including the human figure, fish, dogs and birds, are common. However, many images of mythical creatures also occur. In particular the part-man, part-bird creature known as Hokioi is rendered with similar stylistic treatment, perceptual skill and creative expression. Hokioi is a large, fierce creature capable of carrying off a man. The "bird-man" myth relates to New Zealand's now extinct great eagle, *Harpagornis moorei*. The eagle inhabited the North Otago—South Canterbury region of the South Island more than 500 years ago. This period corresponds with the time when early Maori artists first created many of the rock drawings.

This work is inspired by both the Hokioi myth and the artistic treatment of its depiction in the rock drawings. It uses a bird as a metaphor for the free and creative spirit of our ancestors. It also shows a mast as a metaphor for the courage and skill required by our ancestors who navigated their canoes, exploring the far reaches of the Pacific Ocean.

The artistic intention of this work continues creative investigations surrounding the visual purpose of stylistic depictions of animate imagery found in rock drawings. The

9 10 11

compositional use of a negative body space in many of the figures is of particular fascination. Although graphically the body-space design appears empty, it is doubtless filled with cultural meaning and has become the attention of theoretical speculation. There are two main suggestions about its purpose. One idea is that this space refers to ingestion and consumption; the other proposes that the space refers to spiritual and emotional existence.

The construction of an internal space is a defining feature of this work, and it provides insight into the cultural purpose of depicting a body blank. The small inverted figure is Tane, the Maori god of the forests who created the world between Ranginui (Sky Father) and Papatuanuku (Earth Mother) by separating them. In this work, the Maori creation story is a reference to spaces needed for incubation and birth, for both the spiritual and physical body.

{10} Te Ahorangi—The Heavenly Thread · IAN-WAYNE GRANT

According to the oral traditions of the Ngati Kahungunu of the Wairarapa district of New Zealand, Te Ahorangi (The Heavenly Thread) coexisted with Matakupenga (The Meshes of a Net), and from this union came Te Pungawerewere Katipo (The Redback Spider) along with many other spiders.

The creative nature of the spider and its eye for detail helped inspire Maori women to be diligent, patient and dedicated to the art of *raranga* (weaving), *taniko* (fine decorative weaving) and *tukutuku* (latticework). Te Pungawerewere represents the true nature of weavers and the artistic manner in which they create their *whariki* (mats), *kete* (baskets) and *kakahu* (cloaks). They bring together the heavenly threads of time, constantly reminding us of our roots, helping to preserve *nga whakapapa* (genealogical lines) and *nga tatai korero* (historical accounts) of our people.

The connection between Te Ahorangi and Matakupenga is important because it is the very reason for the spider's existence, just as our own existence lies with that of our women, who as *wharetangata* (the child bearers) give us the gift of life, which is reflected in the stylized pattern on the glass.

So, Te Ahorangi encapsulates the role of *nga wahine* (womenfolk) as *whaea* (mothers) and *kairaranga* (weavers) who continuously strive to keep alive the traditions of our people, further strengthening our links to the past and forever bearing the fruits of their labour for future generations to behold.

{11} Spirit Warrior · DARCY NICHOLAS

This is an image of my ancestor Tamarau, who has the power of flight. He returns in the form of a cloud.

12 13 14 15

{12} **Caged Culture** · SANDY ADSETT

This painting depicts the legend "The bringing of the *kumara* (sweet potato) from the ancient Maori homeland of Hawaiki to Aotearoa (New Zealand)." Pourangahua, a chief from Aotearoa, sailed back to Hawaiki to replace the *kumara* plants that had perished during the first long, perilous voyage of exploration. For the return trip with the fresh supplies, the powerful *tohunga* (spiritual man) Ruakapanga lent the chief his two giant birds to carry the *kumara* plants swiftly to these new lands to the south. On Harongarangi, the bird that flew true and straight, Pourangahua placed the *kumara* tubers. He rode Tiongarangi, the bird that ducked and dived, to ward off the evil spells sent up by jealous *tohunga* who tried to knock Pourangahua and the birds from the sky as they flew over their islands. This legend tells of the many ongoing adventures that followed this chief on his journey home.

In this painting, the birds are caught up in a mesh. This represents the many difficulties we are facing today as we try to sustain our cultural identity. We now share our nourishing *kumara* with other indigenous cultures so that together we can strengthen our resolve through our arts and our legends. We gratefully acknowledge this valuable opportunity to share our art through the Spirit Wrestler Gallery. *Kia ora*. Many thanks.

{13} **Kia Kotahi Mai Ki Te Ao Nei** · WI TAEPA

Let us be one with the creation.
Let us be one with the people.
Let us be one in spirit.
Let us be one in this world.

This series of works started at the *hui* (gathering) Te Mata: Gathering of Contemporary Indigenous Visual Artists in Aotearoa in January 2005. These new works intentionally use symbolic references to reflect Te Mata, such as the indication of Te Aratiatia, The Way of Steps (the steps of knowledge), thereby connecting these sculptures cross-culturally. My works reflect the link Maori have to the spiritual and natural world as the provider of the breath of life. The art forms are used as an umbilical cord that is central to my identity and also provide a link to the indigenous peoples overseas.

These forms are *pou* (pillars), a declaration of ethnic identity to represent communication, reality and infinity. The *pou* is in the form of a container, and each is shaped to embody the concept of *te kore* (void/darkness). The small hole in the top of each *pou* links the world of darkness to the world of *ao marama* (daylight).

The *pou* reference my *matauranga* (knowledge) of the correlation between humans and their cultural, social and personal environment. The *pou* are imbued with my personal

experiences of growing up on the *marae* (gathering place) and are synonymous with the valuable insights, knowledge and oral histories passed on to me by my father and mother and by *kaumatua* (elders). These pieces relate to customs that have evolved over hundreds of years such as kinship, reciprocity, cross-fertilization of indigenous cultures and the respect for their processes and techniques.

These works are intended to acknowledge and offer tribute to the heartbeat of tribal *whakapapa* (lineage) representing genealogical connections across the nations, the breath joining the life force of two great cultures, carrying us forward together, both globally and spiritually—and to convey the enjoyment and deep respect we feel for each other.

Nga Tapuwae o te hau Karanga

My feet have walked here.

{14} **Foreshore Defender** · BRETT GRAHAM

The weaving of a Stone Age culture with futuristic technology is a notion that intrigues me. Since first contact with Europeans, Maori have adopted *pakeha* (foreigners') weaponry and military symbols of status, making them their own: carving the butts of muskets, hoisting flags as religious icons, wielding officers' staffs as *tokotoko* (talking sticks) used on the *marae* (gathering place).

We have appropriated such icons and made them symbols of Maori resistance to settler migration and to the inevitability of land loss. In recent days, legislation has been put in place to deny Maori rights to own the foreshore and seabed, as more and more land is being lost to foreign investors.

Foreshore Defender is my gesture, if perhaps a little pathetic, to protect what is left of our land. I hereby evoke the spirit of the Pacific "flying bat," or the state-of-the-art "stealth bomber," to save us, even though cast in iron and fortified only by the chisel marks of days of old.

{15} **"Kei a Te Po Te Timatatanga o Te Waiatatanga Mai a Te Atua.**

Ko Te Ao, Ko Te Ao Marama, Ko Te Ao Tu Roa" · ISRAEL TANGAROA BIRCH

This piece is from a *whanau* (series) of works, and the title is an adaptation by Hirini Melbourne of the original translation by *tohunga* (expert) Matiaha Tiramorehu (1949). It means: "It was in the night that the gods sang the world into existence. From the world of light into the world of music."

My work is inspired by the voices of *nga taonga puoro* (Maori musical instruments) and the stories they convey. A musical instrument called the *pumotomoto* informs this work. *Pumotomoto* translates as "the fontanelle." In old times when a baby was born, the *tohunga*

would play over the area of the child's fontanelle. This was a transmission of generational knowledge through the medium of sound. As my partner and I are to become parents, I am interested in the sounds our baby can hear while inside the *wharetangata* (womb).

Each Maori instrument has its own *mauri* (life force), *wairua* (spirit) and *reo* (voice). When given life through the medium of breath, they sing. I see my work as having the same concept, but it's light that breathes the work into existence.

"Rhythm and Movement are the essence to life."—Hirini Melbourne

{16} **Dragonfly Hat** · ISABEL RORICK, RCA

When I was asked to contribute a piece to this project, I knew immediately what I wanted to weave. I am, however, more uncertain about what words to use to explain the design and some of the history of spruce-root weaving from the perspective of the Haida people. So much of the knowledge concerning spruce-root weaving has been lost, but I do know that it is known as a Dragonfly design. I found out through the field notes of Charles F. Newcombe, in an interview that he conducted with my great-grandmother Isabella Edenshaw, that the pattern on the brim is called the Dragonfly—I learned through a short channelled interview by my sister with one of our ancestors that the concentric diamonds are the way that they fly.

Although I commonly use another hat pattern known as the Slug Trail and the Spider Web and I know the story behind the design, I have decided not to use that one for this particular hat. I believe that the right to the use of certain patterns was passed on through families, and I believe that I am entitled to weave the Dragonfly pattern because all the hats that I have seen in museums across North America that were created by my great-grandmother were woven in variations of this particular pattern. This leads me to believe that woven designs were like crests; they were recognized as belonging to a particular family.

At the time I took up weaving with my paternal grandmother, Selina (Adams) Peratrovich, in 1974, I was nineteen years old. It was a critical time in the history of spruce-root weaving, as she was literally the last active spruce-root weaver of her generation. At that time, my aunt Delores Churchill and her daughter, April, were the only other Haida women weaving spruce root.

I come from a matrilineal society where knowledge is passed from mother to daughter. Although Isabella Edenshaw was a well-known weaver of her time, due to strict Christian beliefs imposed upon her she did not pass on her weaving knowledge to my maternal grandmother, Florence Davidson. The knowledge, however, did not end there. Selina (Adams) Peratrovich broke with tradition when she was a young woman and learned weaving from her mother-in-law—therefore, the family legacy was continued when she

16 17 18

taught Florence Davidson in the early 1960s, myself in 1974 and my mother, Primrose Isabel Adams, in 1978. I learned what I could from Selina in the last ten years of her life. After her passing in 1984, I continued my research by visiting museum collections throughout North America.

I am glad that these hats and baskets have been preserved in museum collections and are available to us to study. It is sad, however, that no documentation was made when these pieces were collected. Isabella Edenshaw and Mrs. Tom Price are the only two weavers I know of to have pieces attributed to them, and this is because of their husbands' paintings on their hats and baskets.

I would like this ancient art to continue. I have been asked many times to teach weaving, and many times I have been tempted to do so. I had agreed to teach a group of young women last year when a friend told me: "This is your wealth—your family treasure—and it is not a good idea to pass it on to just anyone. Since you have three sons and no daughters, if you must teach, it should be your nieces." Therefore, I have invited my nieces to join me in my home this summer to introduce them to spruce-root weaving. If I get a good response from them, I will pass on the family legacy.

{17} **Hiilang—Thunderbird—Supernatural Being** · ROBERT DAVIDSON, RCA, CC

This design is also a limited edition serigraph print and a limited edition Pendleton blanket.

The flap of its wings booms across the grey sky.

The opening and closing of its eyes—shooting lightning bolts to the earth.

This supernatural being's rare visits still create awe today, as they did in ancient times.

{18} **Raven Dancing Across the Sea** · CHRISTIAN WHITE

He put on two yellow-cedar blankets and walked out among the people. They did not see him. Then he went into the chief's house and to the right, it had ten tiers of retaining planks, on the upper one, in the middle of the sides, one sat weaving a chief's dancing blanket. Then from the blanket she was weaving, something said, "Tomorrow, too, one of my eyes will still be unfinished, unfinished." (Skidegate texts by John Swanton, quoting John Sky)

I chose to carve this piece for the "Manawa" exhibition because dancing is a big part of my life. My late father, Chief Edenshaw, Morris White, started dancing traditional Haida performances at about the age of forty. I grew up watching and listening to the traditional songs. Many beautiful appliqué-designed robes decorated with mother-of-pearl buttons were being made for dancing.

19 20

When the first Europeans sighted Haida Gwaii (Queen Charlotte Islands, British Columbia), canoes filled with Haida people were there to greet them. The robes the Haida wore were finely woven from yellow-cedar bark, mountain-goat wool and dog hair. These black, white, red and blue robes featured abstract designs with many faces and eyes.

I've always admired these chiefly regalia. Recently there has been a revival of the weaving tradition by several of our people, and my wife purchased a set of leggings for me, which I wear proudly at our ceremonies. When I went to the [Te Mata:] Gathering of Contemporary Indigenous Visual Artists in New Zealand, I wore these leggings and other regalia—I also put these leggings on the legs of the dancer depicted in this sculpture. I had a dream about the track designs on the back, which are references to both the hunter and the hunted. In these leggings I have danced at the Canadian Museum of Civilization in Hull, Quebec; at the Field Museum in Chicago, and at the American Museum of Natural History in New York, as well as at many local events in Vancouver and in Haida Gwaii.

{19} **Maori Moon** · NORMAN JACKSON

This moon was inspired by my visits to New Zealand. A Maori carver, Nelson, gave me this piece of totara wood in 2004, when Stan Bevan, Dempsey Bob and I were carving a totem pole for Te Rauparaha Park in Porirua City. The totem pole was one of eight sculptures commissioned by the Pataka Museum to celebrate the New Zealand *haka* (ritualized challenge) "Kamate Kamate." We were all in New Zealand to attend the celebrations at the opening of the "Eternal Thread" exhibition.

I carved the Maori moon here in Ketchikan, Alaska, my Tlingit homeland, in memory of the full moon we share on both sides of the Pacific. The carving honours the power of the moon that controls the tides of the great Pacific Ocean, the tides that link the northern coastal peoples in North America to the southern Maori people of Aotearoa.

{20} **Northern Eagles** · DEMPSEY BOB

I saw the bones of the giant eagles in a museum in New Zealand and that experience became the influence for this piece. The eagle is an important clan crest among the northern tribes. When Darcy Nicholas was in Prince Rupert, we saw fifty eagles one day. It was exciting for both of us, as eagles are close to the environment, the sky and the earth.

In this piece, a young eagle sits on top of the mature eagle, and a human sits on top of them both. The young eagle sits on top of his elder, being carried along on his journey. In a sense, our ancestors are carrying us all.

MOANAURI

OCEANIC BLOODLINES

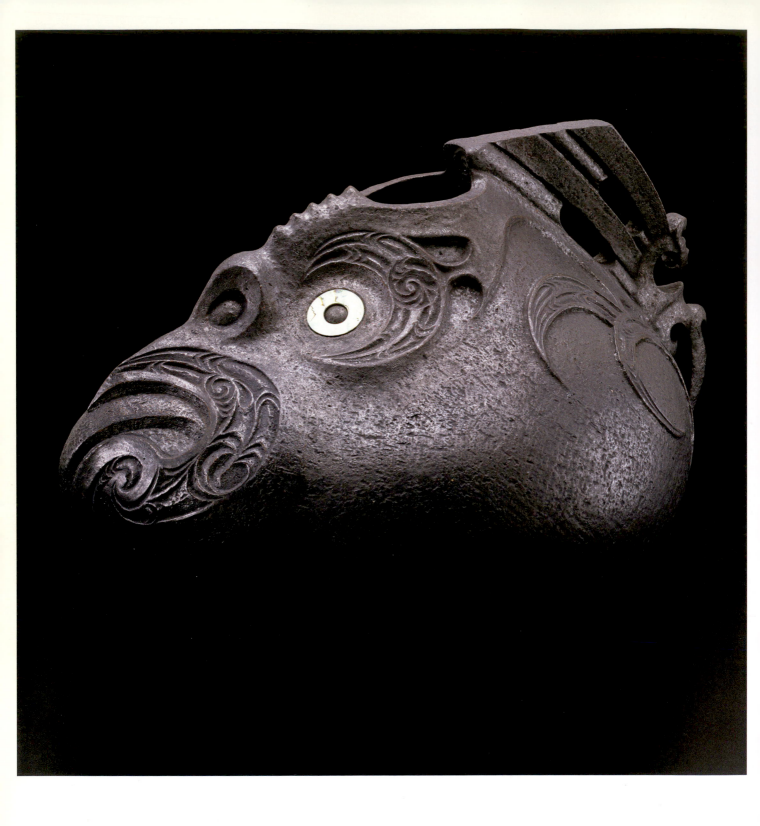

Facing page:

21 **Pokopoko Te Tanihwa**
Manos Nathan
fired clay, oxides
with abalone shell inlay
10 × 13½ × 9½ inches

22 **Rangiriri Te Hautupua** IV
Manos Nathan
fired clay, terra sigillata
with abalone shell inlay
9 × 15 × 16 inches

*Taniwha (water spirits) are
similar to dragons in the
European tradition—nasty,
capricious and malevolent
creatures at one end of the scale
and, at the other end, much more
benign and helpful beings—
often, however, somewhat
mischievous. Chiefs and people
of exceptional ability and
achievement are honoured to
this day by being referred to as*
taniwha *in oratory on our* marae
(gathering places).

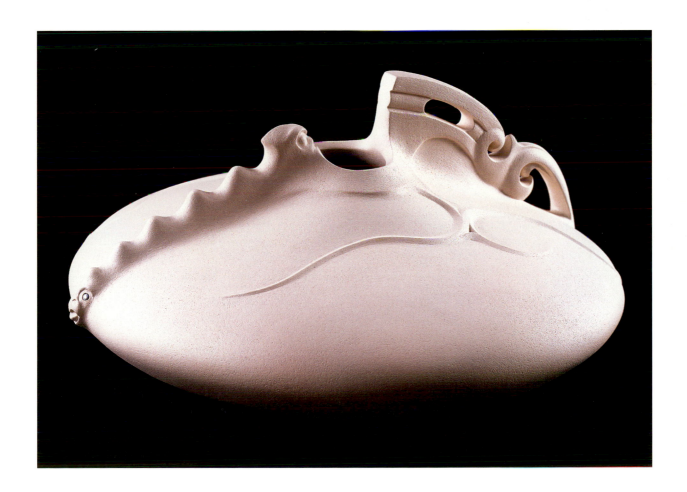

23 **Kete—Te Hera Waka o Tainui (The Sails of the Tainui Canoe)**
Christina Hurihia Wirihana
kiekie with handles of flax fibres
8 × 12 × 4 inches

The long, swordlike leaves of the kiekie *droop down from the heights of the trees, which sometimes makes for very easy harvesting. Of course, some leaves are totally out of reach, and the gatherer is encouraged to leave these for* Tane Mahuta, *God of the Forests.*

Facing page:

24 **Ipu Ika (Fish Vessel)**
Colleen Waata Urlich
raku clay, terra sigillata with wax resist, oxidization fired, decorated with flax, plum twigs, gold and copper leaf
21 × 21 × 6 inches

Maori and First Nations peoples of the Northwest Coast share the same values of hospitality, reciprocity, personal and tribal mana *(power). The fish in this vessel, depicted on an* ahi matiti, *or spit, symbolizes preparation for hosting and our common reliance on fish as a customary food source.*

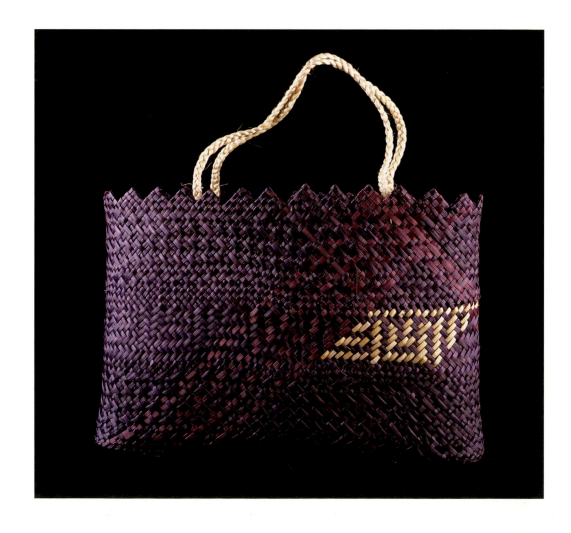

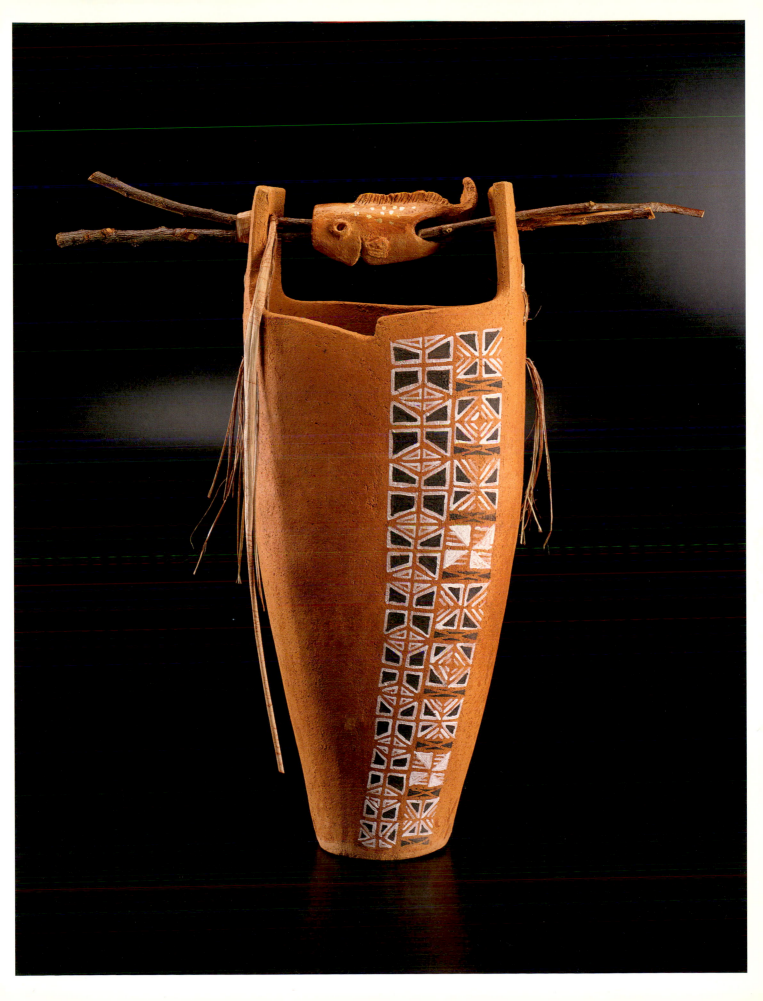

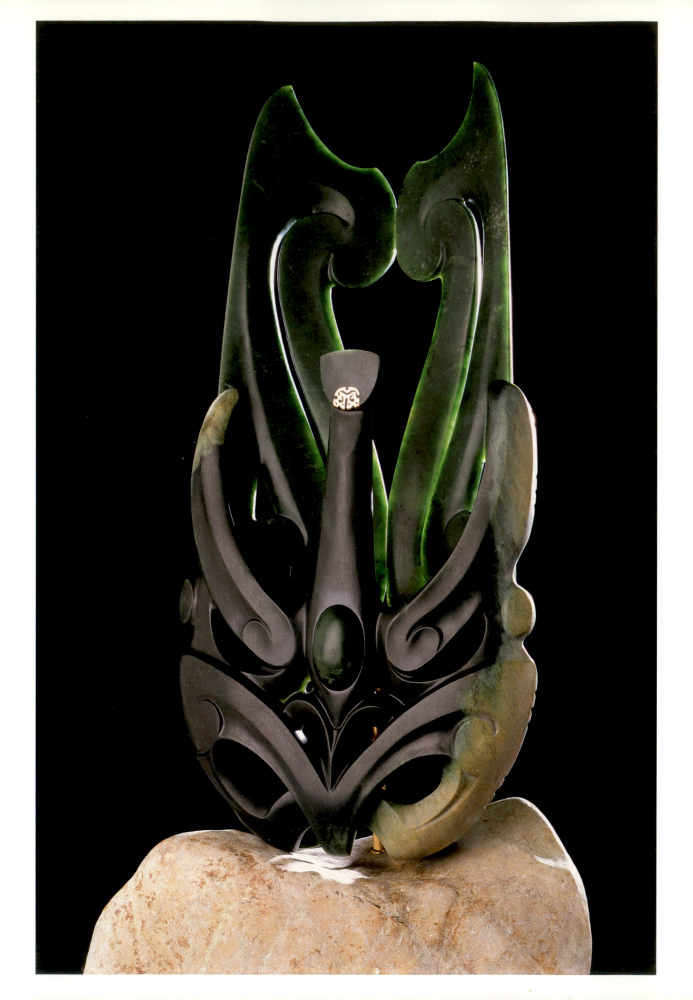

25 **"Whiria Te Kaha..."**
Lewis Gardiner
jade, 9-carat gold and brass
21 × 10 × 3 inches (excl. base)

The tiheru *(canoe bailer) is
a link to the great navigators.
When stating one's* whakapapa
(genealogy), the waka *(canoe)
is an important tie to the* tupuna
*(ancestors). It is from this point
that many individual threads are
joined to make our people and
culture strong.*

26 **Niho Taniwha (Shark's Teeth)**
Baye Riddell
fired clay
each piece approximately
32 × 10 × 11 inches

*A spirit being that inhabits the
sea or inland waters, the* taniwha
*referred to something awesome; it
could be responsible for disastrous
events such as drowning or for
more benevolent actions such as
guiding* waka *(canoes), rescuing
people, appearing as a good
sign or omen or guarding fishing
grounds.*

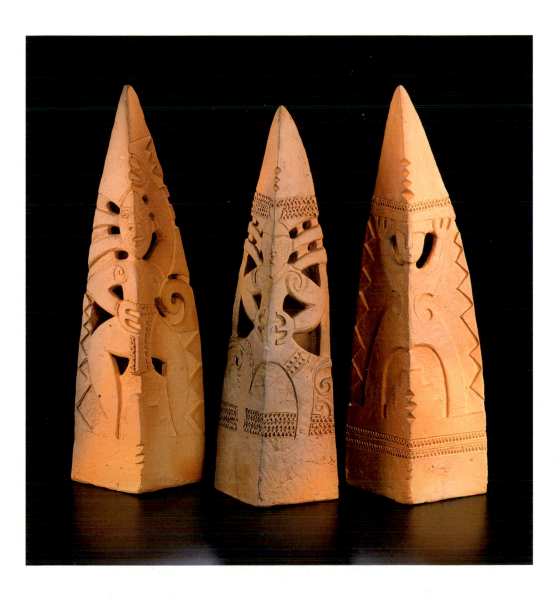

27 **Hei Tiki**
Rangi Kipa
Corian® with abalone shell inlay
3 × 2 × ¼ inch

The hei tiki *is the most iconic of Maori adornment forms. The* tiki *(carved figure) probably has its genesis with "Tiki Ahua," an ancient Maori narrative that explains the creation of the first man. It is said to represent the stylized human form* in utero.

28 **Nguru (Nose Flute)**
Rangi Kipa
sperm whale tooth
with abalone shell inlay
4 × 3¾ × 2 inches (incl. base)

Maori music, much like a good orator, can carry people across time and space, recalling tunes and sounds that connect people emotionally to events and occasions of times long gone and to loved ones who also have passed on. This is the role of the Maori musician, to join the ha *(breath) of humankind to vessels and instruments . . .*

Facing page:

29 **Whakamutunga (Metamorphosis)**
Fred Graham
swamp kauri, stainless steel
and abalone inlay
43½ × 24 × 3 inches

The whale is a frequent traveller between the Northern and Southern Hemispheres. In my sculpture, as the whale crosses the equator it changes both in shape and in body design, from Northwest Coast Indian to Maori. Day changes to night.

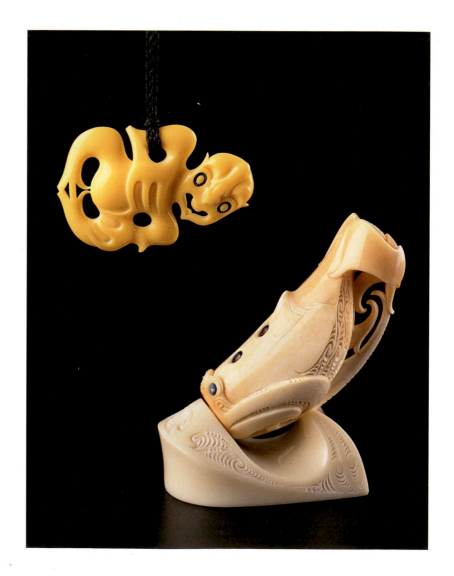

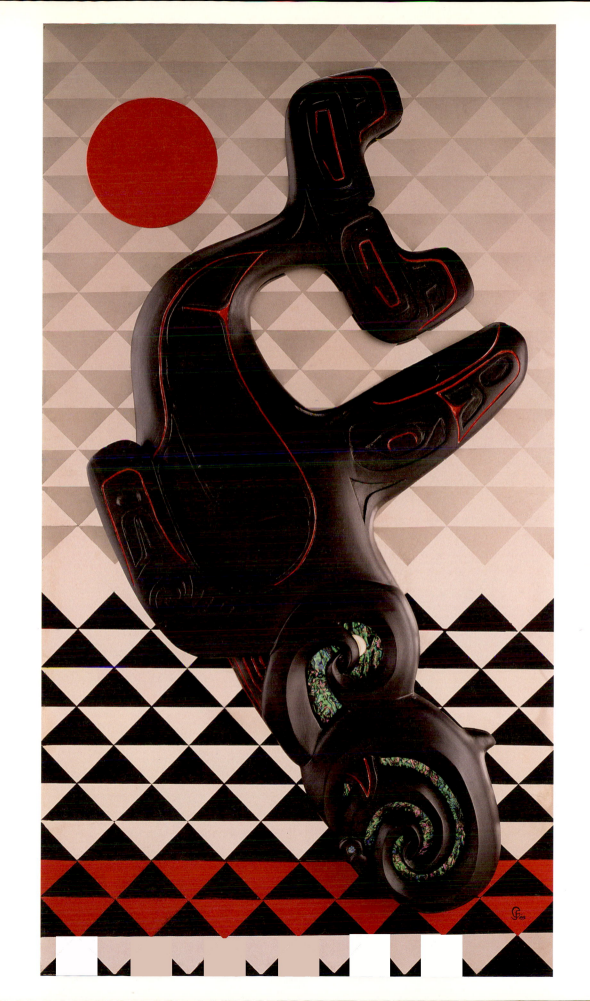

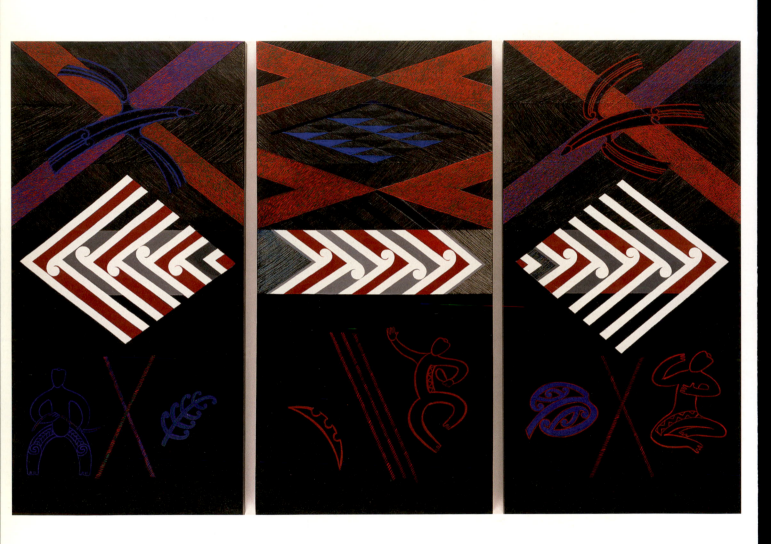

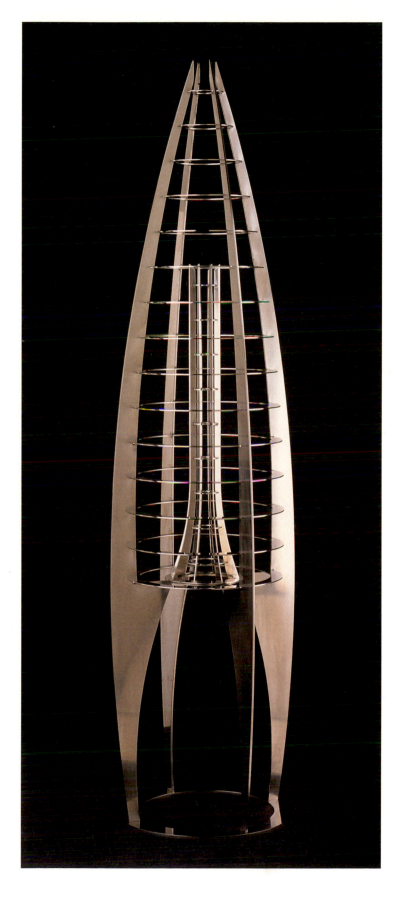

Facing page:

30 **Taki Toru (triptych)**
Sandy Adsett
acrylic on canvas
each panel 30 × 15 inches

Taki toru *means a lashing/tying in threes. The images depict a legend of Paikea, an ancestral sea voyager to Aotearoa, "Land of the Long White Cloud." Paikea was sent a message in the form of directional lashings wrapped around a gourd and cast into the sea by people in his distant homeland.*

31 **Hinaki**
Robert Jahnke
stainless steel
79 × 23½ × 23½ inches

Hinaki *grew out of a concept proposal for a waterfront project for the city of Auckland in 2001 . . . Originally conceived as a nine-metre-high (thirty-foot-high) structure under which one could walk to peer into the internal vortex,* Hinaki *(Eel Trap) was to be complemented by an ascending series of* taruke *(lobster traps) set obliquely on their sides, the largest to have been at two metres (seven feet) in height.*

32 **Lily Leaf Platter (with lid)**
Kerry Kapua Thompson
(Tamihana)
kauri
3 × 19½ × 19½ inches

*This platter was a challenge
for me, as I was playing with
the idea of interweaving lily
leaves in an abstract circular
form of the Path of Life.*

Facing page:

33 **Frog and Raven Warrior
(with war visor)**
Stan Bevan
alder
14 × 10 × 5 inches

*Frog is the liaison between two
worlds, such as the deep forest
and the human world. Raven is
a carrier and communicator of
knowledge—in this case, the two
worlds are an ocean apart. The
Frog and the Raven are crests
that carry the history of the clan.*

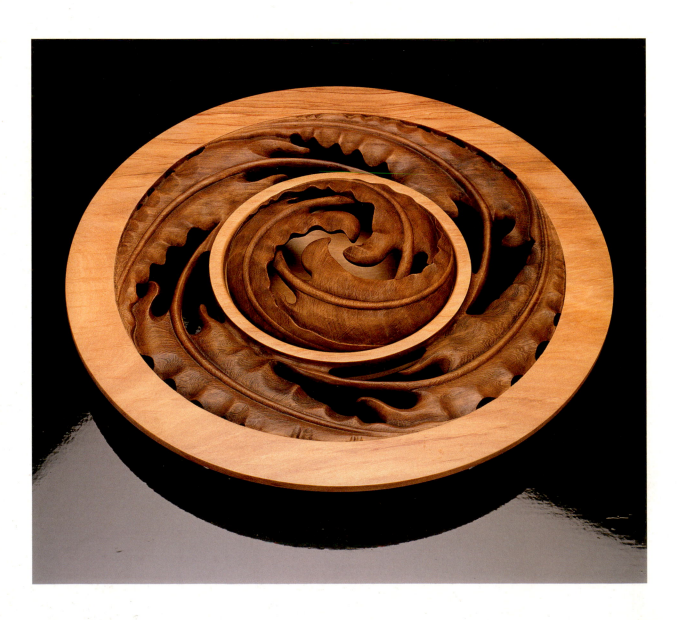

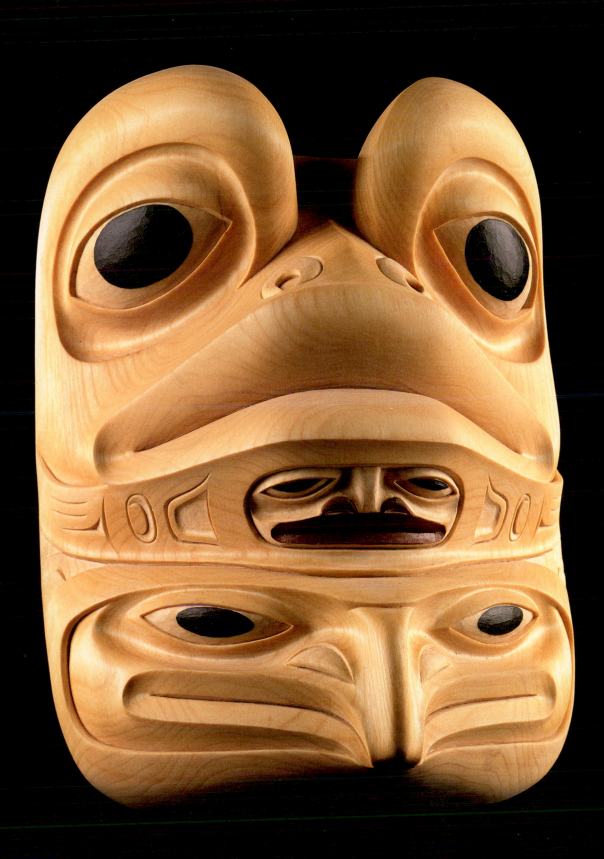

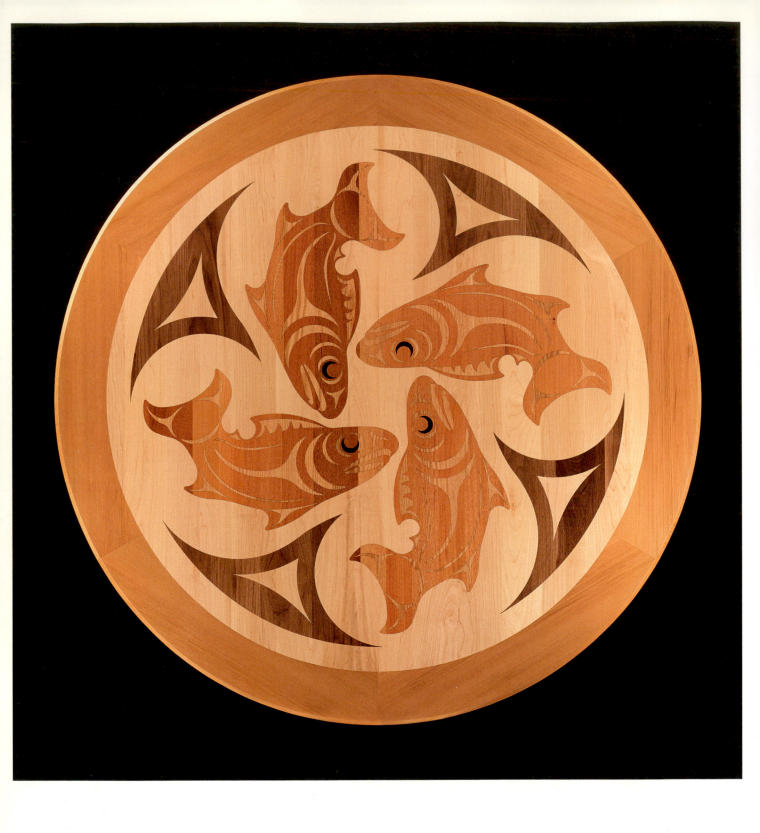

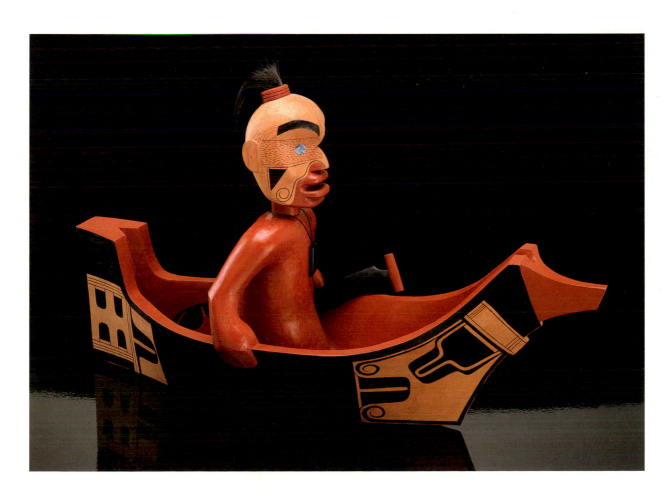

36 **Black Magic Amulet**
Preston Singletary
blown and etched glass
11½ × 23½ × 3¼ inches
(excl. stand)

Black Magic Amulet
pays homage to the story of
NatsílAne', who acquired
the Killerwhale crest for the
DAqL!awe'dí, the Tlinglit.

Because NatsílAne' was
constantly quarrelling with
his wife, his brothers-in-law
decided to take him to an
isolated island and leave him
there. While marooned on the
island, NatsílAne' passed the
time by creating carvings of
killer whales from yellow cedar.

Facing page:

37 **Nanasimigit Halibut**
Hook Sculpture
Christian White
argillite, mastodon ivory,
catlinite, abalone, jade
10 × 8½ × 1½ inches

This sculpture is based on
the elaborately carved halibut
hooks of the Haida. As I carved
the hook, I could see a killer
whale shape in the stone—the
story depicts Nanasimigit
rescuing his wife from the killer
whale chief. The killer whale's
son is the sea otter.

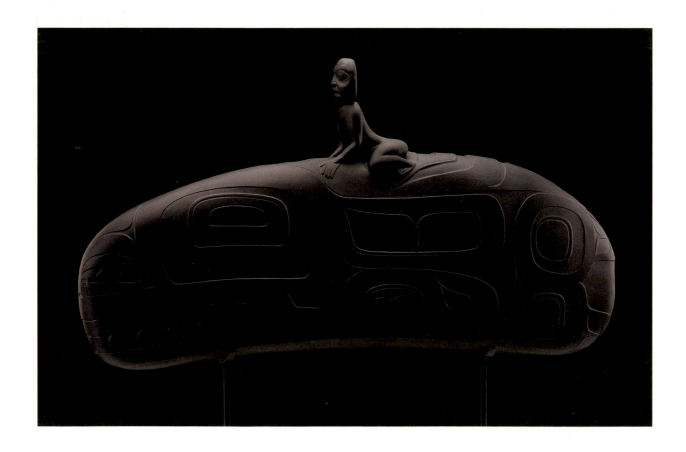

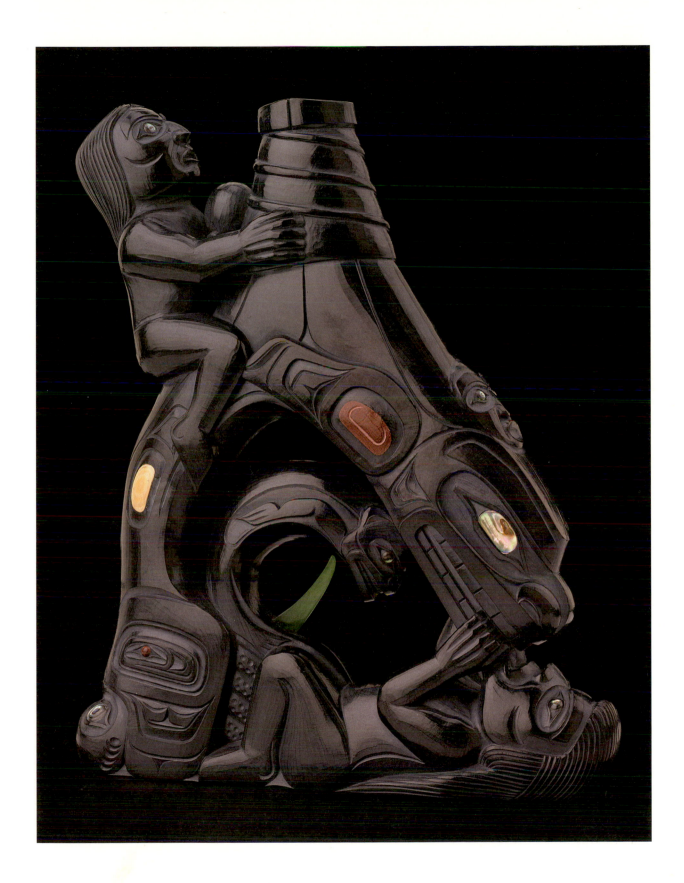

38 Shark Fin Mask

Dempsey Bob

alder

13 × 8 × 4 inches

*The Shark is an important crest
in both Maori and Northwest
Coast cultures; we share the same
deep respect for this fish. The
Shark is part of the Eagle clan
and is one of the main crests of
the northern Tlingit.*

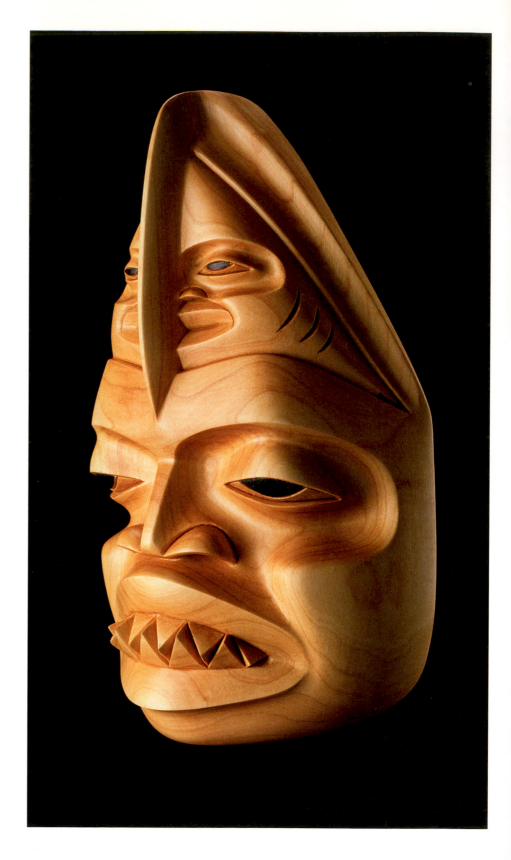

21

22

{21} **Pokopoko Te Tanihwa** · MANOS NATHAN
{22} **Rangiriri Te Hautupua IV** · MANOS NATHAN

These ceramics are interpretations of two famous *taniwha* (water spirits) that inhabit the northern Wairoa River on the North Island of New Zealand. Pokopoko is the great *taniwha* of the southern end of the river where its waters flow into Kaipara Harbour, whereas Rangiriri is the renowned *taniwha* that resides in the upper reaches of the river just south of my home, Tunatahi (Dargaville).

Taniwha inhabit our oceans, lakes and rivers and are guardians of the tribe. All tribes have *taniwha;* some arrived in Aotearoa with the migratory *waka* (canoe) as guides and protectors of the deep-sea mariners. Many stories tell of their involvement with creating or modifying features in our landscape, such as harbours, channels to the sea and islands; they usually live in waters with strong currents, dangerous breaking waves, deep pools and turbulent sections in rivers. Our stories regarding *taniwha* are often prescriptions for correct behaviour, though they can also be very amusing and bawdy at times. In certain respects, *taniwha* are similar to dragons in the European tradition—nasty, capricious and malevolent creatures at one end of the scale and, at the other end, much more benign and helpful beings—often, however, somewhat mischievous. Chiefs and people of exceptional ability and achievement are honoured to this day by being referred to as *taniwha* in oratory on our *marae* (gathering places).

Our oral traditions speak of Pokopoko as a *taniwha* with a legion of lesser *taniwha* under his command that could be recognized by the *kokowai* (red ochre) markings he placed on their backs. Traditions also have it that he is the ancestor Pokopoko Herehere Taniwha (Pokopoko the Water Spirit Binder), who subdued *taniwha* throughout his life and who, once he died and was given up to the waters of the Kaipara, became a *taniwha* himself. He is celebrated in a number of *whakatauki* (proverbs) of the Uri o Hau and Ngati Whatua tribes. The name "Pokopoko whiti te Ra" (Pokopoko Who Causes the Sun to Shine) alludes to Pokopoko as a peacemaker, a reference to his forging of lasting alliances, and *Nga uri o Pokopoko whiti te Ra te aute te whawhea* ("the descendants of Pokopoko are like the aute [paper mulberry] tree, not to be shaken") refers to Pokopoko's reputation for chivalrous tactics in battle and for his commitment to peace once made.

Rangiriri is a guardian who warns of impending danger or disaster. When our *tupuna* (ancestors) migrated from the far north to occupy the Wairoa River region, they sent their *tohunga* (experts adept in the occult arts) back north to "fetch" Rangiriri. He was bound to the river just south of Tunatahi. Rangiriri has the ability to manifest as a *rakau tipua* (sentient log), taking the form of a large log or tree that roams the river against the strong currents and tides. *Hautupua* translates variously as fearsome, remarkable, sea deity and water monster. My interpretation of "Rangiriri Te Hautupua" is "Rangiriri the Remarkable."

23 24 25 26

{23} Kete—Te Hera Waka o Tainui (The Sails of the Tainui Canoe) · CHRISTINA HURIHIA WIRIHANA

Kete (baskets) were made and used in many varied ways, with the weaver having the freedom to choose from various natural materials available to us throughout Aotearoa.

When gathering the materials for weaving, we must adhere to cultural practices such as ensuring that the conservation and preservation of the resource is respected. Also important is acknowledging Ranginui (Sky Father) and Papatuanuku (Earth Mother) for nurturing the natural materials that enable the weaver to foster the beautiful art form of our *tupuna* (ancestors).

Two of my *kete* forms have been woven using *kiekie* (a climbing plant) fibres found growing in our *ngahere* (native bush) of Aotearoa. The long, swordlike leaves of the *kiekie* droop down from the heights of the trees, which sometimes makes for very easy harvesting. Of course, some leaves are totally out of reach, and the gatherer is encouraged to leave these for Tane Mahuta, God of the Forests. The *kiekie* that grows on the ground has ideal leaves: they are spotless and produce quality fibres that, once prepared, continue to whiten when handled during the weaving process.

I use *harakeke* (flax) for the handles of my vessel forms. This plant provides just one of the many natural fibres readily available to weavers in Aotearoa and comes in a number of varieties, each of which has its own properties. The fibres are extracted from the green leaves of the *harakeke*, exposing a fine, hairlike fibre known as *muka*. This silky white fibre is braided to create soft handles. We still use the traditional technique of our *tupuna*, the use of a humble *kuku* (mussel) shell, to extract the *muka*.

I have created intricate designs that allude to events in Maori history or that reference tribal patterns in the *iwi* (tribe), *whanau* (family) and *hapu* (clan) styles. These patterns I use are not new—I simply take elements of a traditional pattern and apply them within a contemporary context, ensuring that I continuously acknowledge my *tupuna*. *Te Hera Waka o Tainui (The Sails of the Tainui Canoe)* is one example. This design makes reference to my tribal affiliation and the respect I hold for the Tainui people on my mother and father's side of the family, as well as for my late husband.

{24} Ipu Ika (Fish Vessel) · COLLEEN WAATA URLICH

A vessel is a vessel in any context, but the use for which it was designed, the ceremonial or cultural context in which it was created, gives it a particular distinction. Customarily, clay had a specific genealogy, and it is to this knowledge, ceremonial and traditional use that contemporary Maori clay workers have returned to give validity to a new art form within a traditionally non-ceramic culture.

This vessel was created as a reflection on the cultural similarities and traditional values that exist between Maori of Aotearoa, other Polynesian peoples and the First Nations peoples of the Northwest Coast of the Americas—a connecting heartbeat. A genetic imprint determines who is Polynesian, who is Maori. We are many cultures, but through our genetic links we are one people of the *waka* (canoes), intrepid sailors and master navigators, Polynesian peoples who spanned the vast reaches of Te Moananui a Kiwa (the Pacific Ocean). That connectiveness between Maori and other Polynesian peoples is highlighted in this vessel through the use of applied pattern, the individual motifs of which appear in women's fibre arts throughout the Pacific. More than 4,000 years ago, ancient Lapita potters in the Pacific placed impressed design motifs on clay vessels, designs that evolved into distinctive patterns used in weaving, woodcarving, tapa cloth and *tatau* (tattooing) throughout the Pacific. In Aotearoa, those adapted motifs found their highest form of expression in the woven borders of beautiful feather and plain cloaks created by master weavers. On this vessel, those ancient Pacific motifs are reapplied but in painted form to the original body of clay, as used by ancient Lapita potters.

Maori and First Nations peoples of the Northwest Coast share the same values of hospitality, reciprocity, personal and tribal *mana* (power). The fish in this vessel, depicted on an *ahi matiti*, or spit, symbolizes preparation for hosting and our common reliance on fish as a customary food source. The fish becomes an icon representing the Northwest Coast peoples and their salmon and customary Maori methods of spit cooking, and preserving fish and birds in their own fats inside an ornately carved and decorated *hue* (gourd or calabash), later to be offered as chiefly gifts. In this context, *manawa* (the heart, or heartbeat) becomes *whakamanawa*, which indicates blessing and honouring, and is further symbolized by the use of copper, in honour of our First Nations brothers and sisters.

{25} "Whiria Te Kaha..." · LEWIS GARDINER

"Whiria Te Kaha Tuatinitini Whiria Te Kaha Tuamanomano"

"The strands of *whakapapa* need to be woven so the identity can be strong."

The *tiheru* (canoe bailer) is a link to the great navigators. When stating one's *whakapapa* (genealogy), the *waka* (canoe) is an important tie to the *tupuna* (ancestors). It is from this point that many individual threads are joined to make our people and culture strong.

{26} Niho Taniwha (Shark's Teeth) · BAYE RIDDELL

Niho taniwha literally translated means "teeth of the monster." A spirit being that inhabits the sea or inland waters, the *taniwha* referred to something awesome; it could be responsible for disastrous events such as drowning or for more benevolent actions such as guiding *waka*

(canoes), rescuing people, appearing as a good sign or omen or guarding fishing grounds. It manifested in many forms, including as large sharks.

These pieces are based on the shark's tooth. Sharks were respected for their fighting ability and likened to warriors. Warriors were also likened to sharks, as in this saying relating to defiance and bravery:

Kei mate I te tarakihi koe, engari kia mate I te ururoa.

Do not die like the *tarakihi*, but rather like the shark.

The *tarakihi* is a fish that does not put up a fight when caught, whereas the shark fights to the very end. Many a careless person has been injured by a shark they thought was dead. The figures on the pieces are portrayed as warriors in various stances of the *haka*, a ritualized challenge, or war dance. The pieces are made from red clay dug from my family land. Red clay has a sacred significance and was often mixed with shark oil and used in ritual practice—for example, it was smeared over the faces of warriors before battle.

In 1840, the Treaty of Waitangi was signed between Maori and the English Crown establishing a basis for mutual habitation of Aotearoa. Among other things the treaty guaranteed Maori continued control of their lands, forests and fisheries. Since then Maori have seen and battled against a continual series of policies and Acts of Parliament designed to seize control of Maori resources. In 2004, despite huge protest, Maori saw the passage of the Foreshore and Seabed Act, which vested control of the foreshore and seabed in the Crown. This legislation by the New Zealand government drew criticism from the United Nations.

This series of *niho taniwha* is a response to what I see as yet another immoral if not illegal act of plunder by the New Zealand government on the Maori people. The struggle goes on—yet we can draw inspiration from the *whakatauki* (proverbs) and continue the fight not only for our rights as Maori under the Treaty of Waitangi but also for our human rights as an indigenous people.

Kia kaha
Kia manawa—nui

(We must) Be strong
Be courageous

{27} **Hei Tiki** · RANGI KIPA

The *hei tiki* is the most iconic of Maori adornment forms. The *tiki* (carved figure) probably has its genesis with "Tiki Ahua," an ancient Maori narrative that explains the creation of

27 28 29 30

the first man. It is said to represent the stylized human form *in utero*. The woven rope, or *aho*, from which the *tiki* is suspended is expected to have as much work and *mana* (power) as the item to which it is attached, as it symbolizes the woven generations between the wearer and the ancient progenitor Tiki himself.

In this piece, however, the *tiki* is made from a new space-age composite material and it makes a bold statement about Maori expressing their identity in the new millennium.

{28} Nguru (Nose Flute) · RANGI KIPA

The *nguru* is a Maori musical instrument predominantly played with the nose, although it can also be played with the mouth.

Maori music, much like a good orator, can carry people across time and space, recalling tunes and sounds that connect people emotionally to events and occasions of times long gone and to loved ones who also have passed on. This is the role of the Maori musician, to join the *ha* (breath) of humankind to vessels and instruments fashioned from Tane, Tangaroa, Hine Puu te Hue and other personifications of our environment, not to entertain but to embellish and elocute the *kaupapa*, or issue at hand in the community. The shape of this stylized sperm whale *nguru* reflects its origin from *niho parava* (whale's tooth).

{29} Whakamutunga (Metamorphosis) · FRED GRAHAM

The whale is a frequent traveller between the Northern and Southern Hemispheres. In my sculpture, as the whale crosses the equator it changes both in shape and in body design, from Northwest Coast Indian to Maori. Day changes to night.

The visits of the whales "down under" remind me of the visits of Northwest Coast Indian artists to Aotearoa, where they become one of us: *tangata whenua*—people of the land.

In 1992, George David stayed with my wife, Norma, and me. Earlier this year, his brother Joe David stayed with us for a few days. He drew the Northwest Coast design for me, and I hope my sculpture does his drawing justice.

{30} Taki Toru (triptych) · SANDY ADSETT

Taki toru means a lashing/tying in threes. The images depict a legend of Paikea, an ancestral sea voyager to Aotearoa, "Land of the Long White Cloud." Paikea was sent a message in the form of directional lashings wrapped around a gourd and cast into the sea by people in his distant homeland. These messages still have absolute relevance to our "Manawa" journey today. First, was the journey a safe one? Second, is there sustenance in the new land? And third, are you multiplying in numbers and in strength?

31 32 33 34

{31} **Hinaki** · ROBERT JAHNKE

Hinaki grew out of a concept proposal for a waterfront project for the city of Auckland in 2001. Ultimately, the project was never realized. Originally conceived as a nine-metre-high (thirty-foot-high) structure under which one could walk to peer into the internal vortex, *Hinaki* (Eel Trap) was to be complemented by an ascending series of *taruke* (lobster traps) set obliquely on their sides, the largest to have been at two metres (seven feet) in height. The concept proposal appeared for the first time at the Bath Street Gallery in Auckland—in a drastically rearranged configuration and at maquette scale—alongside a set of twelve stamp works. *New Zealand Herald* arts writer T.J. McNamara wrote of *Hinaki:*

> These splendidly crafted works confirm Jahnke's status as an artist of formal excellence and deep commitment that goes beyond the polemic to have much wider significance... They are beautifully made objects of great formal beauty. They depict not just a trap for crustaceans but all things that have a narrow entrance to wider issues and, once again, they are closely linked to this land. Special importance is given to the way each of the three structures sinks deeper into the sand, suggesting the way an issue becomes lost in debate, discussion and time. (11 May 2005, B7)

Manawa is the heart, *rarangi manawa* is a line that carries the heartbeat, or a line of significance. In the latter sense it becomes a line of narration in which the concept of the *hinaki* has traversed time and, in the process, the utilitarian form of tradition has metamorphosed into "some 1950s vision of a rocket ship" invigorated by the polemic of entrapment and the aura of Maori sovereignty. The line of narration has been enriched by the words of others entrapped by *Hinaki* and its form that "goes beyond the polemic to have much wider significance" (ibid.).

In this last flight of fantasy, the "rocket" begins a new course of navigation across Te Moananui a Kiwa (the Pacific Ocean), and the *rarangi manawa* will no doubt be invigorated once again amid the art of two nations at the Spirit Wrestler Gallery in Vancouver.

{32} **Lily Leaf Platter (with lid)** · KERRY KAPUA THOMPSON (TAMIHANA)

This platter was a challenge for me, as I was playing with the idea of interweaving lily leaves in an abstract circular form of the Path of Life.

{33} **Frog and Raven Warrior (with war visor)** · STAN BEVAN

I have made two trips to Aotearoa, with many more to come. I have also hosted a few Maori artists in my home territory and contributed to our shared exhibition "Kiwa—Pacific

Connections" in Vancouver. On my last trip to Aotearoa, I was honoured to be included in the opening ceremonies of a living-treasure exhibition, "The Eternal Thread." This gathering also included a carver's event in which we split into groups and created eight large sculptures within a week, based on the *haka* performance ritual.

We started early, stayed late, worked under blazing hot sun or in wind or rain—there was the non-stop buzz of chainsaws, dust, friendly banter and the collaboration of ideas and skills. Along with Dempsey Bob, Norman Jackson and many other talented people offering assistance, we created a two-metre (seven-foot) sculpture of a Tlingit warrior wearing a Frog war helmet.

The highlight of this event was being able to watch artists such as Manos Nathan, Darcy Nicholas, Wi Taepa and many other carvers create their sculptures. Another experience was being able to see two young carvers, Tamati Holmes and Shannon Wafer, whom we had met and worked with two years earlier and who had since gone on to take formal training in the arts and were creating a sculpture of their own. It was a whirlwind event, and I enjoyed the talents and company of everyone involved.

For this project, I wanted to do an extension of Frog wearing a war visor in the image of Raven—the same design as the pole that is now raised in Aotearoa. Frog is the liaison between two worlds, such as the deep forest and the human world. Raven is a carrier and communicator of knowledge—in this case, the two worlds are an ocean apart. The Frog and the Raven are crests that carry the history of the clan. We have protocols that we carry when we travel, and these are presented to the host nation. We met their representative to determine how these protocols will be carried out on their soil. Raven is both a crest and a symbol of eternity and the movement of people, objects and spirit across distances.

{34} **Pacific Wealth (table or wall panel)** · SUSAN POINT, RCA

In First Nations tradition the salmon, once so abundant off the west coast, is believed to be the giver of life. Salmon in the central Coast Salish tradition are usually depicted in pairs, which is also a symbol of good luck. The salmon is an indicator of wealth and an important symbol at the heart of Salish existence, as it is used as a food source and for bartering. I felt that the salmon was an ideal motif for "Manawa—Pacific Heartbeat," because the piece honours the central role of the salmon in West Coast existence and celebrates the connection between all living beings—the ties to the Pacific Rim and the weaving of different woods imply the beauty of blending things together.

The reflection of four also runs through much of my work. It carries many important meanings for all aboriginal peoples: there are four seasons, four winds, four elements (earth, fire, water and air), four connections between all living beings.

I was inspired to work with the laser-cutting marquetry technique after creating a public art piece for the Natural Resource Building in Olympia, Washington (1992), using laser-cut stainless steel. I have continued to experiment with the technique several times using metal, and I created my first laser-cut piece in wood (a puzzle woodblock used to create the *Sacred Weave* print) for the "Kiwa" show at the Spirit Wrestler Gallery in 2003. Laser cutting presents several challenges when creating a puzzle-style piece; each piece of wood must fit together exactly to create a unified whole, which means changing the scale and continuously adjusting the proportions of the cut.

{35} **Been There—Done That** · JOE DAVID

This canoe sculpture represents my flesh and my spirit adventures through play and duty across land, sea and air, in and out of ancient worlds coded in my blood and new worlds mapped in my dreams and visions.

My first visit to Aotearoa twenty-three years ago lasted a long eight months, and towards the end of my stay my paternal grandmother visited me in a dream. In it, I happened onto her in the dark back room of an old house, where she sat, blind, in the cool, musty shadows of my memory. She was singing a song to me, "Where are you our son, where have you gone?" And cradled across her lap was a beautifully carved and painted canoe paddle, which I took to symbolize a map, a means to return home.

It was my grandmother who prophesied when I was born that I was going to be a great artist, and that during my lifetime the world was going to transform and overpopulate with many strange things and people. She also said I would be an adventurer, travelling to many faraway places where I would meet and share with others of like minds and spirits. I would be away a lot, but I would always return to my family and my people, my birthplace and the birthplace of my art.

My sculpture represents Qwat-yaht, a superhero of my people who has supernatural knowledge and power. In the carving, he and his supernatural canoe are one and the same, joyfully flying in, out and through one adventure after another, transforming himself and all around him at will to suit his play and work. He is timeless, and at any given moment he could be you or me or a rock—his example and adventure are boundless, as life should be.

With joy and humility I am able to recognize when Qwat-yaht and I overlap, and I also recognize him in others in this great adventure prophesied by my grandmother. It is with great joy that I see Qwat-yaht also in my beloved Maori friends.

35 36 37 38

{36} **Black Magic Amulet** · PRESTON SINGLETARY

Black Magic Amulet pays homage to the story of NatsîlAne', who acquired the Killerwhale crest for the DAqL!awe'dî, the Tlinglit.

Because NatsîlAne' was constantly quarrelling with his wife, his brothers-in-law decided to take him to an isolated island and leave him there. While marooned on the island, NatsîlAne' passed the time by creating carvings of killer whales from yellow cedar. He put his carvings into the water and tried to put his clan's spirit in them as he had seen shamans do. After several tries, he magically transformed his sculptures into actual killer whales that swam out into the ocean. When they came back to the beach, they magically transformed back into wood.

One day, NatsîlAne' attached a rope to the dorsal fins of the whales and went out to sea with them. He directed them to where his brothers-in-law were paddling their canoe and ordered them to smash the canoe and kill the men. After he had taken his revenge, NatsîlAne' ordered the whales not to harm humans. Since that time, killer whales have served men by carrying the spirits of their dead into the afterlife.

{37} **Nanasimigit Halibut Hook Sculpture** · CHRISTIAN WHITE

This sculpture is based on the elaborately carved halibut hooks of the Haida. As I carved the hook, I could see a killer whale shape in the stone—the story depicts Nanasimigit rescuing his wife from the killer whale chief. The killer whale's son is the sea otter.

A hunter kills a white sea otter. He takes it back to his wife to clean. As she is washing it at the edge of the sea, a killer whale carries her away. The hunter tracks them, taking along medicine, materials and tools that he uses to help others on his journey. His mission to find his wife takes him on a trail along the bottom of the sea, but he eventually rescues his wife with the help of those he has befriended on the journey. He takes his wife back to his town, but she is now a stranger to him, and shortly thereafter she disappears again—killer whale fins are seen in the distance.

{38} **Shark Fin Mask** · DEMPSEY BOB

The Shark is an important crest in both Maori and Northwest Coast cultures; we share the same deep respect for this fish. The Shark is part of the Eagle clan and is one of the main crests of the northern Tlingit.

I have made four trips to New Zealand over the past four years. After the first trip, I felt a connection to the people and the country. I felt a sense of belonging with the similarities

between our cultures. When you travel, it allows you to step outside your culture and see it from a different perspective. It makes you take a closer look at your own culture and your people. I felt a connection to the land and to the Maori culture through the lines in their work; they are similar to our forms and shapes, but they hold different meanings. The flat design and sculpture have many similarities; it is the feeling of the people, the feeling of identity and the feeling of strength.

In the 1960s and '70s, art and culture were revitalized within both Maori and Northwest Coast cultures. In the late '60s, art began to assume a major role in my life because I was working with Haida artist and mentor Freda Diesing; it was with her that many of the older artists of today began their journey. We all owe her a great debt.

When I was at The Return to the Swing gathering at Evergreen State College in Olympia, Washington, I noticed a change in how our sense of the art was being developed through contact with other artists and cultures. Maori, as well as Northwest Coast artists, began sharing more cultural ideas. I think this group has become the core group of international indigenous artists from the Pacific Rim. Art can't be separated from the land or the people that it comes from. The stories and histories of indigenous people always show through in our art and reflect the people who made it.

Totara is a great medium to work in. It's the Maori equivalent of alder, or cedar. I've carved some small pieces in totara as well as two major pieces as part of a group effort. The big ones were for public collections in outdoor venues. They were made in intensely short periods of time, usually in full public view.

Over the years, personal friendships have developed between myself and Sandy Adsett, Colleen Waata Urlich, the Nathan brothers (Alex and Manos), Darcy Nicholas and June Northcroft Grant. We share the great struggle of being artists. Always, we strive to be on the edge with the changing stages of our lives and our views on making art.

Our art requires both cultural understanding as well as the technical skill. Maori have the same feeling for their art. One of our great connections is the feeling for our individual histories, the land and our stories that connect us to the land. We lift each other's spirits, because it is a lonely struggle to be working totally by oneself. Our minds have to come to terms with all the aspects of the art. Good artists must always be learning, and that's what I see in these friends of mine. We are always learning our art, and so we are always learning about ourselves. Northwest Coast and Maori art will continue to get better, as we have already built a strong foundation. Quality, integrity, determination and the beliefs of the people involved make art what it is.

Great art cannot be forced; it just flows through you into your work. It lifts everything up around you. The integrity of the artists comes through in the integrity of the art.

PAPAWHENUA

HEARTLANDS

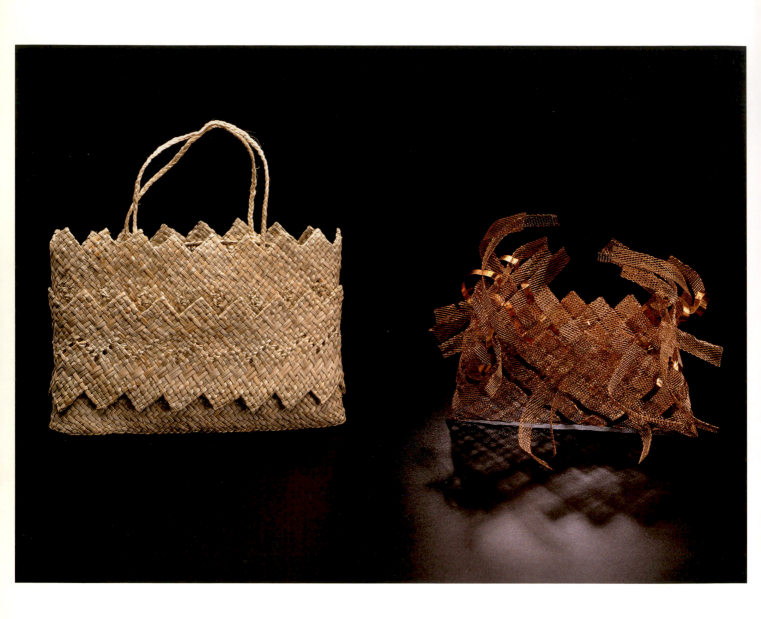

The ability to explore and challenge the boundaries of the woven process using a range of materials allows me to move away from the customary processes without removing myself from the customs with which I am associated. My weaving practice acknowledges tupuna *(ancestors) who have paved a creative* huarahi *(pathway).*

41 **Gleanings**
Hepi Maxwell
New Zealand
flower jade and rimu wood
9 × 6 × 2 inches

The kete kai *(food basket) is created with a well-balanced, open weave that looks aesthetically pleasing and allows the gathered food to be seen. When humans succeed in weaving a perfect, harmonious balance between themselves and their environment, then they have achieved something to be truly proud of.*

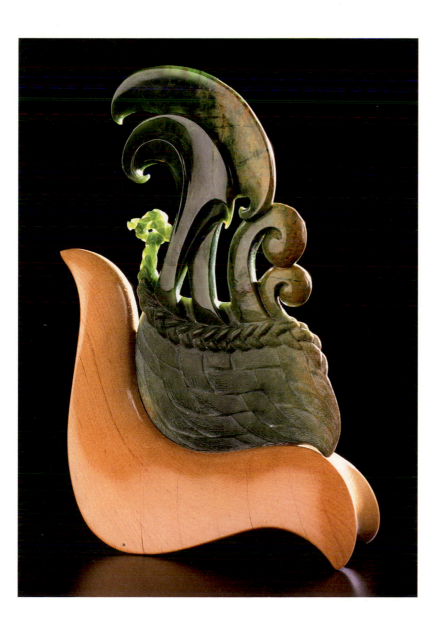

42 **He Aho V**
Gabrielle Belz
acrylic on canvas
36 x 40 inches

Aho *in translation has*
several meanings: string, line,
woof—cross threads of a mat
and genealogy—the line of
descent. Aho tanuhu *means the*
first weft, or widthwise piece, in
a woven cloak. In this painting,
the reference to the cloak and
the genealogy relate to the land.
Like many, the love of the land
moves the centre of my being . . .

Facing page:
(front & back views)
43 **Pouihi**
Simon Lardelli
totara with abalone shell
and whalebone inlay
126 × 16 × 4 inches (excl. base)

Pouihi *means "inspired pillar."*
There are three components to
this carving: the past, present
and future. The overall form of
this carving depicts the Maori
weapon called a kotiate, *which*
was used by chiefs in hand-to-
hand combat and was also
carried as a decorative element
for ceremonies.

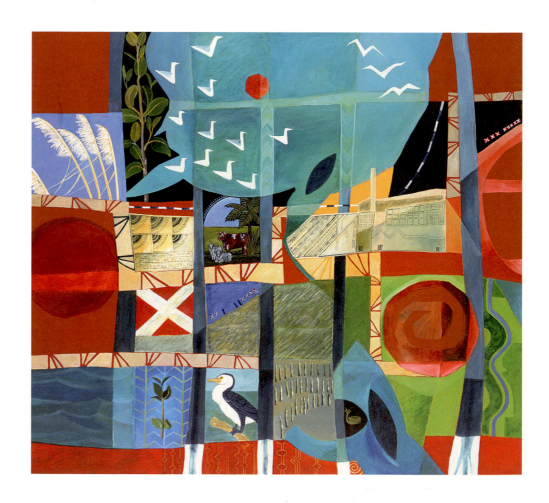

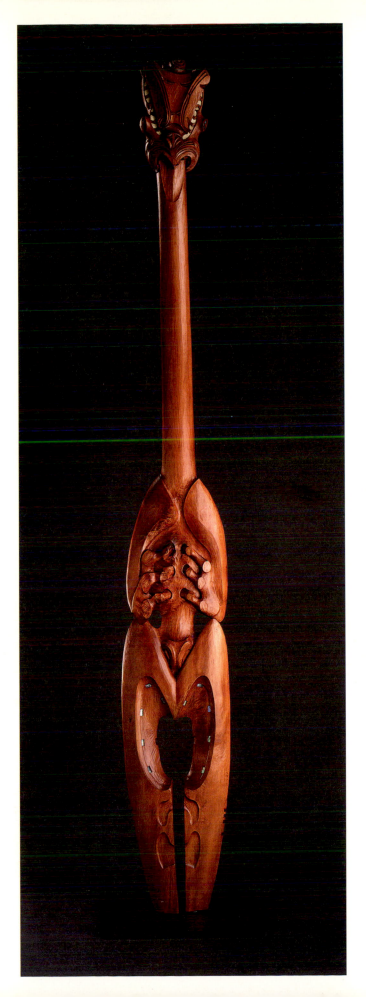

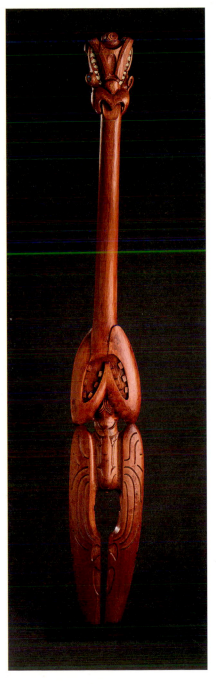

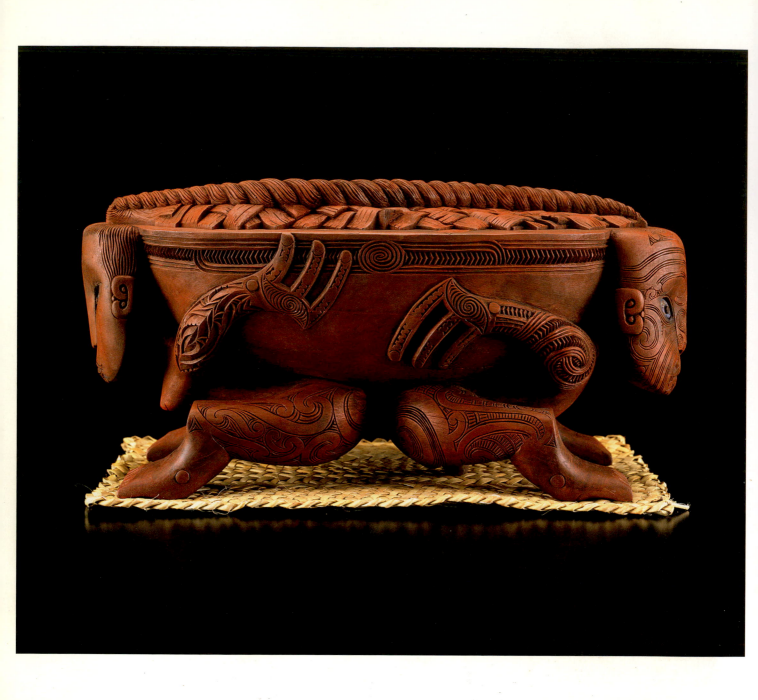

Facing page:

44 **Paepae Taputapu
(Container for Tools)**
Riki Manuel
totara with abalone
shell inlay and flax mat
9½ x 18 x 9 inches

*This particular carving depicts
Niwareka, who brought weaving
from the underworld to Maori,
and Mataora, who brought* moko
*(tattoo)... Although it isn't
common practice, I incorporate
weaving and* moko *designs in
my carvings. I see carving and
weaving as a continuous tradition
of arts that work in partnership,
as witnessed by their presence on
the* marae *(gathering place).*

45 **"He Taonga Tuku Iho"**
Lewis Gardiner
New Zealand jade, Siberian
jade, pukeko (swamp hen)
feathers and flax fibres
14 × 17 × 2 inches (excl. base)

The toki pou tangata *is an
adze that establishes who is in
authority. The adze of authority
is one's internal thread, one's*
whakapapa. *It is by passing
this* taonga *(gift) from one
generation to the next that it
will become the* manawa *of the*
whanau, *the heart of the family.*

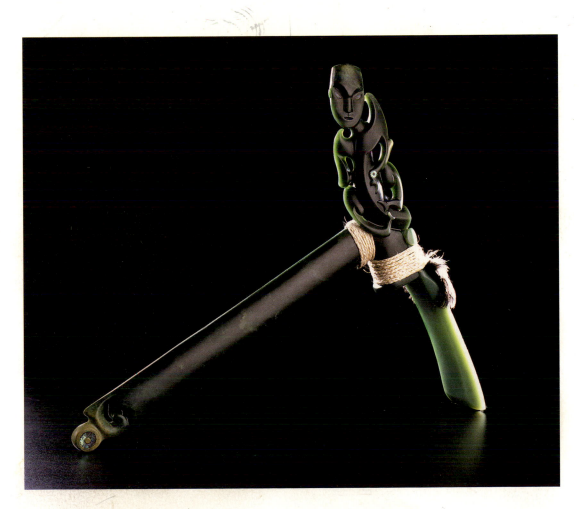

46 **Hine-nui-i-te-po**

(Ancestress of Night)

June Northcroft Grant

acrylic on canvas

40 × 30 inches

This goddess was the daughter of the god Tane and Hine-ahu-one, the earth-formed maiden. Amid the chaos of the relationships of the founding gods, this goddess, Hinetitama, assumes a new name and retreats to Hades, the great darkness, and becomes the goddess of the underworld, Hine-nui-i-te-po.

Facing page:

47 **Tane Mahuta (A Celebration of the Creative Process)**

Roi Toia

kauri and totara and flax cloak

(cape woven by Atareta Marsh)

85 × 20 × 20 inches

Tane Mahuta (God of the Forests) oversees the fertility of the land, bird life and the great forests that once stretched from shoreline to shoreline. This sculpture depicts and personifies Tane Mahuta, whose resources are the raw materials of the creative process.

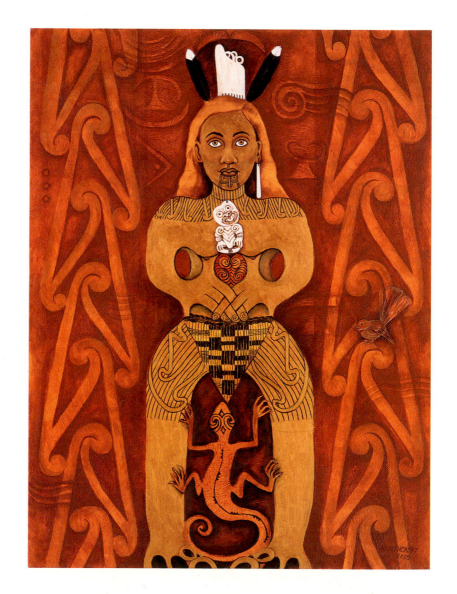

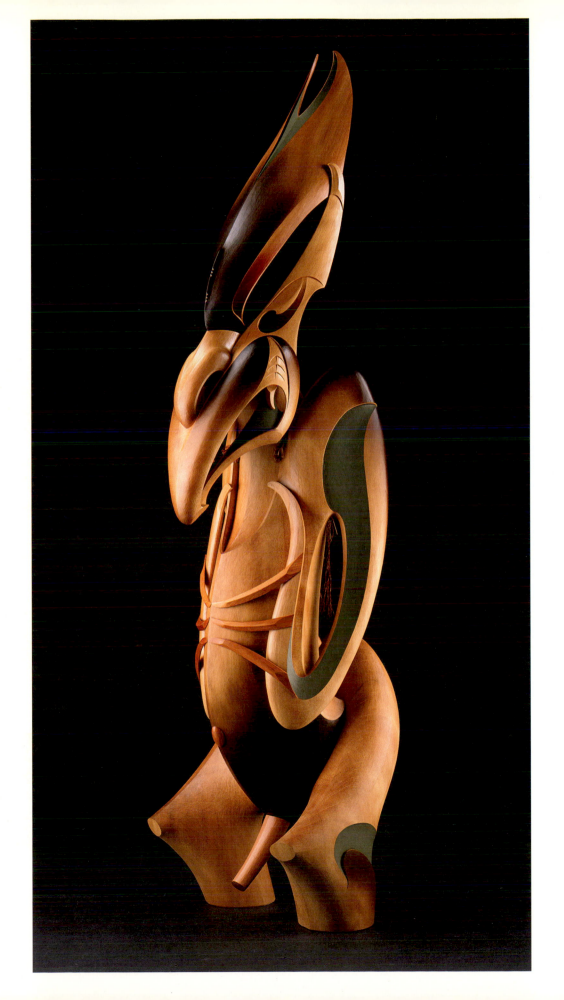

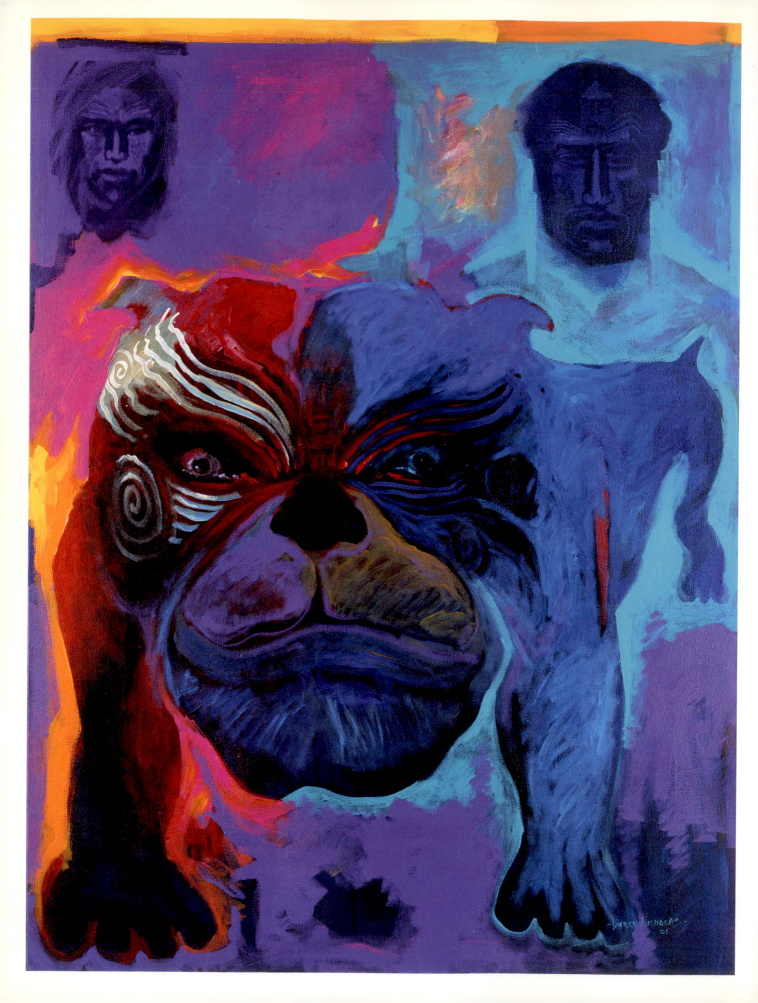

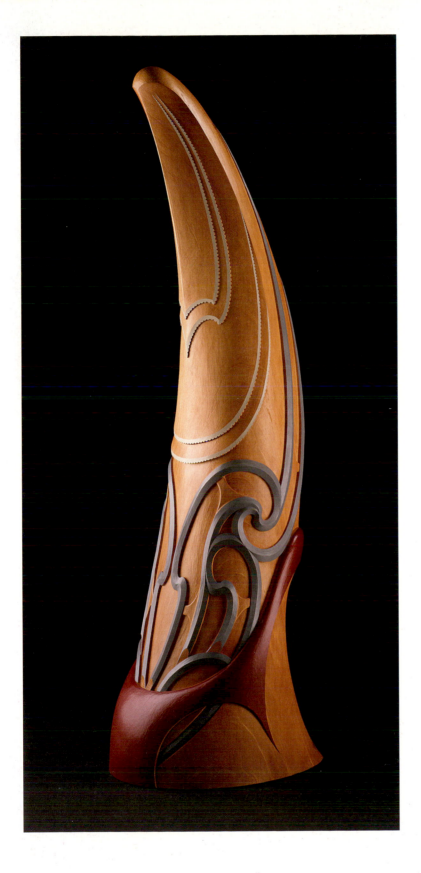

Facing page:

48 **Dog Warriors**
Darcy Nicholas
acrylic on canvas
48 × 36 inches

In 2004, I was travelling in Canada from Terrace to Prince Rupert with my Tahltan-Tlingit artist friends Dempsey Bob and Stan Bevan. We were surrounded by stunning stone mountains that were shrouded in mist, soft rain and snow . . . When I returned to New Zealand, I transformed the power and spirit of their land and painted Dog Warriors.

49 **Niho Rei Kuri/Dog Tooth (Symbol of Strength)**
Todd Couper
kauri
72 × 22 × 16 inches

This piece acknowledges the ancient art of weaving and the strength associated with that art form and its durable materials.

The kuri *(native dog) was originally brought to Aotearoa by our ancestors, but over time it became extinct. Dog skin was prized when it adorned cloaks* (kahu kuri) *because it has valuable qualities of strength and durability.*

50 **Kai Tangata—Land Warrior**
Darcy Nicholas
acrylic on macrocarpa wood
23 × 16 × 4 inches

Land is the foundation of our identity. This mask is shaped like a land mass, and the reverse side carries the tribal genealogy. Kai Tangata were fierce warriors and man-eaters; they protected their land with ferocious passion.

Facing page:
51 **Waitaiki**
Fayne Robinson
kopara wood and kauri,
jade and abalone inlay
47 × 14½ × 6 inches

Many different stories are told about the origin of pounamu *(New Zealand jade/greenstone). This account tells of a fish named Poutini that belonged to Ngahue, who lived in Hawaiki . . . Waitaiki is the female figure on the front of the adze, interwoven with the flesh of Poutini, her husband, the father of all the varieties of* pounamu.

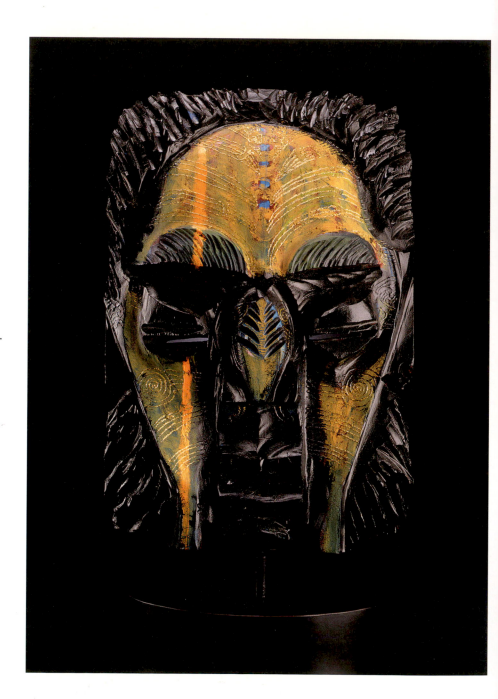

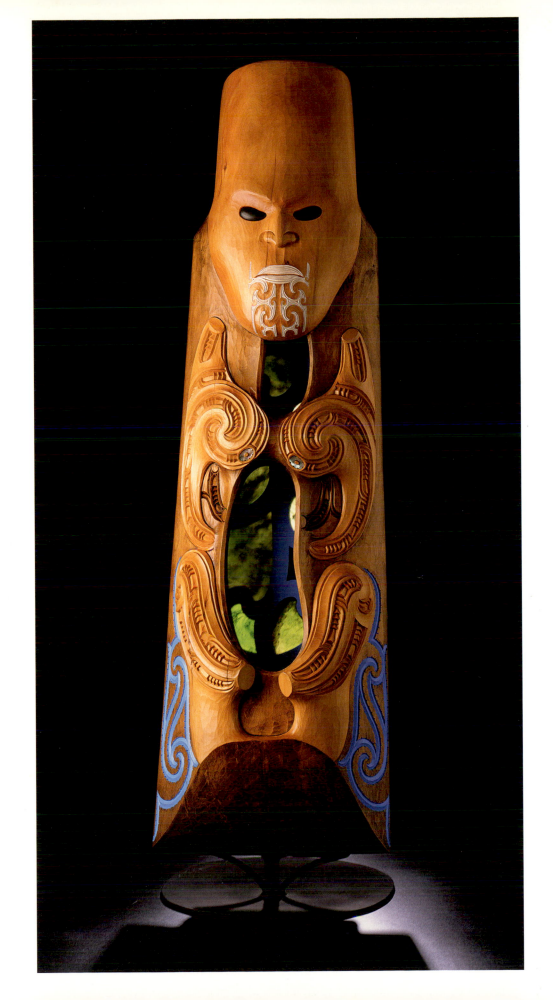

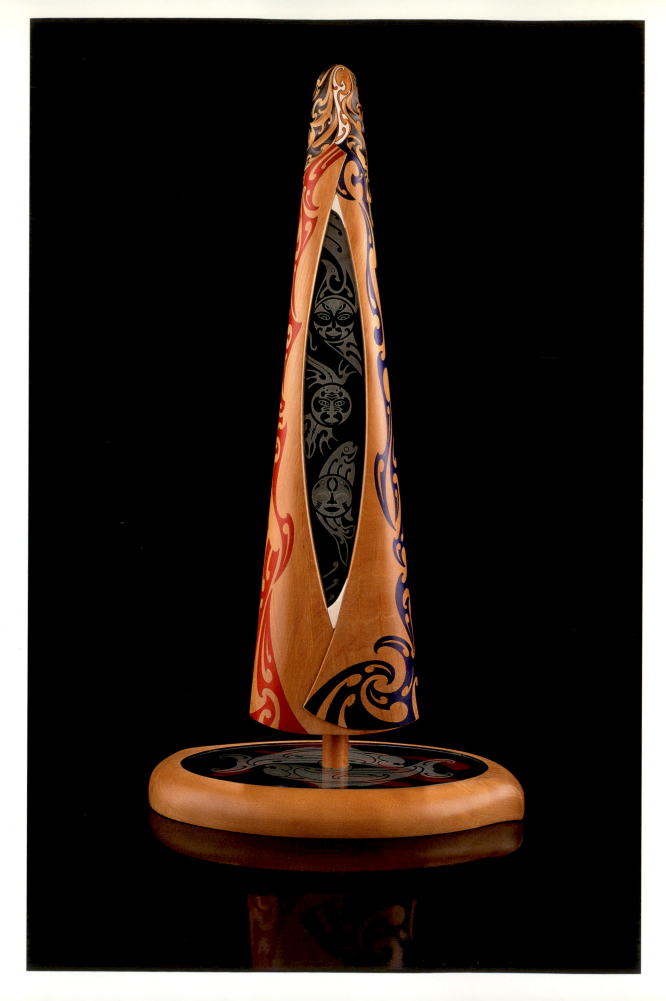

Facing page:

52 **Whakapapa (Generations)**
Kerry Kapua Thompson
(Tamihana)
kauri, sandblasted glass
and cattle bone inlay
40 × 19 × 13 inches (incl. base)

*This sculpture represents a man
and woman united to maintain
the continuations of* whakapapa
*(genealogy)—their faces, on
either side at the top, are
highlighted in bone. Both figures
are wearing cloaks honouring
the traditional* harakeke *(flax)
cloaks, though here they are
decorated with a painted design.*

53 **Tohu—A Folklore
of Mark Making**
Chris Bryant
Aalto Toi Maori paint and
teak oil on demolition timber
10 × 23 × 16, 6 × 9½ × 9½,
6 × 10 × 10 inches (3 pieces)

*This sculpture series pays
homage to Pine Taiapa not
only as a* tohunga whakairo
*(master woodcarver) pivotal
in the revival of customary
carving during the late 1920s
but also as a* matakite, *a seer
and storyteller. . . The series
also pays homage to Para
Matchitt as a founding artist
of the contemporary Maori art
movement that emerged during
the 1950s.*

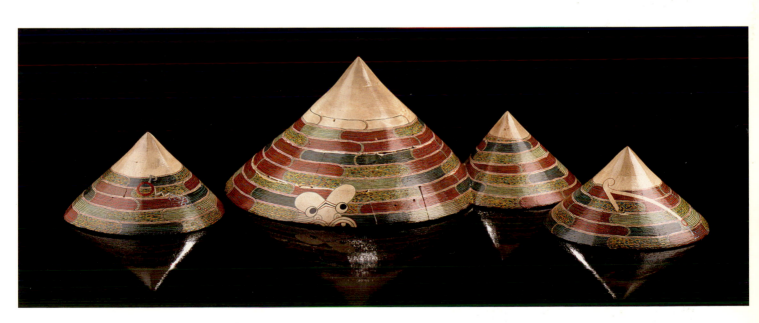

54 **Hamapu**
Paerau Corneal
clay and oxides
34 × 11 × 12 inches

Karanga *is the realm of women.*
Kai karanga *are senior women*
who are the first to be heard on the
marae (gathering place), *their*
voices elevated and mournful as
they call to the ancestors, call to
our living and call to those who
have passed away. The karanga
is a physical and spiritual act of
bringing the past to the present . . .

Facing page:

55 **Koiwi**
Lyonel Grant
totara on bronze base
85 × 12 × 15 inches,
80½ × 9 × 11 inches,
82½ × 10 × 9½ inches

These elegant forms reinforce
and reaffirm our links to our
ancestors. As each ancestral
koiwi (skeletal frame) *is*
returned to Papatuanuku (Earth
Mother), *so does our connection or*
relationship become even stronger
to the land in which they lie.

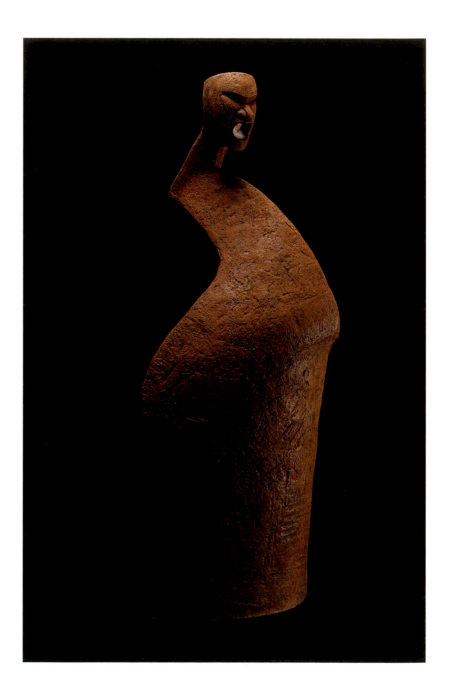

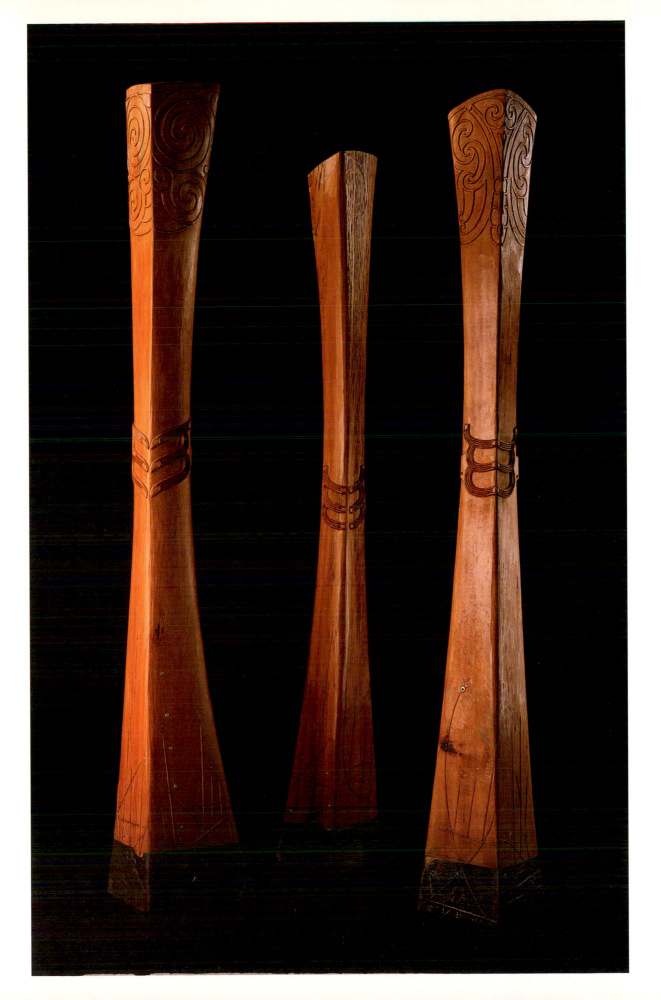

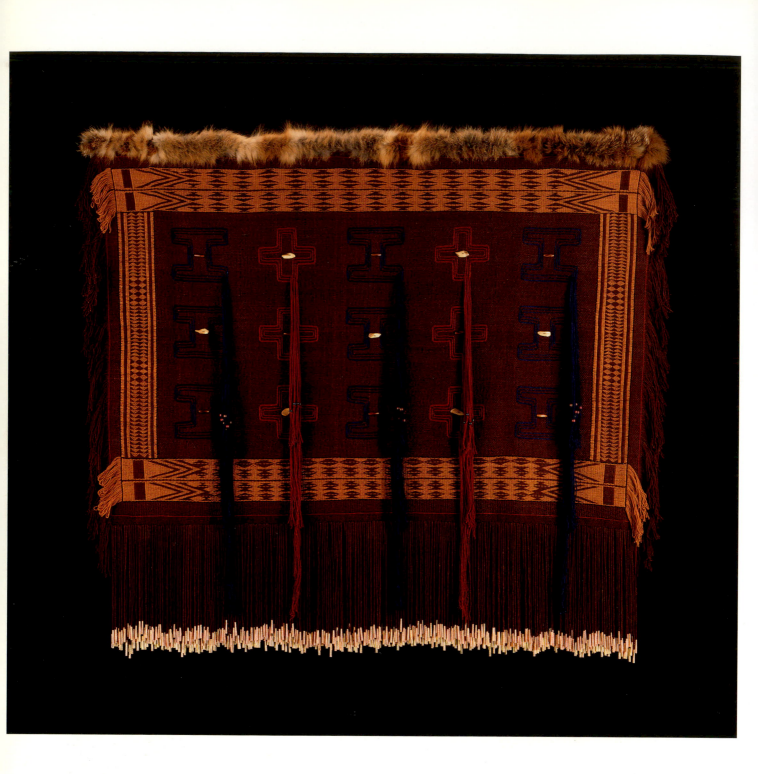

Facing page:

56 **The Basket Mother Robe**
Lani Hotch
merino wool, red fox fur, ivory,
antler, gold and silver cones
37½ with 13½-inch
fringes × 54 inches

*Several years ago, I conceived
of the idea to combine two great
traditions—Tlingit spruce-root
baskets and Ravenstail robes—
to showcase their relationship . . .
There is much overlap in design
between these two art forms,
and I am surprised that no one
has ever thought to do a robe
like this before.*

57 **Beaver Design Naxiin Apron**
Evelyn Vanderhoop
merino wool, beaver pelt,
yellow-cedar bark, deer hooves
18 with 8-inch fringes × 37 inches

*Beaver images were often
depicted on shaman para-
phernalia, as these objects or
designs were usually inspired
by visions of spirit helpers . . .
The female weavers had to be
specialists, transformers
twining wool and cedar-bark
fibre into adornments of power,
media of communication with
the supernatural realms.*

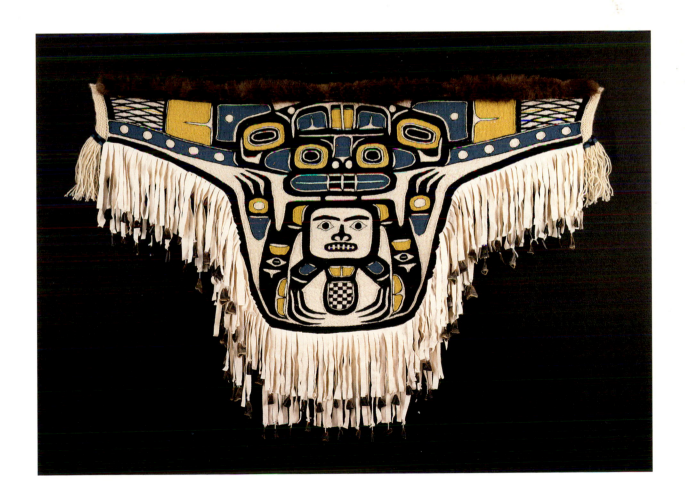

58 **Kete Remembered (feast dish)**
Cheryl Samuel
yellow cedar, thigh-spun warp: New
Zealand merino wool with cedar-
bark core, plaited yellow-cedar
strips, New Zealand abalone shell
buttons, glass beads, brass beads
6 × 18½-inch diameter

Kete Remembered *(feast dish)
has been woven in honour of the
Maori weavers who so graciously
hosted me in Aotearoa. The top
rim recalls the plait work of the
kete,* this time using yellow-
cedar bark from the Northwest
Coast. The paua *(New Zealand
abalone) shell decorations echo
the use of abalone on Tlingit
feast dishes . . . The bowl itself
represents the vast Pacific Ocean
and inside is nestled the island of
my birth,* Oahu.

Facing page:

59 **Naa-Na-Nig-Su
(Grandmother's Panel)**
Tim Paul, RCA
red cedar
18 × 13 × 10 inches

Naa-na-nig-su, *grandmothers
who have gone before us. The
spirits of our grandmothers in
our cultural teachings tell us that
we can call on them whenever we
need to, so that we can do and
say the right things at all times.
The four directions, the four
chiefs, are within nature; you
can ask nature for anything you
want and it will give it to you
for your family.*

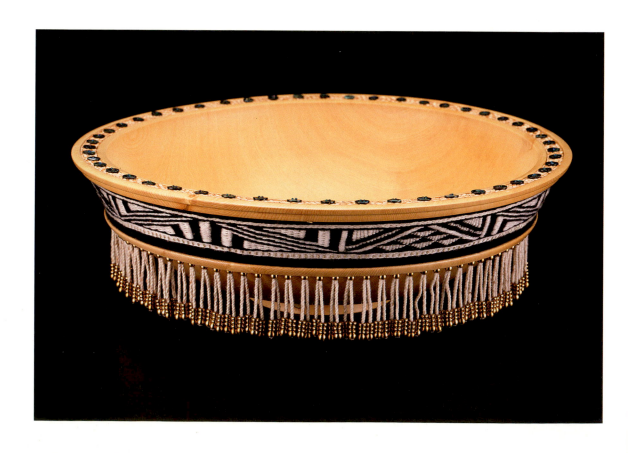

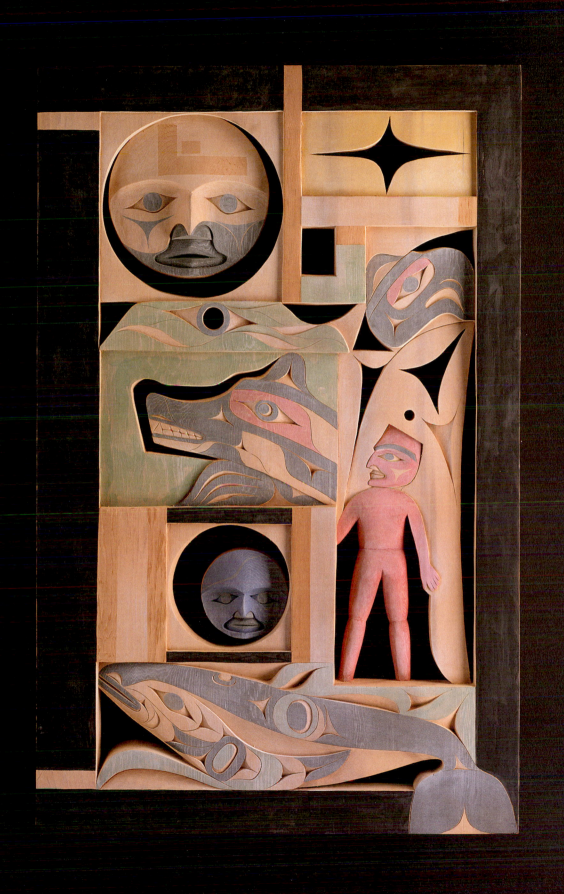

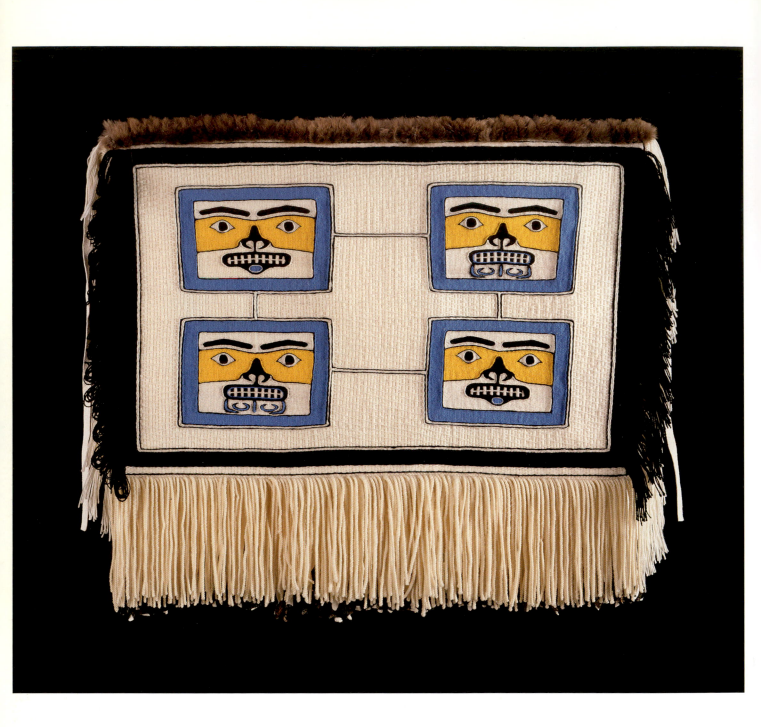

Facing page:

60 **Halaaydm Hanaa'nax (Women of Great Power) Apron**
William White
merino wool, beaver fur, deer hooves, deer leather, cotton
28 × 28 inches with 6-inch fringes

This apron is dedicated to the women who have influenced my life and work. The thin lines that connect the faces are the threads that tie us all together. . . In my life it has been the women who have helped me on my journey, sharing things that only a weaver could share.

61 **Indian Curio Shelf**
Preston Singletary
blown and etched glass, wooden shelf
2 × 53 × 14 inches (shelf); baskets vary up to 12 inches in height and 12 inches in width
Photo by Russell Johnson

These glass baskets pay homage to the complexity and beauty of traditional basketry. I feel that glass brings a new dimension to native art. I like to think that the luminosity of the pieces is like a spirit that exists inside them and that only shows itself in the right light.

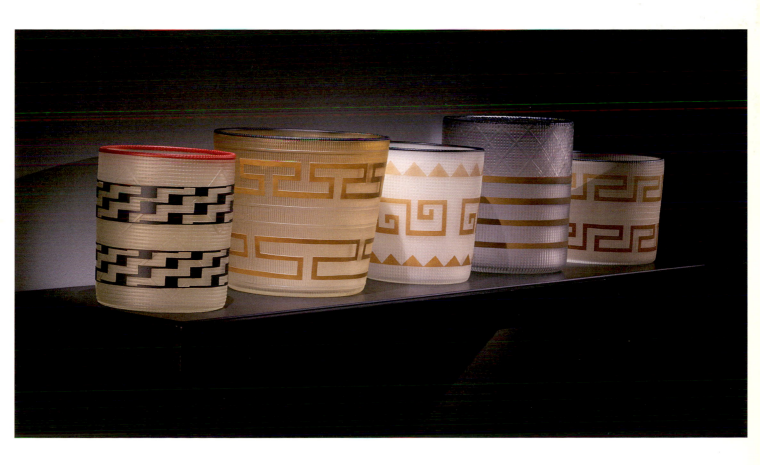

62 **Maori Made in the USA**
Roi Toia
blown and etched glass (executed
by the Pilchuck Glass Team: gaffers
Blaise Campbell and Jen Elek;
artist assistants Jessie Blackmer
and Joe Benvenuto)
29 × 10 × 8 inches (excl. stand)

The hue *(calabash) had many
uses as a container, allowing
water and food to be transported
with relative ease . . . Here, it
is interpreted as a vessel of
knowledge . . . This piece depicts
symbolically the interconnection
of knowledge and wisdom that
combine to empower our very
existence.*

Facing page:

63 **Weeping Volcano Woman**
Norman Tait and Lucinda Turner
alder, horsehair
18 × 13 × 10 inches

*The displacement of the survivors
of the great volcanic eruption
that covered much of the Nass
River in upper British Columbia
is a prominent Nisga'a story
that links our people to the
neighbouring nations; like
many of the Raven stories, it is
a connection to faraway places.
There are also themes of survival,
drastic change, environmental
force, respect for nature and for
the knowledge of elders.*

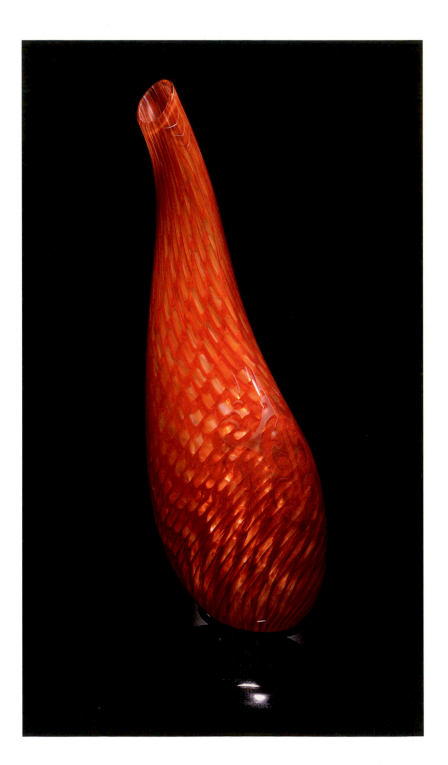

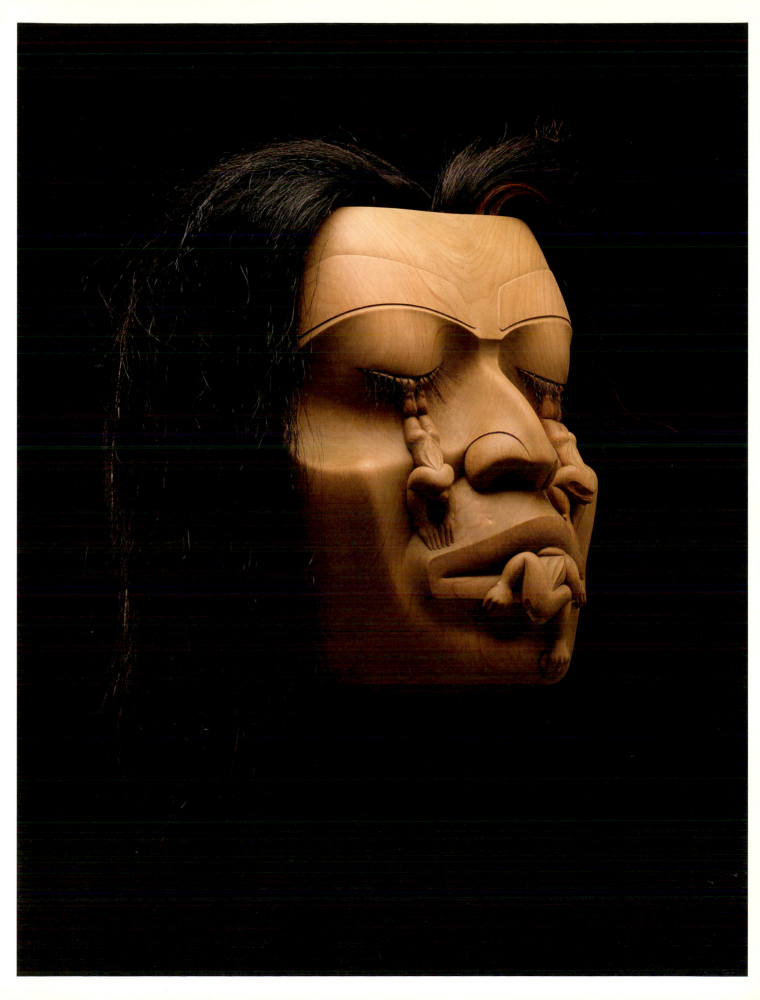

ARTIST STATEMENTS

{39} **Maori Sculptural Kete Form 1** · CHRISTINA HURIHIA WIRIHANA
{40} **Maori Sculptural Kete Form 2** · CHRISTINA HURIHIA WIRIHANA

Whakatauki (proverb):

> *Hutia te rito o te harakeke*
> *Kei hea te korimako e ko*
> *Ki mai ki au*
> *He aha te mea nui o te ao*
> *Maku e ki atu*
> *He Tangata He Tangata He Tangata*

> If the centre of the flax bush
> were plucked
> Where would the bellbird sing?
> If you should ask me what is the greatest thing on this earth
> I should answer
> 'Tis people 'Tis people 'Tis people

The overlay and intersecting of each woven layer reflects the interconnecting of cultures, striving for the retention of a people. Often overshadowed in this contemporary climate are the humble beginnings, and so often the reminders of the past elude us.

The concept for these works is challenged as I manipulate the material and produce suggestive forms. This act is a representation of women, the physical manifestation of Hineteiwaiwa, the tutelary deity of weaving. The conversation with the materials is generated by the gentle handling of the weaver; each woven section is softly massaged during the weaving process, encouraging a patina that informs my *turungawaewae*, my place; my *kainga*, my home, the geographical place where I live, Rotorua. Allowing the materials the freedom to express, and being completely aware of the respect due to natural materials when they are harvested and prepared after their long nurturing embrace by Papatuanuku, Earth Mother, contributes to the significance of the form.

The ability to explore and challenge the boundaries of the woven process using a range of materials allows me to move away from the customary processes without removing myself from the customs with which I am associated. My weaving practice acknowledges *tupuna* (ancestors) who have paved a creative *huarahi* (pathway). This conversation between the tangible and the intangible is ever-present within the bosom of the *wharenui* (ancestral meeting house), the repository of knowledge, the visual library.

39 40 41 42

{41} **Gleanings** · HEPI MAXWELL

A *kete* (basket) requires the perfect amount of flax to create it. The weaver will never destroy the whole plant but glean only enough selected *rau harakeke* (flax blades) to serve the immediate needs of the gatherer and his or her family. The forest should be left in a conditionthat enables it to replenish and carry on providing for the needs of others who pass through it.

The skillfully crafted flax *kete kai* (food basket) was used to collect the delicacies of the forest, especially the *harore* (bush mushrooms) and *pikopiko* (young fern shoots). The *kete kai* is created with a well-balanced, open weave that looks aesthetically pleasing and allows the gathered food to be seen. When humans succeed in weaving a perfect, harmonious balance between themselves and their environment, then they have achieved something to be truly proud of.

{42} **He Aho V** · GABRIELLE BELZ

This painting has been produced as a limited edition print titled *He Aho, Connections to the Land.*

Aho in translation has several meanings: string, line, woof—cross threads of a mat and genealogy—the line of descent. *Aho tanuhu* means the first weft, or widthwise piece, in a woven cloak. In this painting, the reference to the cloak and the genealogy relate to the land. Like many, the love of the land moves the centre of my being, and it is this feeling that connects this work to the theme of the exhibition—"Manawa."

The imagery on the canvas was prepared by painting the landscape (*whenua*) as seen from above. This laid the *papa* (foundation/land) from which the rest of the painting grew. The red oxide colour and brighter red circular areas are a reference to the volcanic activity that formed the area known as Tamaki Makaurau (Auckland). The patterned areas running through the painting allude to the footsteps of our ancestors who have passed through this region. The upright pieces with white bases are my symbols for the agriculture that took place in the rich soil, and the long-term settlements around and on the volcanic hills. The horizontals and verticals are the weave through which appears visual imagery relating to stories of the land and her people. They are also part of the cloak denoting qualities of *mana whenua* (authority), *rangatiratanga* (prestige) and *kaitiakitinga* (guardianship and protection).

The painting refers to activities occurring over time around the section of land dividing Manukau and the Tamaki Estuary. Many of the paddlers in ocean *waka* (canoe), represented by the elliptical shapes, called in at Waitemata Harbour at Auckland before travelling farther to find a place to settle. This narrow neck of land, which provided access

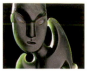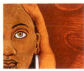

43 44 45 46

from one coastline to the other, saved miles of ocean voyaging around the northern part of the North Island of Aotearoa. Some *waka* were carried across from the Tamaki and placed in the waters of the Manukau to continue the journey down the western coastline.

In the second half of the 1800s, when the Europeans settled in the area, the Crown wanted access from Auckland to the south, and the Great South Road was cut through the land. This gave the Crown and its military access to some of the richest land, which was later confiscated from Maori and divided for colonizers. Then, after the Second World War, many Maori moved to the city as part of the "urban drift." The freezing works, or abattoir, already established in this area provided employment for men and women for many years until its closure. During the 1950s, a new wave of people entered our shores from all over the Pacific, found employment and settled in the cheaper housing in this area.

The *manawa*, or mangrove, protects the fish nurseries in both waterways. In times past, the Manukau was renowned for the plentiful *kai moana* (seafood) that was always available on its shoreline and in its deep waters. The plentiful sea life and the wetlands surrounding the area attracted an abundance of water birds—to such an extent that they are mentioned in traditional narratives.

Despite the changes made to the land by humans and time, the land is still our mother; our heart (*manawa*) is bound to her, our heartbeat (*manawa*) moves with her. If she dies, we also will pass on. Throughout the world we must stop defiling her: *ko Papatuanuku te Matua o te tangata*. Papatuanuku is the parent of all humankind.

{43} **Pouihi** · SIMON LARDELLI

Pouihi means "inspired pillar." There are three components to this carving: the past, present and future. The overall form of this carving depicts the Maori weapon called a *kotiate*, which was used by chiefs in hand-to-hand combat and was also carried as a decorative element for ceremonies.

The past is represented by the generations of carvers who have passed on, leaving as a legacy their influence on today's artists. The four faces at the top of the carving are *nga hau e wha* (the four winds). As the winds change throughout the generations, respect and understanding for each other's differences have begun to develop. In the past, different cultures opposed each other, hence facing them away in different directions.

The present is represented in the midsection of each side, with *tane* (man) on one side and *wahine* (woman) on the other. The man has a decorative *moko* (tattoo) carved on his face. The *moko* shows his *mana* (pride) and leadership qualities. Each section and each symbol of the *moko* can reflect *whakapapa* (genealogy). *Whakapapa* is knowledge, respect and love for tradition, and it continues to be passed on to future generations.

The future is represented in the negative figure at the bottom of the carving, which symbolizes the next generation. It is the idea of passing on knowledge and art, the *taonga* (gift) of *whakairo* (carving), *raranga* (weaving) and *kowhaiwhai* (painting) continuing to be taught.

The carved elements represent the eternal thread that is the spiritual essence of all indigenous cultures. The past has shaped our future, and a mutual understanding and respect has developed so we can work together supporting each other's beliefs in society today.

The *pouihi* symbolizes the joining of two cultures in one *manawa* (beating heart).

{44} Paepae Taputapu (Container for Tools) · RIKI MANUEL

History is a Western concept that relies on the methodical recording of events. Within Maoridom we have traditionally recorded events in several ways including oral tradition and through our arts. From about the 1920s to the 1970s, the art of *moko* (tattoo) was dormant, partly due to the effects of colonization and fashion. During this time, carvers kept *moko* alive by incorporating it in their designs. It also gave them an opportunity to create new *moko* designs, because though technique and tools separate the processes of carving and *moko*, the design aspect remains the same.

This particular carving depicts Niwareka, who brought weaving from the underworld to Maori, and Mataora, who brought *moko*. Since *moko* has made a fashionable return, Niwareka and Mataora have been brought to life again. Although it isn't common practice, I incorporate weaving and *moko* designs in my carvings. I see carving and weaving as a continuous tradition of arts that work in partnership, as witnessed by their presence on the *marae* (gathering place).

{45} "He Taonga Tuku Iho" · LEWIS GARDINER

"He Taonga Tuku Iho"

"A treasure bequeathed between generations."

The *toki pou tangata* is an adze that establishes who is in authority. The adze of authority is one's internal thread, one's *whakapapa*. It is by passing this *taonga* (gift) from one generation to the next that it will become the *manawa* of the *whanau*, the heart of the family.

{46} Hine-nui-i-te-po (Ancestress of Night) · JUNE NORTHCROFT GRANT

The recurring themes of birth, life and death are still foremost in my thoughts as my work manifests. This goddess was the daughter of the god Tane and Hine-ahu-one, the earth-formed maiden. Amid the chaos of the relationships of the founding gods, this goddess,

Hinetitama, assumes a new name and retreats to Hades, the great darkness, and becomes the goddess of the underworld, Hine-nui-i-te-po. Another demigod, Maui, the trickster, tried to defy mortality by entering the domains of Hine-nui-i-te-po, eating her heart and delivering the souls of men from death. However, his attempts were foiled by the fantail; the bird's chattering woke the goddess from her slumber. Maui subsequently met his own demise. In other Polynesian mythology, the spirits of their dead go to a legendary land of Matang, blond people, but it is the Patupaiarehe who are especially referred to as the purest of the blond-haired races. Hine-nui-i-te-po is depicted as beautiful and innocent, awaiting the souls of humankind.

{47} Tane Mahuta (A Celebration of the Creative Process) · ROI TOIA

The world of the Maori breathes a rhythm of physical and spiritual balances. From our earthly viewpoint, nature blends with spiritual consciousness, and as nature controls our existence, it is accountable to elemental guardians... Tane Mahuta (God of the Forests) is one such guardian. One of the most well known of the "god family," he was responsible for parting the two primal parental gods, Ranginui (Sky Father) and Papatuanuku (Earth Mother). This act alone enabled the "human condition" to exist in the dynamic void between them, known as *te ao turoa* (the physical world).

Tane Mahuta oversees the fertility of the land, bird life and the great forests that once stretched from shoreline to shoreline. This sculpture depicts and personifies Tane Mahuta, whose resources are the raw materials of the creative process. Timber is carved to adorn our ancestral meeting houses, daily implements and weaponry. The fibres extracted from the *harakeke* (flax) bush (and related species) are elaborately fashioned to reveal beautiful forms in weaving—from complex *pake* (cloaks) and intricate woven boards in the meeting houses to fish nets and basketry used in everyday life.

This representation of Tane Mahuta is a celebration of this dynamic and reputed ancestral god, especially in its deliberate use of scale. Here he stands tall, larger than life, an imposing figure who commands respect. His disposition is one of embracing and nurturing yet unforgiving and foreboding, likened to nature's cycle as it plays out its daily role between the bodies of Earth and sky.

{48} Dog Warriors · DARCY NICHOLAS

I had been searching for an image of a warrior dog for several years. In 2004, I was travelling in Canada from Terrace to Prince Rupert with my Tahltan-Tlingit artist friends Dempsey Bob and Stan Bevan. We were surrounded by stunning stone mountains that were shrouded

47 48 49 50 51

in mist, soft rain and snow. We had seen bears, eagles, ravens and totem poles and had walked in the forest over ancestral land. I could feel the power and spirit of their land.

When I returned to New Zealand, I transformed the power and spirit of their land and painted *Dog Warriors*. When Dempsey Bob saw the painting he commented with a sly grin, "Your work has changed."

{49} Niho Rei Kuri/Dog Tooth (Symbol of Strength) · TODD COUPER

Taking the shape of a dog tooth, this piece acknowledges the ancient art of weaving and the strength associated with that art form and its durable materials.

The *kuri* (native dog) was originally brought to Aotearoa by our ancestors, but over time it became extinct. Dog skin was prized when it adorned cloaks (*kahu kuri*) because it has valuable qualities of strength and durability. To avoid waste, the skin would be cut into long strips, laid at intervals over a backing made of flax fibres, then sewn down. To further strengthen these cloaks—which were worn by chiefs—they were soaked in water, which stiffened the skin and made them great protection from spears, so this practice was done before going into battle.

The notching along the white painted edges represents the beautiful intricacies of the *taniko* (geometric) pattern often woven along the borders of such garments. The grey painted spirals depict the blood flow or lifeline that represents the *whakapapa* (lineage) of this magnificent art form, which lives on and continues to develop in the hands, hearts and minds of its expert practitioners.

{50} Kai Tangata—Land Warrior · DARCY NICHOLAS

Land is the foundation of our identity. This mask is shaped like a land mass, and the reverse side carries the tribal genealogy. Kai Tangata were fierce warriors and man-eaters; they protected their land with ferocious passion.

{51} Waitaiki · FAYNE ROBINSON

Many different stories are told about the origin of *pounamu* (New Zealand jade/greenstone). This account tells of a fish named Poutini that belonged to Ngahue, who lived in Hawaiki. Poutini and Hine-tu-a-hoanga (Lady of the Grindstone) lived together, but they became enemies. Ngahue fled overseas with his fish, Poutini. They reached Tuhua Island in New Zealand's Bay of Plenty, an island that yields the most obsidian. Hine-tu-a-hoanga followed, whereupon there were quarrels with Poutini, Waiapu (a stone used in making adzes) and Mataa (flint). Finally, Ngahue fled to the west coast of the South Island and

52 53

hid Poutini on the bed of the Arahura River. Ngahue tore off a side of his fish and took it back with him to Hawaiki, where it was made into adzes for building the migratory canoes. (Sandstone, or grindstone, is the main material used for fashioning *pounamu*. In this legend, the grindstone occurs as the enemy of *pounamu*.)

Waitaiki is the female figure on the front of the adze, interwoven with the flesh of Poutini, her husband, the father of all the varieties of *pounamu*. The *pounamu* embedded inside her are a representation of their children Hine-Kawakawa, Hine-Kahurangi, Hine-Auhunga, Hine-Inanga, Hine-Kokotangiwai, Hine-Mata-Kirikiri, Hine-Aotea, Hine-Kokopu and Hine-Totoweka. The painted area represents the rivers in which the stone was found (Te Tai Poutini). The surface design on Wataiki is *Te ara o Poutini* (a representation of Poutini's path). The surface design on the adze is *taratara-a-kai* in recognition of the flesh that Ngahue tore from Poutini, from which the adze was made.

The style of carving is Kati Mahaki, and this sub-tribe is one of the two *kaitiaki* (guardians) of the *pounamu*. *Kei te pumanawa o nga pounamu te Mahaki*. The Kati Mahaki people reside in the heart of the land of *pounamu*.

{52} Whakapapa (Generations) · KERRY KAPUA THOMPSON (TAMIHANA)

This sculpture represents a man and woman united to maintain the continuations of *whakapapa* (genealogy)—their faces, on either side at the top, are highlighted in bone. Both figures are wearing cloaks honouring the traditional *harakeke* (flax) cloaks, though here they are decorated with a painted design. Inside the cloaks, etched in glass, are three faces: the face at the bottom is the fisher within a fish form, symbolic of the water; the middle face is the hunter within a lizard form, symbolic of the land; the top face is a human within a bird form, symbolic of the sky.

The water, land and sky have a physical connection to the people of the land (*tangata whenua*) and are vital to the survival of every generation. Their essential balance provides us with the food, shelter and air that enable us to live and enjoy life as we know it today.

The fish on the base symbolize the food from the sea. The design on the base incorporates a combination of Maori and Northwest Coast design. This is my personal attempt to honour First Nations design and to acknowledge my respect for the culture and art in Canada. It is a reminder of the inspirational cross-cultural experience that my family enjoyed on our visit to Canada, when I participated in a joint exhibition with Christian White in 2004.

{53} Tohu—A Folklore of Mark Making · CHRIS BRYANT

Honouring the legacies of *tohunga* (experts) and artists who have left their mark on the development of both customary and contemporary Maori visual culture is becoming

more common among practitioners and connoisseurs alike. This sculpture series pays homage to Pine Taiapa not only as a *tohunga whakairo* (master woodcarver) pivotal in the revival of customary carving during the late 1920s but also as a *matakite*, a seer and storyteller. Taiapa recalls his many dreams of climbing to the summit of Rainbow Mountain, a sacred tribal site and popular tourist location in Rotorua, to reference the seemly, strange and beautiful carvings in the styles of many tribes as they appeared and receded in the mist.[1] Taiapa interpreted such dreams as a *tohu*, or sign, that led him on an epic journey to find Eramiha Kapua, one of the few surviving Maori adzemen able to impart the skill and knowledge associated with the *toki* (adzes) to a fledgling generation of carvers.

The series also pays homage to Para Matchitt as a founding artist of the contemporary Maori art movement that emerged during the 1950s. He successfully negotiated the support of *tohunga whakairo* such as Pine Taiapa, Piri Poutapu and others to explore simultaneously the interplay of customary Maori visual culture in combination with Western modernist practices. Matchitt experimented, making new marks with the use of power tools, metal adze and chisel as he worked with natural and synthetic materials, paving the way for emerging and established Maori artists to use such new technologies as photography and electronic and digital media. Jonathan Mane-Wheoki, director of art and visual culture in New Zealand, declared during the late 1990s:

> In exploring new media as they arise, the present generation of Maori artists, driven by curiosity, is doing what their *tohunga whakairo* forebears did when metal tools were first introduced into this country: acculturating and indigenizing the new technology for creative and expressive purposes. Maori artists continue—where they have the knowledge, ability, desire and permission—to link back into the world of their ancestors to affirm their own origins and lineage and through art to reconcile that past with insights drawn from their particular present.
>
> The painted green lines that encircle the "marks" developed by carvers from Hoani Ngatoto to Arnold Manaaki Wilson appear as palettes of colour, figurative painting imagery and text, and play on the lines of a computer screen shimmering like the pounamu blade of a *toki*—in essence, for the artist the folklore continues into the future.[2]

1. M. Sorrenson, *Pine Taiapa*, *Master Carver*, vol. 6, *New Zealand's Heritage* magazine (Auckland: Heinemann, 1985), 2435.
2. J. Mane-Wheoki, "Toi Hiko: Maori Art in the Electronic Age," F. Milburn, *Hiko! New Energies in Maori Art*, catalogue (Christchurch: McDougall Contemporary Art Annex, 1999).

{54} **Hamapu** · PAERAU CORNEAL

Karanga is the realm of women. *Kai karanga* are senior women who are the first to be heard on the *marae* (gathering place), their voices elevated and mournful as they call to the ancestors, call to our living and call to those who have passed away. The *karanga* is a physical and spiritual act of bringing the past to the present that will, depending on the occasion, awaken emotions of awe, loss and contemplation.

Ha is the breath outward and *hi* the breath inward. *Hamapu* represents the explosive breath.

{55} **Koiwi** · LYONEL GRANT

These elegant forms reinforce and reaffirm our links to our ancestors. As each ancestral *koiwi* (skeletal frame) is returned to Papatuanuku (Earth Mother), so does our connection or relationship become even stronger to the land in which they lie.

Simple organic bone structure has inspired their shape. However, when one encounters the *koiwi* they seem to take on a persona of their own and, as a collective, they form a balanced, interactive group.

Although any surface treatment is simple and understated, its purpose here is to accentuate the base form and to unify both the bronze and the totara elements. The most pronounced decorative features, however, are the hands situated at the halfway point of the forms. In Maori tradition, it is said that the three fingers common to carved entities represent the life cycle of humans: Birth, Life and Death.

Each form represents one of the three phases of the human life cycle: Te Whanaungatanga (the birth/embryonic phase), Te Tipnga/Puwaitanga (the development and maturation phase) and Te Whakahemohemo (the physical passing).

These philosophies are common throughout Pacifica and indeed with all people, therefore *koiwi* are the tangible links that tie all peoples to Papatuanuku.

{56} **The Basket Mother Robe** · LANI HOTCH

Several years ago, I conceived of the idea to combine two great traditions—Tlingit spruce-root baskets and Ravenstail robes—to showcase their relationship. *The Basket Mother Robe* is the result. There is much overlap in design between these two art forms, and I am surprised that no one has ever thought to do a robe like this before.

Years ago, a group of weavers decided to collaborate on a robe titled *The Healing Robe*, which is a replica of the *Lynn Canal Robe* featured in Cheryl Samuel's book *The Raven's Tail*. That experience brought back the tradition of weaving to our village. We, like the Maori, have chosen to embrace our culture, perpetuate it and be proud of who we are.

54 55 56

I have a great deal of respect for tradition, as I come from a family with several generations of weavers, and I have the utmost respect for the work my grandmothers have done. However, I also feel that each generation has an obligation to make an impact on their culture through innovation and new ideas. I hope that when my grandchildren look back on what I have done, they will have respect for it and yet not feel constrained to just replicate it.

The skip-stitch pattern found at the top of *The Basket Mother Robe* is called the Hood of the Raven and it was found on many of the spruce-root baskets made by the Tlingit weavers. We have several large storage baskets in my family that featured this pattern in small bands at the top of an otherwise undecorated basket. The top patterned border is a design found on a very ornate basket (false embroidered with dyed yellow grass) that was given to my father as a wedding gift by my great-grandmother Mary Willard. I don't know the name of the pattern. The side borders on this robe are unique, as they are done over one or two warps rather than the two and four warps typical of Ravenstail design borders. I wanted the scale of the design to match another basket that my mother had. The triangular design is called the Head of the Salmon Berry, and I made some changes to keep things interesting as I wove. The patterns in the central design field are the Raven's Tail (Cross) and the Tattoo patterns. In a basket these patterns would be much closer together, as the sides of the cross patterns would fit snugly between the top and bottom arms of the tattoo patterns. I separated them to follow the Ravenstail weaving tradition. The bottom-patterned border is just another interpretation of the design found in the top border. The diamond-shaped skip-stitch pattern next to the bottom fringe was also popular with basket weavers—it is referred to as the Haida Spider Web by Cheryl Samuel in her weaving books.

I chose to put red fox fur at the top of this robe, as I wanted the fur trim to complement the colours in the weaving. Sea otter fur, which is typically used in Ravenstail robes, was too dark and didn't offer enough contrast to the brown yarn of the weaving. The fossilized ivory and antler pieces embellishing the designs in the centre field were chosen as a reference to the bone and antler tools a basket weaver uses to smooth and shape her weaving. The gold and copper cones that finish off the bottom fringes are a tribute to the wealth of the weaving traditions of my grandmothers. Copper and gold both symbolize wealth in the Tlingit culture.

There is a group called the Polynesian Voyaging Society that perpetuates the art of Pacific Ocean travel using traditional navigation and the canoes *Hokule'a*, *Hawai'iloa* and *Makali'i* from Hawai'i, *Te 'Aurere* from Aotearoa and *Takitumu* and *Te 'Au o Tonga* from Raratonga in the Cook Islands. Our regional corporation, Sealaska, donated two 400-year-old spruce logs to the society to make their canoes, since not one tree in the Hawaiian

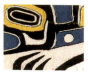
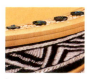

57 58

forests was big enough, or healthy enough, to make a traditional canoe. When the voyageurs on the *Hawai'iloa* travelled through southeast Alaska, they stopped in Klukwan to thank our people for donating the logs. We housed some young people from their group at our house during their stay in Haines and Klukwan.

Our people had a gathering with the travellers and they retold the story of how they wanted to revive the sailing tradition of the Polynesian cultures using traditional vessels and traditional navigation. Their story resonated with us, as we, too, were trying to revive our own traditions, specifically weaving. Klukwan has always been well known for the legacy of Chilkat weaving, and a group of us women were, at that time in 1995, in the process of weaving the Klukwan *Healing Robe*.

I have a Hawaiian name—Lani; it was given to me by my father, who was a merchant marine stationed in Hawaii during the Second World War. He heard the name Lani and decided that if he ever had a daughter he would give her that name. He later moved to Alaska, met and married my mother. They did not have a daughter right away—not until they had already had nine sons. So, nine sons and some twenty years later, they finally had a daughter and I got the name Lani.

{57} **Beaver Design Naxiin Apron** · EVELYN VANDERHOOP

Inspired and challenged by its ancient history, I was drawn to the unique and complex beaver (in Haida language, *T!cin*) dance apron. Three aprons of a similar pattern exist, woven by women in the past who were entrusted with creating spirit apparel since shamans used dance aprons during their healing rituals. Beaver images were often depicted on shaman paraphernalia, as these objects or designs were usually inspired by visions of spirit helpers. The figurative manner in which the beaver apron design is depicted indicates that a shaman created it. The female weavers had to be specialists, transformers twining wool and cedar-bark fibre into adornments of power, media of communication with the supernatural realms.

These thoughts accompanied me as I wove my beaver apron. The Beaver is one of my crests. As my apron grew to completion, the design of this animal's head with beings on each side seemed to encourage each stage of weaving, staring out as if to say, "When will my other part be done?" In this way it was my "helper." I deviated from the beaver apron's historic design by weaving Ravenstail geometric patterns on the outside corners to represent the recent Northwest Coast weaving revival. The beaver image is akin to an upright-headed *tiki* (carved figure) of the Maori.

Many design elements and weaving techniques of the Maori and Haida are alike. House architecture, carved wood columns and canoes further demonstrate the similarities. So it was

a life-enriching experience to meet the Maori artists at The Return to the Swing: Gathering of Indigenous Visual Artists held at Evergreen State College in 2001. In the weavers' studio, Christina Wirihana and Tilly Matthews, Maori weavers, generously shared with me and the other weavers how they prepare flax for spinning and plaiting. Although we never spoke overtly of spiritual matters, mutual respect for the plants, land and animals was a common topic. During my visits to the painting studio, conversations with Darcy Nicholas increased my understanding of Maori sensibilities. He encouraged me to paint within his painting. I spoke of Haida Gwaii (the Queen Charlotte Islands in British Columbia), sweeping a blue sea horizontally; he then placed it vertically, encapsulating it within a water spirit of Aotearoa. At the commencement of the gathering, he gifted me with his painting *Water Spirit*.

Darcy's generosity was continued when he and his brother Garry Nicholas invited my sister, my husband and myself to the 2004 opening festivities of the "Toi Maori: The Eternal Thread" exhibition at the Pataka Museum and art gallery in Porirua City, New Zealand. At the gathering I met Ranui Ngarimu and Reihana Parata. They allowed me to twine on their *karowai* (feather cloak), which was in progress. They showed me how to spin flax and to *whatu*, a four-ply twine technique that is used in cloak weaving. It was such an honour to be given this instruction. I was brought to tears when they gifted me with a *kete* (basket) filled with *muka* (flax fibre) and invited me to create my own weaving with their traditional materials. I also learned from Erenora Puketapu Hetet the *taniko* technique, which is similar to the geometric two-colour, two-strand twining of Ravenstail Northwest Coast weaving, except that it requires more colour strands.

I feel a kinship with the Maori weavers. They thought I was a quick learner, but the truth is we thigh-spin, downward-weave, twine and plait and pattern our weavings very similarly. Weaving was honoured in their culture as it was in ours. Patterns, materials and designs all had meanings of prestige and ancestral status. Ethnologists have hypothesized a shared cultural history within the Pacific Rim area, and I feel in my heart that the Haida and Maori share a common ancestor.

{58} **Kete Remembered (feast dish)** · CHERYL SAMUEL

I was born on the island of Oahu in Hawaii and raised on *lauhala*, *hula* and *aloha*. The woven *lauhala* (leaf) mats of my infancy left their imprint not only on my *opu* (stomach) but also on my mind, for I became a weaver. Weaving led me to Alaska, first to the sophisticated beauty of the Chilkat robes and later to the mystery of Ravenstail. As my skill grew, I was invited to share my knowledge with weavers all over the North, from Oregon to Alaska. Robes that I wove found their way into private and public collections, in North America and Europe.

One day, two weavers from Aotearoa travelled to Europe, looking at weavings of the Maori people in museum collections. These women were Emily Schuster and Christina Wirihana. They saw one of my Ravenstail robes, asked its origin, and when it came time for New Zealand to host the Commonwealth Games in 1990, they asked if I could be invited.

I travelled to New Zealand and represented Canada in the Commonwealth Arts Festival that accompanied the Games. During that time I met a number of Maori weavers, including Maureen Lander, Toi Maihi and Puti Rere; we all shared the excitement of discovering the similarities between Ravenstail and *taniko* (Maori geometric weaving) techniques.

Following the festival, I travelled to Rotorua, was greeted by Emily Schuster and taken to the New Zealand Maori Arts and Crafts Institute, where weavers were working on *kete* (baskets). It reminded me of the *lauhala* of my childhood and I watched eagerly, desperate to try. Emily must have seen the longing in my fingers, for suddenly I was sitting on the floor with the weavers, gifted with materials for my own *kete!* Emily showed me how to start: to weave the bottom and to turn up the sides. The day ended too soon; I was shown to my room and there on the table next to my bed was a big feast dish, abundant with fruits and gifts from my hosts.

The next day I was to move on, to visit another weaver. How was I to finish my *kete?* Emily explained that it was all worked out, that I would go to another weaver who would help me with the middle section. I travelled on and spent some wonderful time with Christina Wirihana, exploring our shared enthusiasm for weaving. And, yes, she helped me continue my *kete*.

Finally, Emily had arranged for Christina to drive me to the Ohaaki Arts & Craft Cultural Centre in Waitomo, to meet Diggeress Te Kanawa. I was welcomed once again in generous Maori style with a lovely feast and tea. After our meeting, I set up my loom with its partially finished Ravenstail weaving. I left the room for a moment, and when I returned, to my tremendous surprise I saw Digger and her daughter Muri sitting at *my* loom, weaving! They were thrilled: "Look at how she does this! We could use this technique in *taniko!*" And, of course, Digger helped me finish my very own *kete*, with further assistance from Christina as we drove back to Rotorua.

Kete Remembered (feast dish) has been woven in honour of the Maori weavers who so graciously hosted me in Aotearoa. The top rim recalls the plait work of the *kete*, this time using yellow-cedar bark from the Northwest Coast. The *paua* (New Zealand abalone) shell decorations echo the use of abalone on Tlingit feast dishes. The woven band shows alternating patterns: a traditional Ravenstail design adjacent to an interpretation of a Maori

taniko pattern, woven Ravenstail-way. At one point, two Ravenstail patterns are placed back to back, indicating the start and finish of my journey. The bowl itself represents the vast Pacific Ocean and inside is nestled the island of my birth, Oahu.

{59} **Naa-Na-Nig-Su (Grandmother's Panel)** · TIM PAUL, RCA

The translation of the Hesquiat term *naa-na-nig-su* is "grandparents," although in this sculpture the name refers specifically to grandmothers. The sculpture is about weaving and basketry patterns—my mother mentioned that her grandmother had said she would sew patterns onto cloth to remember them, and much later she would use graph paper to record her designs.

The sculpture represents the four directions, the four chiefs of nature:

1. The sky chief with a star on its side.
2. The mountain chief with the great thunderbird at its side.
3. The land chief with the most important crest of our family, the Wolf.
4. The sea chief with the killer whale dorsal fin at its side, with our grandmother's spirit locked inside. The killer whale has let go of its dorsal fin to transform itself into a wolf and bring our grandmother's spirit out.

In our family's cultural teachings, we know that everything—the animals and all creatures, the plants and trees, et cetera—has a spirit. My grandmother's family having had good encounters with the killer whale means that over the years we have become one with this animal, and in turn we will receive many good things and power from it.

Naa-na-nig-su, grandmothers who have gone before us. The spirits of our grandmothers in our cultural teachings tell us that we can call on them whenever we need to, so that we can do and say the right things at all times. The four directions, the four chiefs, are within nature; you can ask nature for anything you want and it will give it to you for your family. We know the doorways of nature, and when you go out to nature through these doorways your *naa-na-nig-su* (grandmothers) from four directions can give you something very new or something very old, such as the ancient knowledge our people have—songs, names, medicines, the power of your inner self. You call your grandparents from all four directions because we are all one with nature.

We have ten relatives from nature: the sky and all that is in it, the mountains and all that is there, the land and all that it has and the sea and all that it holds. Our eleventh relative, the earthquake, lives inside the mountains. He can quickly stop whatever we, as

60 61

human beings, are doing and remind us that we are the smallest thing in the universe. The doorways of nature are respected and we must understand nature gives us them to use. We cannot simply keep taking.

{60} Halaaydm Hanaa'nax (Women of Great Power) Apron · WILLIAM WHITE

In 2004, I travelled to New Zealand for a gathering in Porirua City. As part of this gathering, I was one of several Northwest Coast artists who contributed pieces to an exhibit at the Pataka Museum and art gallery in support of the "Eternal Thread" exhibition. It was a great honour for us to be invited to this prestigious event and to share in the opening of this important show before it began its tour to North America.

I spent a month in Aotearoa and was thrilled to meet the Maori people and to see all the artwork. The dedication to and support of their culture was truly inspiring. I spent my time in New Zealand working with Maori artists both in their traditional materials and having them work in our traditional materials. It was a true cultural exchange of ideas and techniques, and we discussed issues that are the same and equally important for both our cultures—the land, sea and cultural issues. These discussions often lasted well into the night.

Of course, I spent most of my time with the weavers. Throughout my journey, I was moved by the dedication of these women in keeping their weaving arts alive. It reminded me of my aunt Betty Sampson, who taught me to weave twenty-three years ago and instilled in me a respect for my culture. One of the Maori elders I worked quite closely with was Mere Walker, who was from a little town called Kawerau. After the gathering I spent six days with her and some of her students in their community. We wove every day. I have found that no matter where you go in the world, weavers are all the same—time is irrelevant; that is to say, when we are working on something time just slips away and we become lost in our own personal universe, even in a room full of other weavers.

One of Mere's students, Aroha [Puketapu-Dahm], is a weaver of contemporary pieces, and I saw how freely the elders respected her non-traditional work. I have always defined myself as a traditionalist, but when I returned from New Zealand I was a changed person. My understanding of first-nations indigenous art has been given the gift of sight from this trip. I now know that as long as the art is coming from the heart of the first-nations people, they have the right to control its destiny. I feel a bit foolish when I think of some of the comments I have made over the years about contemporary art.

This apron is dedicated to the women who have influenced my life and work. The thin lines that connect the faces are the threads that tie us all together. As we travel along life's

journey, it is the people we meet and learn from who help shape us. In my life it has been the women who have helped me on my journey, sharing things that only a weaver could share. They have helped shape my thoughts as well as my work. Maybe I am the thin line in this apron, trying to connect to the past as I move towards the future. The design also honours the power of women with the designs represented in the faces of the Northwest Coast women who are wearing labrets in their lips and the Maori women who are wearing *moko kauwae* (chin tattoos).

{61} **Indian Curio Shelf** · PRESTON SINGLETARY

Glass has offered me the opportunity to travel the world. A student of glass is introduced to ancient techniques developed, nurtured and celebrated in particular places around the world—over time, it has become my quest to visit these places, to meet other artists and to learn from their knowledge.

I began blowing glass in 1982, then two years later I attended the Pilchuck Glass School in Stanwood, Washington, which is more or less where I got my art education by working with other artists. In a relatively short time, Pilchuck has become one of those places that international artists want to experience, and it is renowned for producing some of the most celebrated contemporary glass artists. This school is situated within the Northwest Coast and teaches one of the world's oldest art forms, and it was only a matter of time before a bridge was built between glass and the masks and ceremonial objects of the Northwest Coast. As an artist of Tlingit heritage, I began the journey to make this connection, and it has put me in contact not only with other Northwest Coast artists such as Joe David and Susan Point (who have been invited as part of the artists-in-residence programs at Pilchuck), but also with other aboriginal artists from around the world.

I recently completed a collaborative exhibition with the great American Southwest artist Tammy Garcia, and I have been invited to assist in the development of aboriginal glass programs including the Maori sometime in the future. In 2005, Maori wood sculptor Roi Toia travelled to Pilchuck to be an artist in residence, so this Northwest Coast–Maori connection has already been made. Glass is already bringing aboriginal artists from around the world together.

In every aspect of my work there is symmetry, proportion and balance, from the glass blowing to the design work. These glass baskets pay homage to the complexity and beauty of traditional basketry. I feel that glass brings a new dimension to native art. I like to think that the luminosity of the pieces is like a spirit that exists inside them and that only shows itself in the right light.

62 63

I wanted to display the baskets like we see in old photographs of "Indian curio shops." In the first place, this arrangement shows the architecture of the designs and the power of how they complement each other. On another level, I like how this piece presents itself as a challenge to the anthropological terminology since the time aboriginal art was referred to as "Indian curios."

Glass has a defining historical connection to First Nations culture through trade beads, which were quickly adopted and incorporated into clothing and other ceremonial objects. I see glass blowing as a progression of this connection.

{62} Maori Made in the USA · ROI TOIA

June 2005 was the birth of a new direction for me. Having received an artist-in-residence scholarship at the Pilchuck Glass School in Stanwood, Washington, I was privileged to enter into a world that very few are able to experience. In this isolated arts retreat in a forested wilderness, the raw energy of the glass-blowing furnaces pulsates with the rhythm of the land. I was immersed in the dynamic power of glass.

Such renowned First Nations artists as Joe David, Susan Point and Preston Singletary have all graced the hallowed ground of the "Pilchuck Experience." As the days worked themselves into weeks, I was able to comprehend the vastness and diversity of glass but also the endless possibilities.

I had self-imposed expectations when I arrived at Pilchuck, so it took a week for me to alter my original thought process enough to translate twenty-five years' experience of traditional woodcarving to accommodate the organic medium of glass.

The *hue* (calabash) had many uses as a container, allowing water and food to be transported with relative ease. Its function in domestic life was perhaps featureless; however, it still played a vital role.

Here, it is interpreted as a vessel of knowledge. Knowledge is passed from one generation to another, it enforces conscious thought. Out of this knowledge base, wisdom is conceived and empowered by the spiritual connection that one might have within this world— "Knowledge feeds conscious thought as wisdom awakens spiritual prowess."

I have tried to capture the weight and gourdlike form, then I have introduced the reference to the weaving pattern within the glass surface. This piece depicts symbolically the interconnection of knowledge and wisdom that combine to empower our very existence.

{63} Weeping Volcano Woman · NORMAN TAIT AND LUCINDA TURNER

The displacement of the survivors of the great volcanic eruption that covered much of the Nass River in upper British Columbia is a prominent Nisga'a story that links our people

to the neighbouring nations; like many of the Raven stories, it is a connection to faraway places. There are also themes of survival, drastic change, environmental force, respect for nature and for the knowledge of elders—all of which are woven at various levels through the pieces and people in the "Manawa—Pacific Heartbeat" exhibition.

The story of Volcano Woman takes place in a forest on the Nass River. Three boys are fishing and playing in a nearby stream when a frog decides to make its way from the forest to the stream. At first the boys do not mind the frog, but they make a game of halting its progress and just return it to the forest. But the frog is persistent in its journey to the stream, and this begins to annoy the boys. After the frog's third try to get to the stream, one of the boys decides to end the intrusion through their camp. He picks up the frog and throws it into the fire.

Volcano Woman inhabits the forest and knows of every creature who lives there. Soon she discovers that the frog is missing and wanders the forest calling for it. Finally she comes to the abandoned campfire and sees the frog's charred remains. After mourning her missing child for some time, she comes across a blind old man wandering in the forest. She tells him of her plight and asks the old man to go to the village where the boys live and to ask the villagers to properly punish them for their violent act. He agrees to her request, but the villagers only laugh and send him away.

Volcano Woman persists and sends the old man three more times into the village to repeat her demand for punishment. She tells him that this is an evil village and that it must be destroyed and that he should travel to other villages and let them know of her plan. Volcano Woman then asks a nearby mountain to spit fire on the village until it is completely destroyed. To this day, one can see lava beds stretching out for miles in the Nass Valley. Her message was that one should never take a life, except for food and clothing.

BIBLIOGRAPHY

Adsett, Sandy, Cliff Whiting and Witi Ihimaera, eds. *Mataora—The Living Face: Contemporary Maori Art*. Auckland: David Bateman, 1996.

Crowell, Aron and William Fitzhugh. *Crossroads of Continents: Cultures of Siberia and Alaska*. Washington: Smithsonian Institution Press, 1988.

Fusion: Tradition and Discovery. Vancouver: Spirit Wrestler Gallery, 1999.

He Rere Kee—Taking Flight. Wellington: Toi Maori Aotearoa, Tinakori Gallery, 2004.

Hitéemlkiliiksix (Within the Circle of the Rim): Nations Gathering on Common Ground. Olympia: Evergreen State College, 2002.

Ihimaera, Witi and Ngarino Ellis, eds. *Te Ata: Maori Art from the East Coast*. Auckland: Reed Publishing, 2002.

Kiwa—Pacific Connections. Vancouver: Spirit Wrestler Gallery, 2003.

Macnair, Peter L., Alan L. Hoover and Kevin Neary. *The Legacy: Tradition and Innovation in Northwest Coast Indian Art*. Vancouver and Seattle: Douglas & McIntyre and University of Washington Press, 1984.

Mead, Hirini Moko, David Simmons, Brian Brake and Merimeri Penfold. *Te Maori: Treasures of the Maori*. Auckland: Reed Publishing, in association with Auckland City Art Gallery, 1998.

Nicholas, Darcy and Keri Kaa. *Seven Maori Artists*. Wellington: Government Printer, 1986.

Penfold, Merimeri. *Te Maori. Te Hokinga Mai. The Return Home*. Auckland: Auckland City Art Gallery, 1987.

Samuel, Cheryl. *The Raven's Tail*. Vancouver: University of British Columbia Press, 1987.

"Sisters/Yakkananna/Kahui Mareikura." Adelaide: Tandanya, Adelaide International Festival, 2002.

Smith, Huhana, ed. *Taiawhio: Conversations with Contemporary Maori Artists*. Wellington: Te Papa Press, 2002.

Taiarotia—Contemporary Maori Art to the United States of America. Wellington: Te Waka Toi, 1994.

Whenua—Born of the Land. Wellington: Toi Maori Aotearoa, Tinakori Gallery, 2004.

BIOGRAPHICAL NOTES ON THE ARTISTS

SANDY ADSETT (b. 1939) · Ngati Kahungunu

Sandy attended Te Aute Boys College in Hawkes Bay and received his formal art training at Ardmore and Dunedin teachers colleges. He became an arts specialist for the Department of Education's Advisory Service in the 1960s, helping introduce the new "Maori Arts in Schools" program. In 1993, he was appointed principal tutor at Tairawhiti Polytechnic in Gisborne, formatting a *wananga* (place of learning) arts direction for Toihoukura School of Maori Visual Arts. He returned to his Kahungunu tribal roots in 2002, setting up the Toimairangi School of Maori Visual Culture within Te Wananga o Aotearoa, in Hastings. He is a member of Te Atinga (Committee of Contemporary Maori Visual Arts) of Toi Maori Aotearoa and is on the Te Waka Toi board of Creative New Zealand. His work has been in many major art exhibitions, including "Headlands" (1992) in Sydney, Australia; "Te Waka Toi: Contemporary Maori Art" (1992–94), which toured the United States, and "Kiwa—Pacific Connections" (2003) in Vancouver, Canada. In 2005, Sandy received the Order of New Zealand for Service to Art, and Te Wananga o Aotearoa cited him as adjunct professor for his contribution to art education and the Maori community.

GABRIELLE BELZ (b. 1947) · Nga Puhi, Te Atiawa

Initially trained as a commercial artist, Gabrielle is now a full-time painter and printmaker. She continues to support and promote art in the local and wider community as current chair of Te Atinga (Committee of Contemporary Maori Visual Arts) of Toi Maori Aotearoa, a founding member of Kauwae (National Maori Women's Art Collective), trustee of Toi o Manukau, a long-serving member of Nga Puna Waihanga (a national community-oriented organization that supports all Maori arts), a founding member of the artists' co-operative Pukeko, and she serves on the Creative Community Funds committee for Manukau City. She has participated in solo and group exhibitions throughout New Zealand and elsewhere, including "Mana Wahine" (1995) in Tucson, Arizona; "Haka" (1997–98), which toured the United Kingdom; "Sisters/Yakkananna/Kahui Mareikura" (2002) in Adelaide, Australia, and "Kiwa—Pacific Connections" (2003) in Vancouver, Canada. Recent commissions include design work for Manukau City.

STAN BEVAN (b. 1961) · Tahltan-Tlingit/Tsimshian

Stan is from the village of Kitselas near Terrace, British Columbia. He enrolled in the Gitanmaax School of Northwest Coast Indian Art in 1979 and followed that with an extensive apprenticeship with his uncle Dempsey Bob, who was also an early influence in his decision to become an artist. By 1987 Stan had a strong grounding in art and culture, having contributed to numerous commissions, educational projects and ceremonies under the guidance of Dempsey Bob, and he began to concentrate on his own pieces. He has received numerous commissions, often in collaboration with his cousin Ken McNeil, including a totem pole for the University of British Columbia First Nations House of Learning and a totem pole that represented Canada at Expo 92 in Seville, Spain

(later raised at the Kitselas Cultural Centre). He has been included in many exhibitions defining the future directions of woodcarving.

ISRAEL TANGAROA BIRCH (b. 1976) · Ngati Kahungunu, Nga Puhi

Israel graduated in 2001 with a Bachelor of Visual Arts and Design degree from the Eastern Institute of Technology in Napier, New Zealand. He is currently studying for his Master of Maori Visual Arts at Massey University in Palmerston North. Israel's mixed-media works using a unique lacquer finish have earned him considerable attention and recognition from both his contemporaries and collectors in recent exhibitions, including "Kiwa—Pacific Connections" (2003) in Vancouver, Canada.

DEMPSEY BOB (b. 1948) · Tahltan-Tlingit

A celebrated artist and a dedicated teacher, Dempsey began carving in 1969 and was directed to the Gitanmaax School of Northwest Coast Indian Art in 1972 by Freda Diesing, who was his earliest mentor and teacher. His work is in the collections of the Canadian Museum of Civilization; the University of British Columbia's Museum of Anthropology; the Columbia Museum of Ethnology; the Smithsonian Institution; National Museum of Ethnology in Japan; Canada House in London, England; Hamburgisches Museum fur Volkerkunde in Hamburg, Germany; Centennial Museum in Ketchikan, Alaska, and the Royal British Columbia Museum. Corporate collections include the Vancouver International Airport, the Ridley Coal Terminal in Prince Rupert and the Saxman Tribal House in Saxman, Alaska. He has pieces in numerous private collections including three significant collections—in New York, San Francisco and Vancouver—focussing primarily on his work. In recent years he has become a major contributor to Pacific Rim relations, participating in gatherings. He travelled to New Zealand in 2001, 2002, 2003 and 2004.

CHRIS (KARAITIANA) BRYANT (b. 1970) · Ngati Porou

Chris graduated with a Bachelor of Fine Arts from Te Toi Hou, Elam School of Fine Arts, University of Auckland, in 1994. He is currently completing a Master of Maori Visual Arts at Te Putahi a Toi, Massey University, in Palmerston North. Chris is a practising artist, art educator, curator and writer. He is a founding member of Te Taumata Art Gallery in Auckland. Currently, Chris has returned home to re-establish his Napier studio and is teaching at Toimairangi School of Maori Visual Culture, Te Wananga o Aotearoa, in Hastings. Since his appointment in 1993, Chris has continued to serve on the Te Atinga (Committee of Contemporary Maori Visual Arts) of Toi Maori Aotearoa. He has exhibited since 1994 in various exhibitions in New Zealand and in "Haka" (1997–98), which toured the United Kingdom.

PAERAU CORNEAL (b. 1961) · Te Atihaunui a Paparangi, Ngati Tuwharetoa

Paerau graduated with a Diploma in Craft Design—Maori in 1990 from Waiariki Polytechnic in Rotorua. She currently tutors in ceramics at Te Puna Toi, a Maori visual arts program of Te Wananga o Aotearoa in Palmerston North. She is a member of Nga Kaihanga Uku, a national

Maori clayworkers' group; Kauwae, a Maori female artists' group, and Nga Wahine Kai Whakairo, a national Maori women's carving group. Paerau's work portrays Maori women as strong, enduring and as diverse as the carved female forms within the *whare whakairo* (carved house). She uses hand-building techniques to create her figurative forms and includes woven *muka* (flax fibres) and *raranga* (weaving) in her vessel forms. Her work has been exhibited in "Home Made Home" (1991) at the City Gallery Wellington, "Kurawaka" (1994) at the Dowse Art Museum and "Treasures of the Underworld" at the Expo 92 exhibition in Seville, Spain. Other exhibitions include "Sisters/ Yakkananna/Kahui Mareikura" (2002) in Adelaide, Australia, and "Kiwa—Pacific Connections" (2003) in Vancouver, Canada.

TODD COUPER (b. 1974) · Ngati Kahungunu

Todd attended Te Aute Boys College in Hawkes Bay from 1987 to 1991 and quickly excelled in art. In 1995, he completed the Diploma of Art, Craft and Maori Design at Waiariki Institute of Technology (formerly Waiariki Polytechnic) in Rotorua; he majored in woodcarving/sculpture and graduated with honours. It was during this time that he met Roi Toia, who was teaching there. Roi, impressed with his talent, invited Todd to apprentice with him. They continue to work together, but Todd has forged his own style and direction in carving, with commissioned pieces residing in collections in the United States, Canada, Australia and the Netherlands. He participated in "Kiwa— Pacific Connections" (2003) in Vancouver, Canada.

JOE DAVID (b. 1946) · Nuu-chah-nulth

Joe was born in the village of Opitsat on Meares Island in Clayoquot Sound, British Columbia. One of a large family that moved frequently, including a stop in Seattle, Washington, Joe studied fine art in Texas before witnessing the early developments of the modern Northwest Coast art movement. He has effortlessly blended Northwest Coast and his own Nuu-chah-nulth art with other cultural influences. One of the first artists to visit the Maori and begin a cross-cultural dialogue, he also makes a yearly pilgrimage to the American Southwest to participate in the Sun Dance Ceremony. His interest in shamanism, spiritual healing and traditional practices has become a quest and has led him to journey around the world. He has been included in most exhibitions, collections and publications on contemporary Northwest Coast art; as well, he has produced numerous commissioned pieces and participated in events and causes related to protecting the environment.

ROBERT DAVIDSON, RCA, CC (b. 1946) · Haida

Robert was born in Hydaburg, Alaska, and raised in the village of Old Masset on Haida Gwaii (Queen Charlotte Islands, British Columbia). He moved to Vancouver in 1965 to complete school before enrolling in the Vancouver School of Art. He committed very early to a career in the arts, studying with his father, Claude Davidson, and grandfather Robert Davidson Sr. He quickly emerged as an accomplished artist in graphics, wood and precious metal. His 1994 retrospective exhibition at the Vancouver Art Gallery was the largest solo exhibition of any Northwest Coast

artist, spanning four decades of artistic achievement. He has received the Order of Canada and the National Aboriginal Achievement Award and has been elected to the Royal Canadian Academy of Arts. Major commissions include the Maclean-Hunter Building in Toronto and the Donald M. Kendall Sculpture Gardens at PepsiCo Headquarters in Purchase, New York. In 2004, his solo exhibition "The Abstract Edge" (exploring personal interpretations of Haida design) opened at the University of British Columbia Museum of Anthropology and is now touring.

LEWIS TAMIHANA GARDINER (b. 1972) · Te Arawa, Ngati Awa, Whanau a Apanui, Ngai Tahu

Lewis was born and raised in Mataura, in Southland province in the South Island, then returned in 1989 to the family land in Rotoiti near Rotorua. He attended Waiariki Institute of Technology in Rotorua, graduated in Maori Craft and Design and studied with Ross Hemera, Christina Wirihana and Lyonel Grant. It was during his final year that he was first introduced to the valuable *taonga* (treasure) *pounamu* (jade). In 1995, he became a full-time jade and bone carver, specializing in traditional Maori imagery, and he is quickly becoming recognized as one of the most innovative Maori jade carvers for his unique style, design and composition, using many colours of jade. Winning the Mana Pounamu Awards for contemporary Maori jade design in 1999, 2001 and 2003 further enhanced his reputation, and his jade works are prized by collectors in New Zealand, Europe, Asia, Australia and the United States. He participated in "Kiwa—Pacific Connections" (2003) in Vancouver, Canada.

STEVE GIBBS (b. 1955) · Ngai Tamanuhiri, Ngati Kahungunu

Steve was born and raised in Gisborne. In 1978 he earned a Diploma in Fine Arts from the University of Canterbury in Christchurch, New Zealand, where he majored in painting, printmaking and art history, then completed a Diploma in Secondary Teaching at the Christchurch College of Education in 1979. He has worked as a lecturer in Maori Design at Christchurch Polytechnic and, since 1994, as principal tutor at Toihoukura School of Maori Visual Arts at Tairawhiti Polytechnic in Gisborne. Steve's innovative panel work incorporates contemporary design within a traditional context, inspired by the uniquely painted meeting houses in the Tairawhiti region. He layers translucent washes of paint with personal references to his tribal histories of Gisborne and his *papakainga*, his ancestral home at Te Kuri Marae, Muriwai. Part of a group of people committed to the ongoing development of Maori visual arts, he has travelled extensively, completing a three-month study tour in England, France and Singapore in 1983, and a six-week lecture tour in California in 1992. He has participated in many exhibitions throughout New Zealand, and his work has been showcased in the United States, Samoa and Europe. He participated in "Kiwa—Pacific Connections" (2003) in Vancouver, Canada.

BRETT GRAHAM (b. 1967) · Ngati Koroki Kahukura

Brett, son of renowned artist Fred Graham, graduated with a Bachelor of Fine Arts from the University of Auckland in 1989. The following year he was awarded an East West Center for

Education scholarship that helped him complete his master's degree at the University of Hawaii. He also spent three months studying under the sculptor Atsuo Okamoto. Since 1993 Brett has lectured on contemporary Maori art at the University of Auckland. One of the leading young sculptors of his generation, he is completely comfortable working on a large scale and in varied materials, which has resulted in many large public commissions in New Zealand. He has been regularly showing his work in group exhibitions since 1986, both overseas (in the United States, Japan and Australia) and in New Zealand, as well as in many solo exhibitions since 1991, including "1492–1642," which toured several North Island venues in 1992–94. In 2004, he completed his Doctorate of Fine Arts at the University of Auckland.

FRED GRAHAM (b. 1928) · Ngati Koroki Kahukura

Educated in Hamilton, Fred trained as a teacher, focussing on the arts. He worked as an art specialist in schools in the Rotorua and Northland districts of New Zealand, then taught art to teachers. An important figure in Maori art since the early 1960s, he has participated in most major exhibitions of contemporary Maori art, including "Te Waka Toi: Contemporary Maori Art," which toured the United States. His paintings and sculptural works are many and varied, some dealing with controversial issues, such as the continuing loss of Maori land, although his central themes are inspired by Maori traditions and legends. He is acclaimed in New Zealand as a leading contemporary sculptor, and he is still completing commissions for private and public spaces. Major works can be found in the Auckland High Court Building and the National Archives building in Wellington, as well as in public libraries, city plazas and urban park spaces throughout New Zealand and abroad. In 1986, he visited Canada as part of the International Carvers Exchange, carving *Eagle with a Salmon* for Port Alberni in British Columbia. In 1996, he completed a commission for the Burke Museum in Seattle, Washington. He participated in "Kiwa—Pacific Connections" (2003) in Vancouver, Canada, and in 2004 completed a solo exhibition at the Thornton Gallery in Hamilton, New Zealand.

IAN-WAYNE REIHANA GRANT (b. 1964) · Ngati Kahungunu, Rangitane, Ngati Kahu, Te Rarawa

Ian-Wayne was born and raised in the Wairarapa-Bush district of New Zealand and became inspired by the works of his grandfather Te Winika Reihana Kaio. His interest in carving began at school and continued in 1981 when he began his apprenticeship at the New Zealand Maori Arts and Crafts Institute in Rotorua, learning the technical skills of carving. After graduating, he stayed on as a resident carver, working on tribal meeting houses, restoration and commission works. In 1994, Lyonel Grant asked him to assist in carving the meeting house Ihenga at Waiariki Polytechnic in Rotorua. This became a turning point for Ian-Wayne as a carver. He returned to the institute as a tutor, then left to work on various projects of his own and to fulfill aspirations of his heart. Most recently, he assisted Fayne Robinson in carving his tribal meeting house Kaipo in south Westland on the west coast of the South Island.

JUNE NORTHCROFT GRANT (b. 1949) · Te Arawa, Tuwharetoa,
Tuhourangi-Ngati Wahiao

June graduated from Waiariki Polytechnic in Rotorua with a Diploma of Craft Design in 1989. Inspired by her ancestors and their art, she continues the tradition for the future generations of her family. Her work is often interwoven with powerful figures and stories from her tribal histories. She says, "Each time I paint the story of one amazing *tupuna* (ancestor), another comes to light with yet another fascinating contribution to the histories of the tribe." In 1991, she started Pohutu Prints Originals, specializing in Maori design–based screen prints. Later she opened Best of Maori Tourism Limited, a store specializing in Maori-made and Maori-designed products. Most recently she opened Te Raukura—The Red Feather Gallery. She has received numerous awards for her excellence in business and received the Black Pearl Award for her achievement in arts and culture. She has participated in many contemporary Maori art exhibitions, including "Te Waka Toi: Contemporary Maori Art" (1992–94), "Sisters/Yakkananna/Kahui Mareikura" (2002) in Adelaide, Australia, "Kiwa—Pacific Connections" (2003) in Vancouver, Canada, and "The Big Red" (2004) at the Rotorua Museum.

LYONEL GRANT (b. 1957) · Ngati Pikiao, Ngati Rangiwewehi, Te Arawa

An honours graduate from New Zealand Maori Arts and Crafts Institute in Rotorua, Lyonel trained under master carver John Taiapa. In 1984 he carved the meeting house Matapihi o te Rangi in Tokoroa and Ihenga in Rotorua (1993–96). Since then his work has become more sculptural: it explores the tensions between customary cultural traditions of art located on the *marae* (gathering place) and contemporary art styles found in the gallery; between modernism and Maori art; between different materials; between substance and space. Lyonel has completed many commissions, including three major ones for the Electricity Corporation of New Zealand (1992–98) and three *waka* (canoes): for Te Arawa (1990), Sky City Casino (1996) and the 150th Waitangi Day celebrations. In 2002, Lyonel exhibited a series of domestic-scale sculptures at the John Leech Gallery in Auckland, and in 2004 he created all the artworks associated with the garden design for the New Zealand entry in the Chelsea Flower Show exhibit in London, winning a gold award. He is currently working on another meeting house, for Unitec in Auckland, for completion in 2006–07.

GORDON TOI HATFIELD (b. 1964) · Nga Puhi

Gordon graduated in 1983 from the New Zealand Maori Arts and Crafts Institute in Rotorua, winning the Sir Henry Kalliher Student of Honour Award for his talents. In the mid-1990s he earned Top Warrior status after a long training in Maori disciplines, and he is a role model for Maori youth through his support of rehabilitation projects at schools. A noted woodcarver who designed and carved traditional meeting houses, including the Auckland University meeting house Tane-nui-a-rangi, he is most known as a *ta moko* artist. He began studying *ta moko* (traditional Maori body art) in 1995 and has become internationally renowned since releasing his book *Dedicated by Blood* (with Dutch/Indonesian photographer Patricia Steur), which captures his indigenous tattooing in photos.

Gordon has exhibited in several galleries in New Zealand and the Netherlands. An actor as well as a film and set designer, he worked on the movies *The Piano* and *Whale Rider* and received the Best Actor Award at the New Zealand Film and Television Awards in 1993. In 2004, he was nominated for the *TV Guide* New Zealand Television Award for Best Contribution to Design for his work as production designer.

ROSS HEMERA (b. 1950) · Ngai Tahu

Ross was born in Kurow, in New Zealand's South Island. He earned a Diploma of Fine and Applied Arts from Otago Polytechnic in 1972 and had his first exhibition in 1975. In 1983, he became head of visual arts at Waiariki Polytechnic, Rotorua, and more recently he was named head of the Department of Art and Design Studies at the School of Design at Massey University in Wellington. In 1987, he received a Queen Elizabeth II Arts Council of New Zealand/Air New Zealand Travel Award with which to study fine arts in the United States. Known primarily for his mixed-media sculptures, he has undertaken several significant public commissions, including the *Te Ao Marama* carving at the Museum of New Zealand/Te Papa Tongarewa and glass windows for both Ngai Tahu Development Corporation's Te Waipounamu House in Christchurch and the Albany campus of Massey University. His work has been exhibited in many contemporary Maori art exhibitions, including the American tour of "Te Waka Toi: Contemporary Maori Art," "Maori" at the British Museum in London (1988), "Te Puawai o Ngai Tahu" at the new Christchurch Art Gallery, "Kiwa—Pacific Connections" (2003) in Vancouver, Canada, and "Whenua—Born of the Land" (2004) in Wellington.

LANI HOTCH (b. 1956) · Tlingit

Lani was born in Klukwan, Alaska. Her Tlingit names are Saantaas', Sekwooneitl and Xhaatooch, and she is from the Wolf House of the Kaagwaantaan Clan in Klukwan. Her mother was of Tlingit ancestry and her father was from northern California with ancestral ties to Wales. She has lived most of her adult life in Klukwan with her children and husband, Jones Hotch Jr. (Naatl' of the Gaanaxteidi [Raven] Clan and recently appointed caretaker of the Whale House in Klukwan). Lani comes from a long line of Chilkat weavers. She began weaving under the guidance of her grandmother Jennie Warren, her tribal aunt Jenny Thlunaut and finally Cheryl Samuel, who has taught numerous weaving programs and oversaw the creation of *The Healing Robe*, a group project completed over eight years. Lani's first solo robe was a Ravenstail design titled *The Chilkat River Robe*. She then wove *The Klehini Robe*, a Ravenstail robe now in the Sheldon Museum collection in Haines, Alaska. Her major inspiration is the natural environment in the Chilkat Valley and the weavings and the stories of her ancestors.

NORMAN JACKSON (b. 1957) · Tongass/Tlingit

Norman is of the Tongass Tlingit Nation and was born in Ketchikan, Alaska. His lineage is from his mother, who is of the Tongass Tlingit Hoots Hits Bear House of southern Alaska. His father is Kaagwaantaan Tlingit of Klukwan, Alaska. Norman studied at the Gitanmaax School of Northwest

Coast Indian Art and received advanced training in carving. He also received training in metal engraving from the Totem Heritage Center in Ketchikan. He is recognized as a master artist in metal engraving by the Alaska State Council on the Arts Master Artist and Apprentice Grant, and he has received numerous honours for his excellence in woodcarving. He has apprenticed with master artists Dempsey Bob and Phil Janze and has been invited to pass on his knowledge by participating in several symposia on professional carving. Norman's work is held in major collections and was represented in "A Treasured Heritage," a travelling exhibition put together by the Institute of Alaska Native Artists.

ROBERT JAHNKE (b. 1951) · Te Whanau a Rakairoa o Ngati Porou

Robert earned his Bachelor of Fine Arts in Industrial Design in 1976 and his first-class Master of Fine Arts in Graphic Design in 1978, both from Auckland University. In 1980, he graduated with a Master of Fine Arts in Experimental Animation from the California Institute of the Arts. He is currently professor and head of the School of Maori Studies/coordinator of Maori Visual Arts at Massey University in Palmerston North and a doctoral candidate there. Dedicated to producing students who are not only artists but also theorists capable of supporting the growth of the Maori art movement in New Zealand, he has introduced at Massey a Bachelor of Maori Visual Arts program that includes Te Reo Maori (Maori language) and Tikanga Maori (Maori protocol) as integral components. He is a leading Maori academic and a pioneer in contemporary Maori art; his works have a creative vitality, often with a political edge. Symbols in his work, such as hatchets and classical columns, reference icons of European domination and oppression. He has received numerous awards, participated in many solo and group exhibitions including "Kiwa—Pacific Connections" (2003) in Vancouver, Canada, and been included in many publications. His major public works include window and door designs for the Museum of New Zealand/Te Papa Tongarewa, wall reliefs for the High Court Building and Bowen House in Wellington and the sculpture installation at the Sky Casino entrance in Auckland.

RANGI KIPA (b. 1966) · Te Atiawa, Taranaki, Ngati Tama ki te Tauihu

Raised in Waitara, Taranaki province, where the Land Wars of the mid-1800s left a bitter inheritance, Rangi is motivated to continue customary Maori art traditions in contemporary contexts. Trained as a carver at the Maraeroa Carving School in Porirua City, he has also mastered the making of *taonga puoro* (Maori musical instruments), *to whakairo* (sculpture) and *ta moko*. The celebrations at Waitangi in 1990 to mark the 150th anniversary of the Treaty of Waitangi encouraged Rangi to apply for special admission to the University of Waikato, from which he earned a Bachelor of Social Science in 1993. He enrolled in the Master of Maori Visual Arts program at Massey University in 1999. Rangi is now exploring new media such as Corian®, a space-age heatproof and stainproof composite material. His eye for ethnographic detail in wearable works like *tiki* (carved figures) provides a spin on the historical devaluation of these revered Maori icons and makes them highly crafted, elegant *taonga* (treasures) that reaffirm their place for 21st-century Maori.

DEREK LARDELLI (b. 1961) · Ngati Porou, Rongowhakaata,
Ngati Kanohi (Ngai Te Riwai), Ngati Kaipoho (Ngai Te Aweawe)

Derek is best known as a *tohunga ta moko,* a specialist in indigenous skin markings. He was direc-
tor of the Ta Moko Delegation to the South Pacific Festival of Arts in Noumea in 2001 and Palau
in 2004 and to the New Zealand International Arts Festival at Te Papa Tongarewa/Museum of
New Zealand in 2004. Derek is also a visual artist, carver, *kapa haka* (cultural performing arts)
performer, composer, graphic artist and researcher of tribal history. His career highlight was being
commissioned to create a series of sculptures, *Maui Whaairo,* that are regarded as a New Zealand
cultural icon. Derek is principal tutor at the Toihoukura School of Maori Visual Arts at Tairawhiti
Polytechnic in Gisborne, *kapa haka* tutor for the Whangara Mai Tawhiti Cultural Group, chair of Te
Uhi a Mataora *ta moko* arts collective and trustee of Toi Maori Aotearoa. He participates regularly
in contemporary Maori art exhibitions, undertakes many large commissions and facilitates numer-
ous workshops in New Zealand and overseas, including "Kura, Contemporary Maori Exhibition"
(2000) in Belfast, Ireland, and the New Zealand High Commission exhibition in Singapore (2002).
The Arts Foundation of New Zealand honoured Derek with the prestigious 2004 Laureate Award,
the highest accolade ever given to the art of *ta moko.*

SIMON LARDELLI (b. 1970) · Ngati Porou, Rongowhakaata

Simon attended Waiariki Polytechnic in Rotorua from 1989 to 1992, studying in the visual arts
program taught by Robert Jahnke. In 1990 he participated in the Taharora Marae project on the
east coast of New Zealand's North Island, designing and carving *poupou* (carved figures) and then
the front of the meeting house. From 1993 to 1996 he assisted master carver Lyonel Grant on the
wharenui (ancestral meeting house) Ihenga at Waiariki Polytechnic. Later, employed by Waiariki
Institute of Technology (formerly Waiariki Polytechnic), he tutored in design, sculpture and carv-
ing and assisted in a series of major projects for his *iwi* (people). Since 2001, he has lived with his
whanau (family) in Gisborne. He carved a *wharenui/pawaha* (entranceway) for his old high school,
and he is currently a tutor in tertiary-level sculpture carving at the Toihoukura School of Maori
Visual Arts at Tairawhiti Polytechnic in Gisborne. He has participated in many exhibitions and
attended art *hui* (gatherings) throughout New Zealand.

RIKI MANUEL (b. 1960) · Ngati Porou

Riki graduated from the New Zealand Maori Arts and Crafts Institute in Rotorua in 1979 after
completing a three-year apprenticeship, then attended Wellington Business School. He con-
tinued carving in Christchurch, New Zealand, establishing Te toi Mana Maori Art Gallery in
1985. He has tutored and lectured at many institutions throughout New Zealand. He has partici-
pated in carving demonstrations in Singapore (1986), San Diego, California (1992), Belgium
(1996), the Netherlands (1998) and at the South Pacific Festival of Arts (1990/2000) in New
Caledonia. Among his completed commissions are a 7½-metre (twenty-five–foot) *poupou* (totem
pole) for Christchurch's Victoria Square (1995), carved and painted wall panels for the University

of Canterbury in Christchurch (1988), a *waka taua* (war canoe) for Millennium 2000 and a wall panel for Christchurch International Airport (2002). One of the leading carvers in New Zealand, his work is highly collected both in New Zealand and overseas. He participated in "Kiwa—Pacific Connections" (2003) in Vancouver, Canada.

HEPI MAXWELL (b. 1950) · Te Arawa, Ngati Rangiwewehi

Hepi never expected to earn a living in the arts, but became a carver when he lost his legs in a truck accident. Having no intention of living off the state, he responded to an advertisement in the local paper in Rotorua for potential jade carvers. Hepi has now been carving jade for 28 years and is one of the leading jade carvers in New Zealand. His carving is in a contemporary style based on the gentle, sweeping curves of ancient Maori art. Over the years, his jade pieces have been presented publicly to many people, from prime ministers to sports celebrities, and as awards at institutions and schools. His work has been documented in numerous publications and is held in museums and private collections all over the world. He participated in "Kiwa—Pacific Connections" (2003) in Vancouver, Canada.

ALEX NATHAN (b. 1946) · Te Roroa, Ngati Whatua, Nga Puhi

Alex worked in traditional materials such as bone, shell, stone and wood until the late 1980s when his brother, Manos, introduced him to Michael Kabotie, the Hopi silversmith. Now Alex works exclusively with silver as his primary material and uses traditional materials as highlights. Adapting and exploring traditional Maori designs within the silver medium, he incorporates traditional motifs in his uniquely constructed and carved silver pieces. Since 1986, his primary focus has been directed to resolving historical grievances of his tribe over land and resources with the Crown. This has taken so much of his time that his jewellery production is minimal and creates a constant demand from collectors. His work was exhibited in "Fusion: Tradition & Discovery" (1999) and in "Kiwa—Pacific Connections" (2003), both held in Vancouver, Canada.

MANOS NATHAN (b. 1948) · Te Roroa, Ngati Whatua, Nga Puhi

Since the mid-1980s, Manos has been at the forefront of the Maori ceramic movement. He is co-founder of Nga Kaihanga Uku, the national Maori clayworkers' organization, although his background is in woodcarving and sculpture. (He carved the meeting house at Matatina Marae, Waipoua Forest, on his tribal lands.) His clay works draw on customary art forms and on the Maori cosmological and creation narratives. In 1989, he travelled to the United States on a Fulbright grant to visit Native American potters. A reciprocal visit took place in 1991. His work is held in the collections of the British Museum; the National Museum of Scotland; the Museum fur Volkerkunder, Berlin, and Te Papa Tongarewa/Museum of New Zealand. He was represented in "Te Waka Toi: Contemporary Maori Art," which toured the United States (1992–94), and his work was exhibited in "Fusion: Tradition & Discovery" (1999) and "Kiwa—Pacific Connections"

(2003) in Vancouver, Canada, "Taiawhio—Continuity and Change" (2002) and "Nga Toko Rima: Contemporary Clayworks" (2003–05) at Te Papa Tongarewa.

DARCY NICHOLAS (b. 1946) · Te Kahui Maunga and the tribes of Taranaki and Tauranga Moana areas

Darcy was raised in Taranaki in the 1950s and his paintings reflect his tribal childhood, the power of his ancestral mountain (Mount Taranaki/Egmont) and the stories he inherited. "The faces in my paintings are a reminder of the great spiritual strength that made us warriors of the land and the sea," he says. He has painted and drawn for most of his life, selling his first painting when he was nine years old. Darcy has travelled and exhibited extensively since winning a Fulbright Cultural Award in 1984, when he visited the United States to observe contemporary Native and African-American art. His work is held in public and private collections throughout New Zealand, Australia, the U.S., Canada, Britain, Germany and France. He has held many senior positions and is currently general manager of cultural services for Porirua City in New Zealand. He describes himself as an international indigenous artist. His book *Darcy Nicholas—Land of My Ancestors* was launched in August 2005 in San Francisco.

TIM PAUL, RCA (b. 1950) · Nuu-chah-nulth

Tim is a Hesquiat/Nuu-chah-nulth artist from Esperanza Inlet on Vancouver Island. He has held the position of First Carver at the Royal British Columbia Museum, where he oversaw numerous commissions for totem poles for international sites such as Wakefield Park and Yorkshire Park in England, Stanley Park in Vancouver, and in Auckland. He left this position to oversee a program focussing on Native education for the Port Alberni School Board and Vancouver Island. He is part of the *Legacy* collection and the *Out of the Mist—Treasures of the Nuu-chah-nulth Chiefs* collection of the Royal British Columbia Museum and the "Down From the Shimmering Sky" travelling exhibition that opened at the Vancouver Art Gallery. He has a vast knowledge and understanding of tradition and history, which has influenced his work as an artist, environmentalist and teacher.

SUSAN POINT, RCA (b. 1952) · Coast Salish

Susan began making limited edition prints on her kitchen table in 1981 while working as a legal secretary. She received several early commissions, which established her reputation for innovative proposals and for completing projects on time, on budget and at the highest level. She took courses in silver, casting and carving, all of which led to monumental sculptures in mixed media, and she has worked in glass since 1985. She continues to release a number of print editions each year, but her focus has been on commissioned sculpture. *Beaver and the Mink* was chosen as the gift from the Canadian government to the new addition to the Smithsonian Institution's National Museum of the American Indian. She has several works in Vancouver International Airport, Langara College, the University of British Columbia Museum of Anthropology and the Victoria Conference Centre,

and her designs have been the logo for the annual Pacific Spirit Run, a fundraiser for hospital charities in Vancouver. She has also sat on the board of the Emily Carr Institute of Art + Design in Vancouver.

BAYE RIDDELL (b. 1950) · Te Whaiti

Baye attended Otago University in Dunedin, New Zealand, returning to his home in Tokomaru Bay in 1977. He established a ceramics studio/workshop in 1973 and has been working as a full-time ceramicist ever since. He has tutored extensively throughout New Zealand in tertiary institutions and on *marae* (traditional gathering places), and he has run many art workshops establishing community, national and international networks. He has exhibited widely, been represented in many public and private collections, and had his works profiled in many magazines and books. In 1987 he co-founded Nga Kaihanga Uku, a Maori clayworkers' organization, and in 1989 he was awarded a Fulbright scholarship to establish an exchange with Native American artists. His work was selected for "Te Waka Toi: Contemporary Maori Art," which toured the United States from 1992 to 1994, and he travelled to China and Korea in 2001 as a guest artist for the World Ceramics Expo.

FAYNE ROBINSON (b. 1964) · Kati Mamoe,
Kai Tahu, Ngati Apa Ki Te Ra To, Ngati Porou

Fayne was born and raised in Hokitika (Te Tai Poutini) on the west coast of New Zealand's South Island. He graduated from the New Zealand Maori Arts and Crafts Institute in Rotorua in 1984. After another four years as a graduate carver, he tutored in Hokitika before returning to Rotorua to further his knowledge of carving. Trained in *wananga* (traditional schooling), he is now developing his own contemporary style. Fayne has contributed carving to eight *wharenui* (ancestral meeting houses). His works have been in New Zealand galleries and international collections and he participated in "Kiwa—Pacific Connections" (2003) in Vancouver, Canada. His peers have honoured him as "Te Toki Pounamu" ("The Greenstone Adze") to acknowledge that his carving skills are an important treasure like the *pounamu* (jade). He has completed designing, carving and overseeing the carvings for his family *marae* (gathering place) Kaipo in south Westland in the South Island, which is the greatest honour for any carver.

ISABEL RORICK, RCA (b. 1955) · Haida

Isabel was born in Old Masset, Haida Gwaii (Queen Charlotte Islands in British Columbia), into the Raven moiety Yahgu'7laanaas. Her Haida name, S'it kwuns, means Red Moon, which was a name held by her maternal great-grandmother Isabella Edenshaw. She comes from a long line of weavers, including her mother, Primrose Adams; her aunt Delores Churchill, and cousins April and Holly Churchill. She began to weave seriously in 1982. The artist most dedicated to having weaving considered a fine art form beyond craft, she has been included in many exhibitions showcasing new directions in Northwest Coast art, including "Topographies: Recent Aspects of British Columbia Art" at the Vancouver Art Gallery and "Native Visions" at the Seattle Art Museum.

She has pieces in the British Museum (London), Vancouver Art Gallery, Royal British Columbia Museum (Victoria), Canadian Museum of Civilization (Hull, Quebec), Burke Museum (Seattle), New York Historical Association (Cooperstown), National Museum of the American Indian at the Smithsonian Institution (Washington, D.C.) and Heard Museum (Phoenix).

CHERYL SAMUEL (b. 1944)

Cheryl was born in Hawaii in 1944. She initially pursued a career in science, with an interest in fibre art and weaving. After marriage, children and a move to Seattle, she was attempting to solve a particular weaving problem when she attended a lecture given by Bill Holm at the Burke Museum in Seattle. There she saw the answer to her problem in a Northwest Coast Chilkat robe. She has been largely responsible for the revitalization of Ravenstail and Chilkat weaving by mastering lost techniques, teaching extensively, recreating and expanding the language of weaving, travelling internationally to study and document all historical robes (including fragments) and writing two books on the techniques and history of Northwest Coast weaving. She has collaborated with master Nuu-chah-nulth artist Art Thompson to create robes with a southern coast influence in order to introduce artists from all nations to weaving using their own tribal styles and personal influences. An innovative artist, she has moved into other media including woodturning.

PRESTON SINGLETARY (b. 1963) · Tlingit

Preston was born in San Francisco, California, in 1963. He studied at the prestigious Pilchuck Glass School in Stanwood, Washington, beginning in 1984, and remains connected to the school through various programs and as a board member. He had more than a decade of experience working on the teams for various master glass artists before he began to make pieces that combined his own Tlingit heritage and traditional objects with blown glass in 1987. He has travelled extensively to study international glass techniques, including in Sweden and Finland. He is considered a bridge artist between glass blowing and Northwest Coast art. He has worked with many other aboriginal artists interested in the glass medium and has helped establish glass programs for aboriginal students. His work has been exhibited internationally and is included in such collections as the Seattle Art Museum, the new National Museum of the American Indian at the Smithsonian Institution, and the Museum of History and Art in Anchorage.

WI TE TAU PIRIKA TAEPA (b. 1946) · Te Arawa, Ngati Pikiao, Te Atiawa

Wi served in Vietnam and as a prison officer at Wellington's Wi Tako prison before becoming a self-taught carver. While working as a social worker, he developed an interest in clay as an alternative to wood for teaching boys in reform institutions how to carve. In his own work, clay offered more freedom than stone or wood. In 1992, he graduated from Whitirea Polytechnic in Porirua City with a Diploma in Craft Design and completed his Bachelor of Fine Arts at Wanganui Polytechnic in 1999. He is currently a resident artist at Te Whare Wananga o Awanauiarangi in Whakatane, New Zealand. Now known for his ceramic work, he prefers a "low-tech" approach—hand building, sawdust firing

and incorporating Maori and Pacific design elements. He is keen to develop, with other members of Nga Kaihanga Uku (the national Maori clayworkers' organization), a solid *kaupapa* (purpose) for Maori clay workers. He has participated in many exhibitions, including "NZ Choice" (1994) in Santa Ana, California; National Gallery of Zimbabwe (1995) in Harare; "Haka" (1997–98), which toured the United Kingdom, and "Kiwa—Pacific Connections" (2003) in Vancouver, Canada.

NORMAN TAIT (b. 1941)/LUCINDA TURNER (b. 1958) · Nisga'a
Norman was born in 1941 in the northern community of Kincolith, British Columbia. He learned from his family protocols, oral histories and ceremonies and had an early interest in the arts. He carved the 16½-metre (fifty-five–foot) totem pole for the entranceway to the Field Museum in Chicago and a totem pole commissioned by the British royal family for Bushy Park in London. He has carved and ceremonially raised five totem poles in Greater Vancouver, including at the University of British Columbia Museum of Anthropology, Stanley Park, Capilano Mall and the Native Education Centre. He has conducted extensive research into Nisga'a art and is the foremost Nisga'a artist in wood, precious metals and graphics.

In 1991, Lucinda began with Norman an apprenticeship that has evolved into a working relationship, collaborating on numerous pieces while both artists also produce pieces independently. They completed two major sculpture commissions for the Vancouver Stock Exchange as well as many private commissions. Their work has been included in many of the exhibitions and publications documenting the contemporary art form.

KERRY KAPUA THOMPSON (TAMIHANA) (b. 1967) · Ngati Paoa
Kerry has been carving for twenty-two years in many materials and is possibly the leading artist working in bone. Although he attended a diploma course in Maori design at Waiariki Polytechnic in Rotorua and learned from Hepi Maxwell, Rex Christianson and other artists working in the same materials, his style of carving and two-tone staining process are uniquely his own. In 1992, he was a jade tutor for the Whangaroa Trust in Kaeo, New Zealand, and, with a grant through Te Waka Toi in 1994, became a full-time artist working primarily in jade and bone. He still produces the most ornate "wearable art" in varied media but has recently created larger, more challenging sculptural mask and figurative forms, and inlaid flutes, delicate *heru* (decorative ceremonial combs) and carved vessels. His art is contemporary yet incorporates elements of Maori design, such as the *koru* (unfurling fern frond) and the *matau* (fish hook), that feature his complex curvilinear forms. His work has been collected and exhibited both in New Zealand and overseas, including in "Kiwa—Pacific Connections" (2003) and "Koru—Spiral of Life" (2004) in Vancouver, Canada.

ROI TOIA (b. 1966) · Nga Puhi
Roi was born and raised in Southland province in the South Island of New Zealand, although his *whakapapa* (genealogy) is the Te Mahurehure *hapu* (sub-tribe) from the Hokianga in Northland on the North Island. In 1983, he received a three-year apprenticeship to the New Zealand Maori

Arts and Crafts Institute in Rotorua, where he learned to carve with the adze and chisel and graduated with honours. He has carved on four *whare whakairo* (carved houses), which fuelled his passion for perfecting the technical aspects of his art and led him to learn about the ideology and spiritual aspects of carving. After a decade carving in the traditional style, Roi explored a more contemporary direction and developed his own distinct style. In 1995, he was the carving tutor at Waiariki Institute of Technology in Rotorua; in 1996 he started his own business, Mauri Concepts, which was conceived during the exhibition "Reflections" in Rotorua. His work is held in many private collections in New Zealand and abroad and was exhibited in "Fusion: Tradition & Discovery" (1999) and "Kiwa—Pacific Connections" (2003), both held in Vancouver, Canada.

COLLEEN WAATA URLICH (b. 1939) · Te Popoto o Nga Puhi Ki Kaipara

Largely self-taught, Colleen developed her interest in pottery while completing an art major at Auckland Teachers College. She continued to experiment during the 1970s, encouraged by Alec Musha, one of the first Maori potters. She believes strongly in tradition, decorating with traditional Maori weaving patterns or by adding *muka* (flax fibre), feathers or shell to her works. For her, "working with clay means working with the body of Mother Earth, she who influences and sustains us physically and spiritually." Colleen has long served the community, national art committees and Nga Kaihanga Uku, the national collective of Maori clayworkers. In 2002, she completed her Master of Fine Arts degree with honours in sculpture at Elam, University of Auckland. Her dissertation on the ancient Lapita ceramic legacy to the Pacific contributed to a published paper. Her work has been exhibited throughout New Zealand and in "Mana Wahine" (1995) in the United States, "Te Atinga" (1997) in Bath, United Kingdom, "Haka" (1997–98) in its British tour, "Sisters/Yakkananna/Kahui Mareikura" (2002) in Adelaide, Australia, and "Fusion: Tradition & Discovery" (1999) and "Kiwa—Pacific Connections" (2003), both held in Vancouver, Canada.

EVELYN VANDERHOOP (b. 1953) · Haida

Evelyn is from Masset, British Columbia. She has a Bachelor of Fine Arts from Western Washington University and has had successful parallel careers as a weaver and watercolour artist. She studied watercolour painting in Europe, and one of her paintings was chosen by the United States Postal Service for a stamp to commemorate Native American dance. She has also been chosen as an artist in residence at the Smithsonian Institution's National Museum of the American Indian in Washington, D.C. She comes from a long line of Haida weavers, including her grandmother Selina Peratrovich and her mother, Delores Churchill. She has also studied weaving with Cheryl Samuel.

CHRISTIAN WHITE (b. 1962) · Haida

Christian was born in Queen Charlotte City and raised in Old Masset, Haida Gwaii (Queen Charlotte Islands, British Columbia). He is from the Dadens Yahgu'7laanaas Raven Clan and his Haida name is Kilthguulans (Voice of Gold). He started carving argillite at the age of fourteen under the direction of his father, Morris White. He studied the work of the great masters and especially

of his great-great-grandfather Charles Edenshaw. A self-supporting artist since the age of seventeen, Christian shows an advanced knowledge of Haida forms and an emerging personal style based on narrative story telling and strong use of inlays of various materials, even in his earlier pieces. His sculpture *Raven Dancer* was purchased for the permanent collection of the University of British Columbia Museum of Anthropology when he was twenty-one years old. He has constructed a major longhouse in his home village of Masset and is a dedicated teacher and cultural participant. He has been active in the repatriation committee lobbying for the return of Haida artifacts and for overseeing the return to Haida Gwaii and reburial of human remains taken away for study.

WILLIAM WHITE (b. 1960) · Tsimshian

William lives in northern British Columbia. His Tsimshian name is Lii Am Laxuu and he is a member of the Raven Clan of the Git-wil-gyoots, which translates as "the people of the seaweed." A weaver for twenty-three years, he has also been a dedicated teacher for more than a decade, with a particular interest in supporting the growing interest in Tsimshian weaving and the return of weaving as a cultural and personal statement at ceremonies. He has travelled throughout the Tsimshian Nation and smaller villages, promoting and teaching traditional weaving. He is proud to be a Chilkat weaver and honoured to be a carrier of the traditional knowledge among the people of the Tsimshian Nation. He publicly wove a robe at the University of British Columbia Museum of Anthropology as part of the educational program "My Ancestors Are Still Dancing," and this robe is now in the permanent collection of the museum.

CHRISTINA HURIHIA WIRIHANA (b. 1949) · Ngati Maniapoto, Ngati Raukawa, Ngati Pikiao

Christina is a master weaver and has been weaving for more than forty years. She attributes her knowledge to many people, especially her mother, Matekino Lawless, who is also a weaver and has been her strongest support and mentor. Christina is grounded in the traditional weaving techniques but has moved towards more contemporary forms. She continues to push the traditional boundaries of weaving, using materials such as glass, copper, stainless steel, wood and Perspex. Christina lectured at the Waiariki Institute of Technology, Rotorua, for seventeen years and was responsible for the design, quality control and installation of all the fibre components for the great meeting house Ihenga. She currently lectures at Te Whare Wananga o Awanuiarangi, Whakatane, where she manages the weaving department. In 2003, she was awarded the Te Waka Toi Award for New Work, in recognition of leadership and outstanding contribution to the development of new directions in Maori art. She has lectured, been an artist in residence, tutored and participated in many exhibitions throughout New Zealand, the South Pacific, Australia and the United States. Christina's work is also in museums, galleries and private collections around the world.